MUSEUMS AND DESIGN EDUCATION

Museums and Design Education
Looking to Learn, Learning to See

Edited by

BETH COOK

REBECCA REYNOLDS

CATHERINE SPEIGHT
Centre for Excellence in Teaching and Learning through Design
(CETLD), University of Brighton and the
Victoria & Albert Museum, UK

ASHGATE

Published by
Ashgate Publishing Limited
Wey Court East
Union Road
Farnham
Surrey, GU9 7PT
England

Ashgate Publishing Company
Suite 420
101 Cherry Street
Burlington
VT 05401-4405
USA

www.ashgate.com

British Library Cataloguing in Publication Data
Museums and design education : looking to learn, learning
 to see.
 1. Museums--Educational aspects--Great Britain.
 2. Education, Higher--Great Britain. 3. Institutional
 cooperation--Great Britain. 4. Design--Study and teaching
 (Higher)--Great Britain.
 I. Cook, Beth. II. Reynolds, Rebecca. III. Speight,
 Catherine.
 069.1'5-dc22

Library of Congress Cataloging-in-Publication Data
Cook, Beth.
 Museums and design education : looking to learn, learning to see / by Beth Cook, Rebecca Reynolds and Catherine Speight
 p. cm.
 Includes bibliographical references and index.
 ISBN 978-0-7546-7713-0 (hbk) -- ISBN 978-0-7546-9431-1 (ebook)
 1. Museums--Educational aspects. 2. Design--Study and teaching
 (Higher) I. Reynolds, Rebecca. II. Speight, Catherine. III. Title.

 AM7.C66 2009
 069'.15--dc22

ISBN 9780754677130 (hbk)
ISBN 9780754694311 (ebk)

2009038242

Mixed Sources
Product group from well-managed
forests and other controlled sources
www.fsc.org Cert no. SGS-COC-2482
© 1996 Forest Stewardship Council

Printed and bound in Great Britain by
TJ International Ltd, Padstow, Cornwall

Contents

List of Illustrations

List of Tables

Notes on Editors and Contributors

Editors

Beth Cook, CETLD Research Fellow, University of Brighton and V&A

Beth Cook is a CETLD Project Research Fellow based at the V&A. She has worked with students for three years, specifically on the Behind the Scenes research project, and has also worked in wider visitor research at the V&A for over four years. She studied Archaeology and Museum Studies, and has worked at the Imperial War Museum and the V&A.

Rebecca Reynolds, CETLD Higher Education Officer, University of Brighton and V&A

Rebecca Reynolds is the CETLD Higher Education Officer based at the V&A. Her responsibilities include research into design students' learning in the museum; developing museum-based educational resources for HE design students, some using mobile learning technology; and museum-based teaching for HE students. Before this Rebecca taught academic English and study skills to art and design students from overseas. She has an MA in Museum Studies (University of Leicester, 2007).

Catherine Speight, CETLD Research Fellow, University of Brighton and V&A

Catherine Speight is the CETLD Research Fellow based at the V&A. She is responsible for CETLD's overarching research programme exploring how design students critically engage and reflect upon their practice in the museum environment. She has been working closely with students for three years, developing specific techniques for this research, and linking knowledge about the two sectors. Prior to this appointment, Catherine worked for a number of museums including Brighton Museum and Art Gallery, the Museum of London and the Imperial War Museum. She has also worked as an educational researcher for both Solent University and the University of Brighton. She has a BA (Hons) in Geography and an MA in Museum Studies (University of Leicester).

Contributors

Kate Arnold-Forster, Head of University Museums and Collections Service, University of Reading

Kate Arnold-Forster has worked in the museums sector as a volunteer, curator and consultant for more than two decades. She is Director of the Museum of English Rural Life and Head of University Museums and Special Collections Services at the University of Reading, where she has led a major programme of capital and collections development. She has undertaken extensive research into the sector through the national (UK) survey of university museums and collections. She is also a Fellow of the University's Centre for Excellence in Teaching and Learning in Applied Undergraduate Research Skills, which focuses on the development of new approaches to collections-based student learning.

She has held positions on a wide range of national and regional bodies and is currently on the committee of the UK University Museums Group. She is a Fellow of the Museums Association.

Anne Boddington, Director for the Centre for Excellence in Teaching and Learning through Design and Dean of the Faculty of Arts and Architecture, University of Brighton.

Anne Boddington is an architect with a research Masters in cultural geography. She has a wide range of experience in managing academic development and practice, research and consultancy projects across the fields of architecture and design. She has served on a number of professional committees for the Architects Registration Board (ARB) and the Royal Institute of British Architects (RIBA). Her research interests focus primarily on the relationships of architecture and the built environment to the cultural landscape and on architectural and design pedagogy.

Jos Boys, Senior Research Fellow, CETLD, University of Brighton

Dr Jos Boys is CETLD Senior Research Fellow in Learning Spaces. Her background is in architecture and she has also worked as an architectural journalist, practitioner and researcher. She has considerable experience as a teacher of architecture in HE, across both design and contextual subjects, and at all stages from access through to postgraduate. Jos' research explores relationships between architectural space and diverse social and cultural practices. She is currently writing up her Ph.D., *The Spaces In-Between Architecture: Domestic Space and Struggles over Constructing the Social 1830–2000*, as a book. Other publications include Neutral Gazes and Knowable Objects, in Duncan McCorquodale et al. (eds) (1996) *Desiring Practices*. London, Black Dog Press.

Professor Geoffrey Caban, University of Technology, Sydney

Geoffrey Caban is Emeritus Professor of Design Studies at the University of Technology, Sydney and Life Member of Clare Hall, Cambridge. His appointments have included Visiting Fellow at the Powerhouse Museum in Sydney, Conjoint

Professor at the University of Newcastle and Adjunct Professor at the University of the Sunshine Coast. From 1991 to 1998 he was Dean of the Faculty of Design, Architecture and Building at UTS, and from 1988 to 1991 was Dean of the former UTS Faculty of Design. He is a foundation member of the Australian Academy of Design, and has been a member of the Quality Review Committee of the Darling Harbour Authority, a member of the Facilities Review Committee for the 2000 Sydney Olympic Games, and a member of the Foundations for Architecture Advisory Committee of the State Library of NSW.

Professor Caban is the author of a number of books and publications in the areas of design history and design education including the books *World Graphic Design* (Merrell, 2004) and *A Fine Line: A History of Commercial Art in Australia* (Hale and Iremonger, 1984). His recent publications have focused on the value and effectiveness of various educational strategies in the design learning process, including those employed in settings such as museums and the workplace. In collaboration with co-researchers at the Powerhouse Museum he has published *Museums and Creativity: A Study into the Role of Museums in Design Education* (Powerhouse Publishing, 2002).

Mark Carnall, Curator, The Grant Museum of Zoology, UCL

Mark Carnall is the curator of The Grant Museum of Zoology and Comparative Anatomy, University College London (UCL). He is a palaeobiologist and curates the historic teaching collection, founded in 1828. Recently, he has been working to catalogue the collection, recording specimens with a 3D laser scanner, as well as using other new technologies to bring the relatively hidden collection to a wider audience. As well as having a lifelong interest in natural history and science communication, Mark grew up with videogames and the internet and is particularly interested in applying these technologies to keeping museums pertinent, innovative and engaging to public audiences.

Morna Hinton, Head of Learning, V&A

Morna Hinton is Head of Learning at the V&A, where she manages a large team of educators and administrators running programmes and developing resources for schools, families, young people, adults, students and creative industries professionals. Her initial training was as an art and design secondary school teacher, with an academic background in History of Art, and an MA in Museum Studies. She joined the V&A Learning and Interpretation Division in 1991, and worked on schools programmes, gallery interpretation and visitor research before taking up her current position in 2002. She is currently developing a research project on sketching museums by HE students.

Torunn Kjolberg, PhD student, University of Brighton

Torunn Kjolberg is a Ph.D. student at the Faculty of Arts and Architecture, University of Brighton, researching the practice of 'visual research' in fashion and textile design education. Her studentship is funded by CETLD and ADM-

HEA (Art, Design, Media Higher Education Academy). She also teaches research methods and design theory and history to undergraduate students. Her current research interests include visitors' experiences in museums, design education and practice, and material culture and memory. Torunn has a background in fashion design and has previously worked as a freelance designer, stylist and visual merchandiser. She holds an MA in History of Design and Material Culture.

Patrick Letschka, Senior Lecturer (Architecture and Design), University of Brighton

Patrick Letschka is a senior lecturer at the University of Brighton. He is the area leader for wood and visual research on the MDes 3D materials practice WMCP and 3D design programmes. He also teaches visual research methods at the Royal College of Arts, London.

Since completing his MA in Design by independent study at the University of Brighton, Patrick has used moving image to explore the relationship between the making process and the symbolic function of objects. He actively designs and makes a wide range of ecclesiastical furniture and artefacts, which have been installed in churches throughout England, from his studio workshop in the heart of Sussex.

Dr Karina Rodriguez-Echavarria, Research Fellow, Management and Information Sciences Faculty, University of Brighton

Karina is a research fellow at the University of Brighton engaged in research projects concerned with the use of information technologies for cultural heritage; in particular the assembly and visualisation of interactive virtual environments. Karina obtained her Computing Engineering degree from the ITESM, Mexico in 1999. She completed her Ph.D. at the University of Wolverhampton in the area of knowledge-based engineering in 2005, and an MA in Histories and Cultures at the University of Brighton in 2008. Currently, she is co-chair for the International Symposium on Virtual Reality, Archaeology and Cultural Heritage (VAST2008) and Information Director for the ACM *Journal on Computing and Cultural Heritage*.

Dr Carol Ann Scott, Museum Consultant

Dr Carol Scott is the Renaissance London Programme Manager for 2012 working with London's non-national museums to develop their Olympic programmes. She was Manager of Evaluation and Audience Research at the Powerhouse Museum in Sydney from 1991–2008, President of Museums Australia 2001–2005, Inaugural Chair of Australia's Special Interest Group in Evaluation and Visitor Research, National Research Manager for CREATE, a Co-ordinator of the National Community Arts Training Unit at the Australia Council for the Arts and worked for 10 years in the field of Aboriginal Education. Her Ph.D. thesis examined a typology, assessment framework and evidence base for museum value. She has published extensively and is in demand as a consultant, facilitator and presenter.

Jill Seddon, Principal Lecturer (Historical and Critical Studies), University of Brighton
Jill Seddon is leader of the academic programme in the history of art and design at the University of Brighton, and teaches history and theory of design to practice-based design students. As a member of the University's Gender and Built Space research group, Jill has focused on the work of women designers between the wars, contributing a chapter to *Women and the Making of Built Space in England 1870–1950*, published by Ashgate, in 2007. She is also a principal investigator researching the public sculptures of Sussex as part of the Public Sculpture and Monuments Association's national recording project.

Rhianedd Smith, Undergraduate Learning Officer, Museum of English Rural Life (CETL-AURS), University of Reading
Rhianedd Smith BA, MPhil, PGCAP, AMA is the Undergraduate Learning Officer at the Museum of English Rural Life, University of Reading. She is part of a CETL for Applied Undergraduate Research Skills (CETL-AURS) funded project investigating the potential role of university collections in higher education teaching and learning. Rhi is also undertaking a CETL for Careers Management Skills (CCMS) Fellowship exploring how volunteering with collections can be used to enhance student employability. Prior to this Rhi has worked at the Ure Museum of Greek Archaeology, University of Reading and the Pitt Rivers Museum, University of Oxford.

Lars Wieneke, Research Fellow at the University of Brighton, EPOCH Research Group, University of Brighton
Lars graduated as an engineer in media technology in 2003. Since then he has worked as a lecturer in the department of Interface Design at the Bauhaus University in Weimar, where he taught courses in conceptual design and implementation of new media environments as well as software design of interactive systems. Currently Lars is working as a Research Fellow at the University of Brighton where he researches the application of user-created content in museums and cultural heritage. In particular he is interested in the connection of virtual and real world museums and the interactions between museums and their visitors/users.

Preface

Morna Hinton

Over the last 20 years education has been of growing importance to museums, with the increasing development of learning and interpretation departments, educational curators and outreach programmes for new audiences. However, throughout this process, higher education (HE) in the UK has tended to be overlooked. *Museums and Design Education* is an attempt to redress that balance by presenting the results of research and projects aimed specifically at the HE audience. While there are many examples of good practice in the UK of museums and universities working together in productive and innovative ways, these still tend to be based on individual enthusiasm and opportunistic arrangements. This book aims to draw out the more general lessons we can learn, both strategic and practical, to support the better embedding of long-term, sustainable and constructive relationships between museums and universities so as to enable effective student learning. The hope is that it will provide the stimulus and focus for debate around the issues and questions it raises.

The year 2005 saw the creation of a unique partnership between the University of Brighton, the Victoria and Albert Museum (V&A), the Royal College of Art (RCA) and the Royal Institute of British Architects (RIBA). With funding from the Higher Education Funding Council for England (HEFCE), the Centre for Excellence in Teaching and Learning through Design (CETLD) set out with the aim of enhancing research-led teaching and learning in design to bring together resources and expertise from HE and collections-based partners. In fact all four partners encompass both education and collections to varying degrees.

Museums and Design Education has been edited and in large part written by three researchers from the CETLD project who have been based at the V&A (Beth Cook, Rebecca Reynolds and Catherine Speight). They have invited contributions from across the partnership and beyond. Authors have been drawn from museums and universities internationally including (in addition to the University of Brighton and the V&A) the University of Reading and its Museums and Collections Service, the University of Technology and the Powerhouse in Sydney, and the Grant Museum of Zoology at University College London. As this book makes clear, this is an emerging area of collaboration. Being aware of the different ways that terminology is used in both sectors (such as the relationship between 'looking' and 'seeing') as well as the phrases that are unique to each (such as the museum sector term 'object-based learning') is important for working towards a common understanding. There are terms that occur frequently in the book, and sometimes

in slightly different contexts. For this reason we have not attempted to standardise these or provide a glossary that outlines them.

At the first annual Henry Cole lecture at the V&A on 30 October 2008, Professor Christopher Frayling, Rector of the RCA, reflected on the fact that the collections of the V&A were initially founded as a teaching resource for the Government Schools of Design. This intertwining of the history of museums and universities is by no means unique, as Catherine Speight and Kate Arnold-Forster explain in Chapter 1 of this book. Writing at the beginning of the twentieth century, the lawyer and antiquarian David Murray confidently asserted that: 'Every professor of a branch of science requires a museum and a laboratory for his department; and accordingly in all our great universities and other teaching institutions we have independent museums … each subject taught having its own appropriate collections' (quoted in Arnold-Forster 1989).

What is interesting here is not just the fact that museums were considered necessary but that they were posited alongside laboratories as a means of generating new knowledge. Rhianedd Smith's chapter describing another Centre of Excellence in Teaching and Learning project to develop applied undergraduate research skills (CETL-AURS) at the University of Reading with its Museum of English Rural Life shows how far removed from academic life some university museums have become since the days when they were considered as central to teaching as laboratories or indeed workshops and studios. A challenge for all museums today, not just those with a specific association with universities, is how to reassert this vital relationship between the world of creativity and the intellect.

Although attitudes are now changing, the history of HE in the last 20 or 30 years has shown some ambivalence towards use of museum and gallery collections as part of the curriculum. When I was studying for my Postgraduate Certificate in Education (PGCE) in 1989–90, an opportunity arose to work with the V&A on a project around the statue of the *Three Graces* by Antonio Canova. A handful of students were selected to work with the then newly-appointed Head of Education, David Anderson. I was not one of them. However, one of the chosen few declared rather grandly that he didn't want to do it because it was all 'old stuff' and museums were not creative places. I saw an opportunity and seized it, putting myself forward eagerly to take his place. As a history of art graduate rather than somebody from a practice-based discipline, I liked museums and had undertaken my PGCE with the aim of going into museum or gallery education. But the attitude of my fellow student was not untypical. Although I had ended up doing a history of art degree, I'd started off on an art foundation course in 1983. We had art history lectures during which it was more or less a point of honour amongst most of my fellow students to fall asleep, because the procession of slides in a darkened room was considered to be irrelevant to their own practice.

Those students may have been surprised to learn that the original V&A collections were formed as teaching aids for the Government Schools of Design, which were founded in 1837 with headquarters in London's Somerset House. There was also a network of regional outposts including one in Brighton, where,

as in London, there was a strong association with an institution that later became a museum, the Royal Pavilion. Brighton School of Art, founded in 1859, was originally located in rooms adjacent to the kitchen of the Pavilion before moving to the nearby Grand Parade site in 1877, where it still is to this day. CETLD therefore brings back together three institutions that were originally connected to the Schools of Design: the Brighton School of Art (now the Faculty of Arts and Architecture at the University of Brighton), the V&A and the RCA.

The mission of the Schools of Design was to improve the quality of British manufacturing, and the collections consisted primarily of plaster casts and copies of things thought relevant to what we would now call design, but which was then referred to as 'ornamental', as opposed to 'fine' art. By the 1850s the Schools of Design were all but defunct, when they came into the sights of the famously energetic Henry Cole. With the proceeds of the Great Exhibition of 1851, Cole set about revitalising both the Schools and their collections.

By the 1860s the collection, now located in the South Kensington Museum on the site of the current V&A, had taken on a purpose of its own and was no longer primarily concerned with the education of designers and manufacturers. Whereas previously the Museum had collected things thought relevant to design, it was now collecting more elite artefacts, for example from Renaissance Italy. This was at least in part on the basis that they would be a wise financial investment, but connected to that was a rise in connoisseurship as a guiding mission for the collection. The Museum gradually became less accessible to those it had originally intended to serve. An artisan connected with Lambeth School of Art (an extension of which became the current City and Guilds of London Art School) complained in 1864 that the Museum 'might as well be on the moon' for all the advantage he could derive from it. Even those students based at South Kensington itself declared the Museum to be of extremely limited utility (Cardoso Dennis 1999).

Research into how design tutors and students were using the V&A in 2006, by the CETLD researchers and Susie Fisher, painted a picture that was startlingly similar in some ways to that of 140 years earlier: 'Not all students enjoyed the Museum environment, citing orientation problems, objects displayed under glass and high charges as disincentives to visit' (Fisher 2007:1).

Many tutors may themselves have been trained in the sort of 'anti-history' art school environment I referred to earlier and seemed both ambivalent about the value of museums and unsure about how best to make use of a visit. There also appeared to be a culture of challenging anything representing the establishment: 'It was the job of the HE art and design departments to undermine orthodoxy and create anew' (Fisher 2007: 1). This led to the use of 'deconstructive inquiry' as a method of approaching the Museum and its collections. Nonetheless, tutors felt students needed help learning to visually interrogate objects, while feeling that any attempt to 'teach' it was doomed to be clumsy and ineffective. Catherine Speight notes: 'Seeing goes beyond looking and is about actively engaging and understanding the object' (see Chapter 2). Constructivist theories of learning posit the learner as active meaning-maker. However, research for CETLD has shown

that students only gradually over time gain confidence in their own opinions and meaning-making. Evaluation of a project described by Rebecca Reynolds found that the first or second year undergraduates were more likely to want 'an educated opinion that informs' while the postgraduates were more likely to be receptive to the views of other students and not to want to hear from design tutors or historians (see Chapter 5).

Museum education has lost sight of the early origins of many museums in the collections of university departments and art schools. Speight notes that the educational role of the museum lost ground in the early part of the twentieth century (see Chapter 2). When museums began to take on the mantle of public educators once more in the latter part of the century it was schoolchildren, not university students, who were the first beneficiaries. For example, it was not until the twenty-first century (2002) that the V&A appointed its first dedicated Higher Education Officer, despite 17 per cent of its overall visitors being students compared to around 2 per cent from schools (2007–2008 figures). A specialist schools service has existed at the Museum since 1991. HE Officer posts remain a rarity in museums, and the CETLD project itself arose in part from the significant dearth of research into the specific needs of HE students in relation to collections-based learning.

The other key purpose of CETLD was to develop excellence in teaching and learning through design. The focus was to be both learning *about* design and learning *from* design, learning 'about' and 'from' being key concerns for HE tutors as Jos Boys reminds us (see Chapter 4). Museum collections present opportunities for HE students to both learn *about* a particular subject, for example the history of ceramics, but also to learn things *from* the gallery context, such as 'historiography, curation, narrative construction, or exhibition design'.

However, there appears to remain a mismatch between the mindset and expectations of HE art and design academics, and of museum professionals. For museum educators more used to dealing with the known quantity of the school curriculum, varied examination syllabuses in the latter stages of secondary education already present issues to overcome, so the HE landscape can present a serious challenge if they try and match learning programmes and resources to specific curricula. Courses that meet the same Quality Assurance Agency (QAA) 'benchmark statements' can vary enormously in content and approach, and the students studying them, especially in art and design, tend to end up pursuing very personal projects. If museums concentrate on the 'about' bit of the HE learning equation then they are setting themselves up to fail as they will never be able to cover every possibility. The 'from' dimension offers far more scope, especially in terms of ways of engagement, and looking: 'From the art and design academic's point of view, the value of making unexpected, lateral connections may appear so obvious that they can fail to see that it is a skill which has to be learnt rather than one that can be just picked up by "doing"' (see Chapter 4). It is not just students who need to learn this skill. Museums need to start to present these sorts of 'left field' connections both in display and interpretation if they wish to be

fertile resources for HE art and design. In doing so, they will also be taking an important step towards fulfilling their potential as catalysts for personal creativity in all visitors, not just students.

Opportunities to go behind the scenes are very often requested by tutors bringing groups as well as individual students. What this privileged access represents to tutors and students is the subject of one of the CETLD research projects discussed by Beth Cook (see Chapter 7). Boys suggests that in part the desire to look in stores and conservation studios is a manifestation of the desire to make new and unconventional connections between objects. When viewed 'off display' in this way, artefacts might be quite randomly placed next to each other (because they were acquired in the same year, made of the same material or are scheduled for cleaning at the same time). This sort of serendipity presents an alternative to the carefully conceived and ordered displays in the museum's galleries and exhibitions. It is tied into wider debates about the nature of access in museums, and issues regarding the relationship between seeing, drawing, and touching objects that Cook expands on.

In Chapter 3 Cook and Speight examine issues of pedagogy in museums and HE and conclude that there are some tensions inherent in considering students in the same terms as other adult learners, which is where they often end up falling within museum education services. While for adult learners the informal, free-choice, non-assessed nature of the museum learning environment is appropriate, for students there is also the need to marry up what they are getting from a visit with the assessment requirements of their course. This is especially true when they are pursuing individual projects but also applies when they visit with a group. Theano Moussouri has proposed a distinction between 'focused' and 'unfocused' visiting strategies, and has suggested that those people coming with a less focused approach will be more receptive to what the museum offers in the way of learning and interpretation. Speight comments that design students often have a moderately focused strategy (see Chapter 2), as CETLD research shows they are driven to visit by the specific content of temporary exhibitions or their own research interests (Fisher 2007: 1). This can be both good and bad for museums. It can be good because it means that students have intrinsic motivation within the museum visit context, which should lead to 'deep' rather than 'surface' learning (although interestingly this intrinsic motivation in the museum relates to an extrinsic motivation – assessment – coming from their college or university). It can be bad because it means students are less receptive to what museums offer. If it doesn't match their own agenda they disregard it. This has been evident in our own programming at the V&A. For a time we put on student study days on specific topics, sometimes with high-profile speakers, which 'missed' the focused and individualised interests of their target audience and therefore failed to attract large numbers of attendees.

In Chapter 5, Reynolds presents a case study of web-based learning resources designed to sidestep the need to hit very particular subject interests both by promoting engagement in a more general way as well as by acknowledging the

critical 'deconstructive' standpoint that art and design students often start from in relation to museum displays. An important principle applied by Reynolds to the learning resources she developed, based on testing out of prototypes, is that of multiple perspectives. This seems to present a neat way of accommodating both 'authority' and the questioning of it. It is also a means by which to avoid what Mikhail Csikszentmihalyi describes as a 'fixed presentation of material in museums' that thwarts further exploration of it (Csikszentmihalyi and Hermanson 1999). By 'unfixing' the objects Reynolds believes we can encourage students to explore their own responses and kick-start a more considered relationship as well as encouraging them to spend time with objects and displays that they might otherwise overlook. In Chapter 10 Reynolds presents a taste of what different viewpoints can offer via a facilitated conversation between Chris Rose, Principal Lecturer in 3D Design at the University of Brighton and visiting professor at Rhode Island School of Design, USA and Norbert Jopek, Sculpture Curator at the V&A. Jopek's depth of historical knowledge and Rose's visual enthusiasm and imaginative reaction combine to produce an engaging interpretation of some of the V&A's plaster casts of the type used as teaching aids in the Government Schools of Design (although the particular examples discussed were acquired after the collections of the Schools of Design had become part of the then South Kensington Museum).

Reynolds' research into appropriate pedagogies for web-based learning resources led her to question the prevalent museum education adoption of constructivism in various guises, where, as Cook and Speight discuss, visitors will not merely receive and accept information from the museum but develop their own understanding in the context of their other experience (see Chapter 3). Reynolds instead puts forward the notion of a 'conversational framework' that Diana Laurillard developed as a description of 'the minimal requirements for supporting learning in formal education' (Laurillard 2007: 161). Laurillard's theory is that a range of interactions between the student, their tutor and fellow learners contain all the elements needed for successful learning, for example a concept being stated by the tutor, then questioned or tried out by the student, compared to the conceptions of other students and finally reformulated. This framework acknowledges that transmission of a body of knowledge is a legitimate goal for universities.

This is not to say that constructivism does not have a place in HE. As Cook and Speight note, it is there implicitly in workshop/studio practice and 'crits' where students' work is critiqued by their tutors and fellow students. It can be found elsewhere in the sector too. In Chapter 6 Rhianedd Smith finds a useful parallel to constructivism in problem- and enquiry-based learning where a scenario or problem is presented which students must work on as a group, an approach first developed for medicine.

Overwhelmingly though, there seems to be a disjuncture between museum pedagogies and those of universities. Geoffrey Caban and Carol Ann Scott contrast learning about exhibition design through lectures in an academic setting and learning about it through direct experience within the museum (see Chapter

8). Both groups of students learned something but for those who had been given lectures 'their learning base was ... constructed for them and ... their increases in understanding were related to the content determined by the lecturer'. The learning of students who had visited the museum was characterised by discovery and was 'more individualized and personal with greater variety between respondents depending on what each selected to see and what elements of the exhibition caught their attention'.

The fine grain of a visit to the V&A by a group of textiles students from the University of Brighton is captured by Torunn Kjølberg in Chapter 9. Her interest is in 'a typology or a structural framework of "visual research"'. This framework emerges as a complex web where the student's engagement with any given object is informed by the museum's physical and metaphorical context, other students, the materials brought to draw and record with, the tutor's instructions and so forth. She describes how students either accept or reject the structures imposed on them by their tutor, be it to do with which galleries to visit (specified so tutors have some idea where students will be) or the constant injunction to make their drawings 'useful', the starting point for further development. Interestingly, the most visually stunning objects seem to inhibit 'use' in this way and the students gravitate towards the less complete, 'imperfect' objects, or those that have some sort of particular presence.

The introduction of new technology into both HE and museum sectors has initiated debate about whether 'e-learning' is a type of pedagogy in its own right or just an enhancement of other models of learning. Rebecca Reynolds addresses this in Chapter 11. She feels that the use of technology such as hand-held mobile devices has particular challenges when considering design students, many of whom work in direct physical contact with materials to make things. They need to interact with the 'real' and a screen on a PDA can be as much of a barrier to museum objects as a glass case. However, she rightly identifies that there are a variety of different types of high-tech interpretation in museums and argues that the ability to 'ask the user questions, or encourage them to interact with other users, ask them to reflect on what they have experienced during a visit, or offer ways of researching further' is appropriate for the physical environment of galleries with multiple routes through.

Patrick Letschka and Jill Seddon have explored ways of students making, (rather than just using), their own multimedia interpretation of objects in both museums and private collections (see Chapter 12). Their project found that creating short films and posting them onto a shared web-space engaged design and design history students with collections in a very meaningful and reflective way. As one student put it: 'It is amazing to see that 30-second films can express such deep and poignant ideas and philosophies and also spark debate'. The project also highlighted the fact that online interaction between members of any given audience group tends to be partial.

Online communities and gaming are examined in Chapter 13 and 14 by Mark Carnall and Beth Cook, and Lars Wieneke and Karina Rodriguez-Echavarria.

All four argue that these sorts of virtual environments offer opportunities to the museum and HE sectors, as well as a potential for collaboration that has not been much exploited to date. The mass appeal of games such as *World of Warcraft* is made clear in some striking statistics offered by Carnell – there are twice as many *World of Warcraft* players as there are residents in Scotland. Furthermore, there are estimated to have been more visitors to a virtual museum in the *Pokémon Diamond and Pearl* games in 2007 than there were real visitors to the V&A, Natural History Museum and Science Museum in London combined (10 million *Pokémon* 'visitors' compared to 7 million real world visitors). Wieneke, and Rodriguez-Echavarria point out that in the multi-user virtual environment or 'muve' *Second Life,* the particular attributes of 'action and shared creation offer a far wider spectrum of possibilities and potential for design education than has yet been adopted'. While a large number of HE institutions and some museums have developed a presence on *Second Life*, examples of collaborative projects are still thin on the ground. Such projects could make good use of the most popular learning patterns of colleges and universities on *Second Life*, which are to allow learners to create virtual exhibitions and to participate in events that would be difficult or impossible to recreate in the real world. They can also tap into the inherent sociability of a 'muve' and the potential that has for learning.

The consultation document *Understanding the Future: Museums and 21st Century Life* issued by the Department for Culture, Media and Sport (DCMS) in 2005 asked: 'How could stronger links be created between the Higher and Further Education sectors and museums?'(DCMS 2005: 2). In 2006 the responses to this consultation were analysed and recommendations published, among them some concerning the relationship between the HE sector and museums: 'A priority is to build new mechanisms to link museums, especially those with limited research activity, into academic communities' (DCMS 2006: 12). *Museums and Design Education* is a step towards achieving that goal.

Bibliography

Arnold-Forster, K. (1989) *The Collections of the University of London: A Report and Survey of the Museums, Teaching and Research Collections Administered by the University of London*. London, London Museums Service.

Cardoso D.R. (1999) Teaching by Example: Education and the Formation of South Kensington's Museums, in Baker, M. and Richardson, B. (Eds) *A Grand Design: The Art of the Victoria and Albert Museum*. London and Baltimore, V&A and Baltimore Museum of Art, 107–116.

Csikszentmihalyi, M. and Hermanson, K. (1999) Intrinsic Learning in Museums: Why Does One Want to Learn?, in Hooper-Greenhill, E. (Ed.) *The Educational Role of the Museum*. London, Routledge, 146–160.

DCMS (2005) *Understanding the Future: Museums and 21st Century Life*. London.

DCMS (2006) *Understanding the Future: Museums and 21st Century Life.* London.

Fisher, S. (2007) *How do HE Tutors and Students Use Museum Collections in Design?* Qualitative Research for the Centre of Excellence in Teaching and Learning through Design. Unpublished report.

Laurillard, D. (2007) Pedagogical Forms for mobile learning: framing research questions, in Pachler, N. (Ed.) *Mobile Learning: Towards a Research Agenda.* London, WLE Centre, Institute of Education, 153–175.

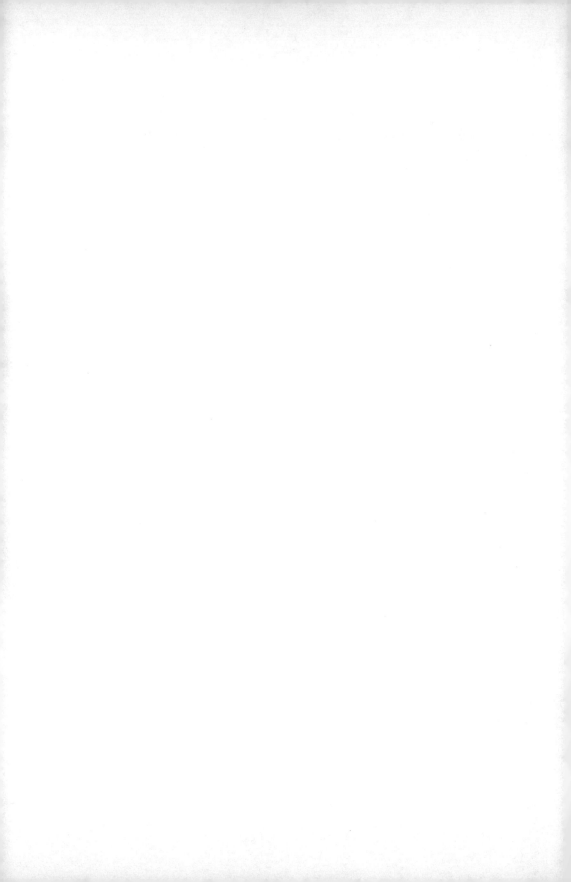

Acknowledgements

The editors would like to thank all of the contributors for their work on this publication. In particular, we would like to thank Jos Boys and Morna Hinton for their support. In addition, the following people have generously given their time and their advice: Martin Bazley, Anne Boddington, Cynthia Cousens, Richard Doust, David Gosling, Roland Mathews, Alison Minns, and Nancy Proctor. We would also like to thank Claire Jarvis, Dymphna Evans and everyone at Ashgate. Finally, our thanks go to everyone at the Centre for Excellence in Teaching and Learning through Design (CETLD) in Brighton.

Chapter 1

Museums and Higher Education: A Context for Collaboration

Kate Arnold-Forster and Catherine Speight

It is widely recognised that the UK government's focus on widening participation[1] to 60,000 new entrants by 2010 has had a transformative effect on discourse about higher education (HE) (DIUS 2008). With the impact of fees affecting degree choice and student numbers expanding at an unprecedented rate, HE has embraced a broader and stronger focus on transferable skills and employability. New generations of students are offered a learning experience that increasingly embraces socio-constructivist concepts of knowledge and learning (see Chapter 3). This has been accompanied by a growing variety of subjects and emphases attracting different kinds of learners and including vocational fields that demand different pedagogic methodologies. Against this rapidly changing environment, museums and universities are beginning to explore forms of collaborative working, with subjects such as art and design standing out for their extended engagement with new forms of object-based learning and their work with museums and galleries.

A parallel transformation has been at play in the wider museums context. Museums, through their growing body of specialist museum educators and learning theorists, have begun to reconsider how learning takes place in museums and through their collections (Falk and Dierking 2000). A growing understanding of the importance of alternatives to didactic models of learning has begun to shape how museums approach their role as settings for a variety of informal and formal learning, designed for, and accessible to, a wide range of audiences (Knowles 1981; Hooper-Greenhill 1999). What we might broadly describe as museum learning is now considered a function embedded in the whole spectrum of activities, from curation and conservation, through to exhibitions and learning programmes. Recent thinking from the Department for Innovation, Universities and Skills (DIUS) on the delivery of cultural policy and strategy has been a further factor informing political and professional ideas about the role of museum learning (Burnham 2009). Within this discourse, museums have been increasingly

1 Widening participation addresses the large discrepancies in the take-up of higher education opportunities between different social groups (see <http://www.hefce.ac.uk/pubs/hefce/2008/08_15/> which outlines the HEFCE strategy to promote and provide the opportunity of successful participation in higher education to everyone who can benefit from it).

seen as partners in the wider network of cultural provision (DCMS 2008). For many museums, operating in such a climate has provided the chance to move towards a fundamental reassessment of their role as responsive organisations for learning. Likewise, for many educational and community organisations partnering and working with museums for the first time, it has emphasised the need to address practical and intellectual issues surrounding collaborative working. While work with schools and community groups has received much attention, the work being undertaken between universities and museums has largely been overlooked, despite what many consider to be huge advances in the way museums have sought to develop their role as responsive institutions for learning.[2]

The very specific practices of university-based museum learning over the past three to four hundred years have been distinct from the way in which public museums have addressed the needs of specialist academic audiences. Universities originally created museums that utilised collections primarily to support teaching in disciplines such as medicine, natural sciences and archaeology. Typically, the traditional collection housed in a university museum employs specimens and objects to illustrate a variety of systems, evidence and classification in a formal pedagogic setting such as the laboratory or classroom, or alternatively as a repository for the investigation of material culture.

A consequence of this type of object-centred didactic teaching is that museum education within universities has remained comparatively insulated from the evolution of museum education in the public museums sector. However, this situation is changing: the once close links that bound together many academic disciplines taught by universities with their museum collections no longer provide an automatic source of interconnection and mutual dependence. Internal shifts in curricula have moved away from observation-based laboratory activity, taxonomy, identification and other forms of traditional study associated with museums. Despite this, more recently there has been a discernible renewal of interest amongst commentators, curators and academics alike, in how to engage collections more fully in order to meet new and rapidly developing learning and skills agendas in HE.

Many now regard David Anderson's report, 'A Common Wealth', as a watershed in museum learning in the UK. First published in 1997 and revised in 1999, his report argued for museums to offer better services to learners of all kinds and for additional resources and a higher profile for museum education (Anderson 1997; Anderson 1999). This led to a fundamental reassessment of the relationship between museums and their audiences. As the first comprehensive review of museum education in the UK, it has been hugely influential in its ideas about the role of education in museums and galleries and for informing the development of collections-based learning in all parts of the sector. It is now widely accepted in the museum sector that the educational role and function of the museum as a learning environment should be central to its

2 Two American studies published in 1981 and 1990 set the context for studies in this area but little attention has been given to this topic in the UK (Collins 1981; Solinger 1990).

identity, underpinning all aspects of museum activity including exhibitions, displays, events and publications (Hooper-Greenhill 1999; Falk and Dierking 2000). This has contributed to an increasing profile for museums as innovators in the development and delivery of educational experiences. This is reflected in public recognition for, and expansion of, their programmes, as well as success in winning substantial government investment in learning opportunities. Universities have also made significant advances in learning and teaching and have similarly begun to reach beyond physical campus boundaries into other environments and contexts including museums and galleries, so utilising their collections and recognising the importance and potency of shared knowledge and expertise. Rhianedd Smith expands upon these ideas (see Chapter 6).

Strategic Context

Working collaboratively and in partnership is a theme underlined by Anderson as well as by more recent strategy and policy reviews relating to both HE and the museum sectors (UMG 2004). Programmes such as Renaissance, a scheme that has invested £150 million in England's regional museums and is aimed at raising the standards and enhancing the role and contribution of museums in learning, social inclusion and economic regeneration, led to an increase of more than 18 per cent in school visits to museums between 2002 and 2007, with a total of one million school visits made to 'hub' museums in 2006–7 (Roberts and Kerr 2008). Similarly, the Strategic Commissioning Programme aimed at promoting engagement between schools and museums and other institutions. These are just two examples of significant government investment aimed at stimulating links between the worlds of formal education and the museum sector, and represent a rapid process of change.

By contrast, research in the UK into the impact of adult learning provision in museums, nationally, and specifically in the HE sector in recent years has been relatively limited (Anderson 1995). This research showed that although over 70 per cent of museum visitors were adults, there was still a widespread lack of dedicated provision for any form of adult learning in museums (Anderson 1997). Anderson identified considerable resistance remaining within many museums to developing educational services for adults of any kind. This, he argued, arose from a fundamental cultural dichotomy that divides traditions of scholarship, object-focused research and curation from the demands of public-facing activities, such as the delivery of museum education programmes. Although Anderson's observations specifically related especially to networks of larger national and regional museums, the same reflections could also be applied to many university museums. With certain notable exceptions, many of these had made little progress in employing specialist museum educators or in seeking new approaches to museum learning to inform or enhance the use of their collections in teaching even in the late 1990s (Arnold-Forster 1999). Challenged by a decline in traditional

teaching in university museums and collections, many university-based curators have begun to address the need to explore new approaches to collections-based learning within universities (UMG 2004).

In parallel, there has been an increased interest and focus on student learning in HE, with an increasing emphasis being placed on empirical research. This and associated research has established the benefits of understanding diverse learning styles and the opportunities that collections-based learning can offer (UMG 2004). Experiential learning, student autonomy, self-directed and reflective learning are all transferable concepts to the use of museums and collections in an HE context.

Developments in funding and government policy are also beginning to shape what might be regarded as a redefinition of priorities and collaborative policies across both HE and museum education, reinforcing points of convergence. Museums and universities have to operate within political and economic contexts where increased public accountability, competition for funding and growing costs have affected both sectors. Both sectors are increasingly required to demonstrate their social and cultural contribution in an increasingly audited and politicised environment:

> As crunch time approaches ... and as the demands that are made on the public and private resources available to the non-profit sector continue to grow at a faster rate than those resources themselves, virtually every museum may find itself faced with several much tougher questions ... Without disputing the museum's claims to worthiness, what these questions will address instead is its relative worthiness (Weil 2004: 42).

The Government sees both sectors as uniquely placed to help with the delivery of high-level policy goals, specifically in relation to widening participation and social inclusion. In the case of museums, some commentators have identified this as a form of politicisation, arguing that they offer 'safe, non-judgemental' environments (GLLAM 2000). Others are concerned that the Government is leading museums in 'the delivery of politically motivated social and cultural agendas that threaten their objectivity and neutrality' (Houlihan 2001: 21). It has been argued that they have little choice but to align themselves with government policy because it provides a rationale for their work (Crooke 2008). So while the public museum sector may be forging new relationships with schools and lifelong learning communities, supported by the availability of government funding, HE is also beginning to adapt and respond to opportunities to engage with museums and to share their knowledge of learning. The CETLD project is a consolidated example of this activity.

A heightened interest in brokering increased collaboration across the education and cultural sectors has been signalled by a recent series of government reports that have demonstrated the value of museums as responsive institutions for learning, including emphasising the specific value of links between the further and higher education sectors and museums (DCMS 2000; DCMS and DfES 2004;

DCMS 2005; DCMS 2006; DCMS and DfES 2007). In particular these point to the potential of common but also complementary resources shared between the two sectors. Museums, libraries and archives, for example, are increasingly being encouraged by the Department for Culture Media and Sport and others to work with universities, particularly to help exploit and capitalise on the amalgamation of their respective expertise (DCMS 2006).

Of recent developments, the HEFCE-funded initiative to establish 74 Centres for Excellence in Teaching and Learning (CETL) in English universities represents the largest ever investment in a specific HE teaching and learning initiative.[3] This book is principally the result of one such Centre (CETLD) that has developed opportunities for innovation and new research in collections-based learning. It has also drawn significantly on the Centre for Teaching and Learning in Applied Undergraduate Research Skills (CETL-AURS), University of Reading. The work of both has engendered a renewed interest in the role of museums in supporting HE teaching more generally and, in consequence, an impetus to broker new links and partnerships across both sectors. Research into the interface of museums/HE as part of the CETL initiative has been accompanied by in-depth research and evaluation into the way students learn from collections and objects.

Museums and Universities

Museums and universities are subject to the competing demands made of them by the people they serve as well as the increasingly focused expectations of their funding bodies. In universities, there is a need to balance the requirements of teaching and research in an increasingly diverse sector where other institutional priorities constrain the relatively specialist interest in collections-based teaching and learning. Museums likewise need to rebalance the variety of activities that are associated with the protection and conservation of their collections with those of providing access to them. Ultimately, this has meant that successful museum-university partnerships have required active brokerage through funding initiatives and policy commitments that provide time to align mutually agreed objectives and form sustainable partnerships that extend the learning environment for all constituencies of society.

The CETL initiative has provided one such timely opportunity to explore new collaborative approaches to museum and HE engagement in the context of teaching and learning. It has enabled museums such as the V&A to strengthen their commitment to HE partnerships with a range of universities nationally.[4] What has

3 Centres for Excellence in Teaching and Learning (CETLs) were set up to promote excellence across all subjects and aspects of Higher Education teaching and learning.

4 Including the University of Brighton, the RCA, University College London, Royal Holloway University of London, University of the West of England, University of York, University of Cambridge and the University of Leicester.

become increasingly apparent is that, for such collaboration to succeed necessarily requires both universities and museums to address many of the traditional barriers to greater partnership working. These include differing approaches to scholarship, limited and shared pedagogic knowledge of both the structures and the way in which different kinds and levels of students in HE learn from museum collections. This has all impeded integrated activity and the opportunity of shared agendas between the sectors.

Stedman, writing in 1990 about museum-university partnerships in the United States, concluded that substantial differences exist in the basic missions of both sectors, which have influenced their approach to education: 'Museums are more orientated to preserving culture, whereas universities stress dissemination of knowledge through education. Whilst museums emphasise investigation, recording and interpretation of the world, universities concentrate on the discovery or creation of knowledge and its transmission from one generation to the next' (Stedman 1990: 222).

Yet, it could be argued that as institutions of learning, museums and universities increasingly share similar functions and characteristics that distinguish them from other public institutions. As Solinger commented, these commonalities include 'A deep respect for intellectual attainment and learning for its own sake, appreciation of and questioning about humanity's role in the world and a sense of commitment or obligation to society with respect to educating its citizens' (Solinger 1990: 3). Both are forms of academic institutions with highly educated professional staff engaged in the dissemination of knowledge. There are similarities in the way both employ academic specialists, although this assertion can only be applied to a relatively small subset of museums (Stedman 1990). Thus, when collaboration between museums and HE takes place successfully, it can bring substantial benefits to both sectors including reaching new audiences, sharing costs, resources, skills and risks. Collaboration can also provide access to funding opportunities.[5] For both sectors, opportunities for partnership funding are of increasing importance and promote valuable cross-institutional and interdisciplinary perspectives and expertise. While much of this has focused on stimulating collaborative research schemes or knowledge transfer projects, it is notable that once links are established between universities and museums they often evolve into relationships that lead to interesting developments in teaching and learning. A number of national museums, in particular, can now point to active collaborations with HE. Notable examples in the UK include: the Victoria and Albert Museum (V&A), which runs a variety of fellowships and partnerships with HE institutions including an exchange fellowship with the University of Sussex and a range of funded research programmes; the Courtauld Institute of Art, which runs a collaborative partnership with the State Hermitage Museum in St Petersburg including symposia, lectures, conference and a visiting curator scheme; and Manchester Museum where museum staff teach at

5 For example, the Arts, Humanities Research Council were in 2008/09 sponsoring research networks and funding schemes (<www.ahrc.ac.uk>).

both undergraduate and postgraduate level in partnership with the University of Manchester's teaching departments (Kerr 2003; HDT 2007).

Evidence of active collaboration remains mainly confined to links between national and larger museums, or within universities that hold their own museum collections. Close geographical proximity and synergies between institutional cultures, as well as the scope and accessibility of relevant collections have all been critical factors in ensuring successful collaborative partnerships. A growing number of regional museums in both the local authority and independent sectors continue to build and strengthen links with universities. This is more often initiated and stimulated through mutual research interests than through shared HE learning agendas. Such links offer the basis for future partnership work and for involvement in creative schemes to ensure that student learning can take advantage of the resources and environments that museums can offer.

A Way Forward?

There is no doubt that the past decade has seen a significant renewal of interest in museums and collections as resources for HE in teaching, learning and research. The incorporation of new ideas from museum learning practice and broad changes in the curricula have done much to reverse the previously declining use of collections in university teaching. The role of the university museum is also proving critical in this discourse, with a tradition of museum learning in HE that can offer fertile territory for drawing together new pedagogies from within and outside the HE sector. It also offers opportunities for new ways of utilising collections that were purposefully formed for their relevance and value to university-taught academic disciplines. The CETL initiatives have created further important, if confined, opportunities to instigate and share new learning, teaching and research methodologies and skills, particularly in the area of art and design, for students, educators and academics in museums and universities. The impact and evaluation of this research and the associated pedagogic practices remain at an early stage of development and application; ensuring the dissemination and extension of this legacy beyond the duration of the CETLs and transferring this knowledge to a wider range of disciplines remains a challenge that will require the engagement and support of both the museum and university sectors.

Developments in government policy are also leading towards important points of convergence and the potential for collaboration, drawing on the complementary skills and resources of the museum and university sectors. Supporting the HE sector in delivering the higher level vocational and transferable skills levels required by employers within undergraduate and graduate teaching is just one area where museums can, as this book demonstrates, make an important contribution, as part of the creative and cultural sector (HEFCE 2008). Museums, both within and outside HE, offer resources, contexts and methodologies for teaching from objects, while academics, particularly those from art and design, offer expertise in

the making of objects and artcfacts and in delivering subject knowledge. However, further integration of policy, the strategic transformation of learning environments and further support will be needed to establish the necessary practical mechanisms for ensuring all parts of the HE sector can benefit from access to high quality collections and object-based learning of the kind that the CETL programmes, in particular, have helped to initiate.

This book attempts to provide an introduction to a number of newly emerging themes and teaching and learning methodologies involving collections, with a particular focus on those surrounding museums' engagement with art and design education. It offers an overview of recent developments in student learning through a series of papers and case studies exploring issues and projects that review recent developments within HE. With a focus on innovation, it also examines the work of CETL-funded programmes at Brighton and Reading, which have combined the adoption of new technologies with the adaptation of museum and HE learning practices in novel and traditional settings.

Bibliography

Anderson, D. (1995) Gradgrind Driving Queen Mab's Chariot: What Museums Have (and Have Not) Learnt from Adult Education. In Chadwick, A. and A. Stannert (Eds) *Museums and the Education of Adults*. Leicester, National Institute of Adult Continuing Education, 11–33.

Anderson, D. (1997) *A Common Wealth: Museums and Learning in the United Kingdom*. London, Department of National Heritage.

Anderson, D. (1999) *A Common Wealth: Museums in the Learning Age*. London, DCMS.

Arnold-Forster, K. (1999) *Beyond the Ark: Museums and Collections of Higher-Education Institutions in Southern England*. Reading, South East Museums Service (Western Region).

Burnham, A. (2009) Speech to University of Liverpool: five lessons from Liverpool's year as capital of culture. Retrieved 27 April 2009, from <http://www.culture.gov.uk/reference_library/minister_speeches/5730.aspx>

Collins, Z.W. (1981) *Museums, Adults and the Humanities: A Guide for Educational Programming*. Washington, DC, American Association of Museums.

Crooke, E. (2008) *Museums and Community: Ideas, Issues and Challenges*. Oxford, Routledge.

DCMS (2000) *The Learning Power of Museums – A Vision for Museum Education*. London.

DCMS (2005) *Understanding the Future: Museums and 21st Century Life*. London.

DCMS (2006) *Understanding the Future: Museums and 21st Century Life*. London.

DCMS (2008) *McMaster Review: Supporting Excellence in the Arts – From Measurement to Judgement*. London, The Stationery Office.

DCMS and DfES (2004) *Inspiration, Identity, Learning: The Value of Museums*. London.

DCMS and DfES (2007) *Inspiration, Identity, Learning: The Value of Museums, Second Study*. London.

DIUS (2008) Secretary of State sets out priorities for Higher Education in the year ahead. Retrieved 27 April 2009, from <http://www.dius.gov.uk/news_and_speeches/press_releases/secretary>

Falk, J. and Dierking, L. (2000) *Learning from Museums: Visitor Experiences and the Making of Meaning*. Walnut Creek, CA, Altamira Press.

GLLAM (2000) *Museums and Social Inclusion*. Leicester, Research Centre for Museums and Galleries.

HDT (2007) The Hermitage and the Courtauld: Shifting the Focus to Scholarship. Retrieved 27 April 2009, from <http://www.hermitagerooms.com/about_us/index.html>

HEFCE (2008) HEFCE strategy for employer engagement. Retrieved 27 April 2009, from <http://www.hefce.ac.uk/econsoc/employer/strat/>

Hooper-Greenhill, E. (Ed.) (1999) *The Educational Role of the Museum*. London/ New York, Routledge.

Houlihan, M. (2001) Museum Impossible. *Museums Journal* 1/101, 21.

Kerr, J. (2003) The Manchester Museum Annual Report 2002-2003: Reflecting the World at the University of Manchester. Retrieved 27 April 2009, from <http://www.museum.manchester.ac.uk/aboutus/reportspolicies/fileuploadmax10mb,12806,en.pdf>

Knowles, M. (1981) Andragogy. In Collins, Z.W. (Ed.) *Museums, Adults and the Humanities: A Guide for Educational Programming*. Washington, DC, American Association of Museums, 49–60.

Roberts, M. and Kerr, R. (2008) *Renaissance: Results for 2006–07*. MLA Council.

Solinger, J.W. (1990) *Museums and Universities: New Paths for Continuing Education*. New York, American Council on Education/Macmillan Series on Higher Education.

Stedman, H.J. (1990) Museums and Universities: Partners in Continuing Education. In Solinger, J.W. (Ed.) *Museums and Universities: New Paths for Continuing Education*. New York, American Council on Education/Macmillan Series on Higher Education.

UMG (2004) University Museums in the United Kingdom: A National Resource for the 21st Century. Retrieved 27 April 2009, from <http://www.umg.org.uk/media/Text.pdf>

Weil, S. (2004) Creampuffs and Hardball: Are you Really Worth what you Cost? *Museum News* 73/5, 42–43.

Chapter 2

Museums and Higher Education: A New Specialist Service?

Catherine Speight

Museums have long supported the needs of specialist academic audiences. Many university museums evolved from teaching collections that were used to support student learning. Learning from objects has been, and remains, the distinctive feature of many academic disciplines including zoology, biology, medicine and the subject of this volume, art and design. Historically, museums were understood as locations of collections and academies of knowledge; objects were often displayed chronologically and laid out as if they were textbooks. One could argue that there has always been a strong relationship between museums and the teaching of students in higher education (HE).

In the early part of the twentieth century, the growth of formal education institutions in Western societies, the development of formal academic disciplines and the rise of subject professionals had a major impact on the museum's educational role (Hein 1998; Hooper-Greenhill 1999). As museums moved away from their modernist origins, their purposes and functions changed. It was only in the latter half of the century that museums realigned their professional interest in museum education as a result of a need to provide public services.

Museums are increasingly recognised as educational providers and must split their efforts between the requirements of different audiences. This includes learning opportunities for school-age children, and more general 'inspirational' materials for adults and casual visitors. In this situation, the needs of HE students are often subsumed into those of adult learners, which may on the face of it make sense. But unlike other sections of the leisure-visiting adult population, students' reasons and motivations for visiting the museum are very different. Whilst there has been general research into learning in museums, there is limited information available about the learning needs and styles of specialist groups.

By exploring the museum's changing relationship with its audience, this chapter argues that museums need to develop their knowledge and awareness of HE students. It argues that museums are well placed to meet the pedagogical demands made of them by different groups. It does not propose that all museums should be offering a specialist service but offers some reasons why it may be worth considering HE as a distinct audience while serving the needs of a wider public.

This chapter has been framed by research conducted at the Victoria and Albert Museum (V&A) into the learning needs of design students.[1] It will consider how students and tutors from HE are actually using museums, starting from the baseline research programme carried out at the V&A in autumn 2006 with tutors and students from the University of Brighton and the Royal College of Art (RCA). Although our research has primarily focused on the needs of design students, findings may also be transferable to other disciplines. This is the beginning of a much larger debate and one that we believe is worthy of further exploration.

The Growing Importance of Education in Museums

This next section looks broadly at changes to the role of the museum. It explores how the growing importance of education and research into museum learning has stimulated discussions about the relationship museums have with their audiences, including HE students. Museum education departments have for a long time had an uneasy relationship with other departments in the museum, and have often featured much lower in their institution's hierarchy (Anderson 1997). Historically, research into learning has not been a high priority for museums, although in the last few decades this has changed and it is now growing in priority.

For some commentators, the museum as an institution has been marked by crisis as a result of this increasing emphasis on the museum's educational role and a consequent disregard of its traditional purpose: 'Traditional notions such as the authority of the curator, the sanctity of objects and even the prestige of the institution itself as a source and distributor of knowledge are being challenged' (Roberts 1997: 132).

This crisis has manifested itself as a divide between those who continue 'to define museums in terms of their collecting role and those who centre museum work on questions of purpose/interpretation' (Witcomb 1998: 385). The role of museum education is situated at this disjuncture, with some scholars embracing it while others, including some curatorial departments, are in need of further convincing. Concern has been raised that by focusing on the educational role of the museum, other functions will be neglected.

Museums are under pressure from Government to broaden their audience profile and to include visitors from a diverse range of backgrounds. For some in the sector, this approach has had a negative impact on the needs of traditional academic audiences who are not considered a target priority for museums. The museum's traditional role as a purveyor of scholarly activity is being called into question. In *Re-Imagining the Museum – Beyond the Mausoleum*, Andrea Witcomb (2002) reports candidly on the difficulties museums face in making themselves more appealing to a broad audience: 'The tension between specialist research-

1 The V&A has a specific remit to engage with this group as part of its mission to support the creative industries and the needs of designers and other creative professionals.

based knowledge and the need to communicate effectively with a diverse range of visitors is the subject of intense pain and soul searching in many museums' (Witcomb 2002: 60).

This 'tension' is a growing problem that museums must face as they attempt to meet the needs and demands of different audiences. Witcomb's discussion relates to changing curatorial practices in Australia and the broad demands and expectations made of specialist staff in the museum. The tension she describes grows out of the museum's dual function as both authoritative expert and public communicator. A similar picture has been painted in the UK. A number of recent research reports have identified that research and scholarship within the museum are no longer held in the esteem they once were (MGC 1999; Travers 2006; RIN 2008).

Museums have been subject to new developments in theory and practice in recent decades. There has been a paradigmatic shift to a broad academic perspective referred to in its various guises as 'post-modernism, constructivism... or most colloquially – as meaning making' (Silverman 1995: 161). This paradigm shift has led to an increased emphasis on the educational value of museums and the importance of understanding the nature of the visitors' learning experience. Government, formal learning institutions and museums themselves have acknowledged the potential that museums can offer as both formal and informal learning environments. This has generated momentum to understand the ways in which people learn in museums and has helped to establish theoretical foundations and a body of knowledge about the nature of such learning experiences (Hein 1995; Falk and Dierking 1995; Hooper-Greenhill 1999).

As a term, museum education is often conflated with museum learning although the two are broadly distinct. Both have been prioritised in the museum, yet there is still no single definition on what each means (Hooper-Greenhill 1999). The differences between museum education and learning are firmly located in contemporary discussions about the role and purpose of the museum in the twenty-first century. Witcomb defines this current moment as 'one of momentous change' and as a 'rupture with the past' (Witcomb 2002: 3). Hooper-Greenhill calls it a period of fundamental change where museums are being challenged on different fronts and are reviewing their educational purposes and redesigning their pedagogies (Hooper-Greenhill 2007).

Contemporary definitions of museum learning acknowledge both the nature of the learning environment and the different experiences visitors have when they get there (Hooper-Greenhill 1999; Falk and Dierking 2000). This includes a growing awareness about the way visitors construct their interpretation of a museum visit; drawing from prior knowledge, skills, background and personal motivation as well as the processes that inform such an approach. It remains distinct from the type of learning conducted in formal education institutions because of the context in which it occurs. Museum learning frequently engages the body and the senses and is more open ended and individually led. The status of museum education, on the other hand, remains unclear. Some see it as part of the museum's core role while others see it as the responsibility of museum education departments and the

way they deliver learning in the museum (Hooper-Greenhill 2007). It can also be about the approach museums take towards the facilitation of learning in their spaces – from workshops, events and resources through to the dissemination of knowledge and scholarship through museum interpretation such as object labels, text panels and exhibitions.

Developments in critical theory have spurred changes to the educational role of the museum, in particular investigations into knowledge and social movements as well as the increasing professionalisation of museum education as a practice. Against this backdrop, there has been a semantic shift from the expression *museum education* to the expression *museum learning* (Hooper-Greenhill 2007). This represents a fundamental change in the way learning is perceived and how the educational function of the museum is understood. It could be argued that this shift has been driven by a transition from modernism to a postmodernism, which has challenged definitions of the museum's purpose and function and the relationship it has with its visitors (Hooper-Greenhill 1992; Roberts 1997).

Postmodernism is difficult to define. Most definitions follow the conception that it is a cultural paradigm that evolved from the erosion of the boundaries that defined modernism (Lyotard 1984 in Moore Tapia and Hazelroth Barrett 2003). The difficulty with such an assertion is that the meaning of modernism still remains confused, so a departure from it to postmodernism remains more so (Harvey 1990: 7).

Museums as we know them now came into being during the modernist period. The delivery of knowledge in the modernist museum manifested itself in *positivist-behaviourist* approaches. In this tradition, knowledge exists independently of the knower and understanding was a process of coming to know, that which already exists. The task of teaching was a simply a case of transmitting knowledge to the learner.

Postmodernism acknowledges that knowledge is constructed by the learner in interaction with their social environment. The *relativist-constructivist* approach recognises that individuals bring varied prior experiences and knowledge into a learning situation that influences how they perceive and process information. Individuals are therefore active in making knowledge or meaning individually or socially. It was only during the latter half of the twentieth century that the changes this approach bought to museum education theory became more readily accepted (Hooper-Greenhill 1999). Both frameworks have influenced the theoretical positions that educators take about the process of learning in the museum (Hooper-Greenhill, 1999).

As the role of the museum changes, museums are being reconceptualised as places that can facilitate communication and exchange (Karp and Lavine 1991). The cultural dichotomy that once existed between museums' scholarly and curatorial roles and their need to provide public services is less prevalent. A postmodern approach to museum education recognises the shifting socio-cultural, historical and political contexts that museums are subject to. This includes offering a rich and varied experience to a diverse and multifaceted audience as well as developing approaches and ways of working to support the needs of different audiences. It

manifests itself in different ways in the museum and can take the form of activities that include personal narratives, collaboration, or multiple interpretations (Moore Tapia and Hazelroth Barrett 2003).[2] By acknowledging their role as facilitators of knowledge and exchange, museums can develop a stronger sense of connection between themselves, their collections and HE students. This will in turn lead to the development of new skills and techniques through which to support the needs of this group in the museum.

Supporting the Needs of HE Students in the Museum

Research into the learning potential of museums suggests they are well placed to meet the pedagogical demands made on them by different groups. They offer a qualitatively different learning experience to the type of learning that takes place in schools, colleges and universities (Falk and Dierking 2000; Hooper-Greenhill and Moussouri 2001). Since the advent of the UK Labour government in 1997, museums (along with other cultural institutions such as libraries and archives) have been encouraged to increase their provision for learning. For museums, this has included directives to widen participation and access to collections for government-targeted groups including schoolchildren, adult learners and families. Museums have worked on developing projects and tailored resources for these groups but evidently in concentrating on the needs of some specific groups, they have until recently overlooked others.

Innovations in HE pedagogy and current ideas informing museum learning practice are prompting discussions about the way museums and their collections can be used as resources for teaching, learning and research in universities. Unlike the services they offer schools and adult learners, museums' support for HE students is not well publicised. Existing provision for other groups in museums suggests that some suitable infrastructure may already exist for HE students, but the lack of formal arrangements and procedures means that it has not been given the priority or visibility it deserves. There remains, most significantly, a lack of specialist knowledge and expertise about the needs of this group and how to effectively engage with them in ways that draw from HE learning and teaching practices.

There is a growing awareness within the museums sector that stronger links need to be made with HE. Developments in funding and policy have highlighted important and distinctive areas in which museums and universities need to work more closely together. A recent government consultation paper, *Understanding the Future: Museums and the 21st Century*, articulated the need for links and models of collaboration between museums, higher and further education sectors to be

2 Examples of gallery trails designed for HE design students as detailed in Chapter 6 demonstrate one such approach.

considered as well as formalised systems for exchange between staff, students and scholars (DCMS 2005).

Despite this desire, there remains a lack of theoretical and empirical research that consolidates the needs of both sectors. Museum curators and educators could benefit from greater knowledge about the needs of specialist groups in both the resources they offer and exhibitions they design (Anderson 1997; Caban and Wilson 2002). A few museums in the UK have responded to this challenge and there are now a number of HE programmes provided by museums. Some museums are joint partners in BA and MA programmes while others supervise PhD students. University museums provide a wide range of services for students too. Opportunities for HE learners include study days for tutors, modules based on study collections for students, museum-based research studentships and academic services. However, most projects that support the needs of this group are ad hoc and based on personal relationships between curators and tutors, which are often difficult to replicate (Anderson 1997).

By partnering universities, museums can also create strategic positions in which to share resources and expertise and open up their collections to new perspectives and funding opportunities. The granting by the Research Councils of 'academic analogue status' to national museums and galleries has been regarded as a step towards strengthening collaboration between museums and universities and funding joint research projects. The Arts and Humanities Research Council (AHRC) and other scholarly funding bodies provide opportunities for museums with analogue status to focus their research programmes and to develop public outcomes such as symposia, exhibitions and publications. In some instances, this has resulted in the development of long-term collaborative partnerships with academic institutions.[3]

A systematic review of existing provision and the benefits of museum-university collaborations is needed, as well as sustained research into the educational processes that occur for different levels of HE students in museums and their allied services, such as archives. A greater emphasis on research-led practices informed by the experience of museum and university professionals will also help to raise the profile of this emerging discourse.

What do Museums Offer HE Students?

Museums offer students what can only be described as a plethora of learning domains from archives to specialist libraries, exhibitions and access to objects in storage. Even in a postmodernist world, they offer valuable expertise, informed judgement, and arguably a form of credible authority that is well aligned with the scholarship conducted in universities. These resources are available to a range of

3 This is a scheme that is limited to a small number of museums and relates to research funding rather than teaching and learning.

audiences including HE students, although the needs of different subject groups may require different kinds of guidance as to their use and interpretation. Museums have a public duty to appropriately present these resources and to provide effective guidelines on how to use them. Equally, HE students need to take responsibility for identifying and articulating what resources they need for their own scholarship.

As in other education sectors, teaching in HE has shown a movement towards student-focused or self-directed learning, although it is open to question how far HE has actually moved in this direction. This has resulted in changes in the nature of the learning experience and the material that is presented. It also places responsibility on the individual learner and requires considerable reflection to enable them to understand their own learning styles. At HE level students are expected to design and develop their own research tools and skills and to use a wide variety of sources. The depth and effectiveness of these approaches may also vary considerably between academic disciplines. Similarly HE students must engage with a wide range of dialogues and synthesise a range of skills as part of their learning experience.

As educationally rich settings, museums offer expertise and knowledge beyond that of the formal learning environment of the lecture hall. They are important sites of fieldwork (Brookfield 1986) and are part of what might be termed the students' 'extended campus'. Learning occurs in many settings that are external to formal learning environments (Falk and Dierking 2000) and the identities of individual learners are often shaped by the cultural institutions they come into contact with, which stimulates their learning (Bruner 1986; Ogbu 1995).

However, many students who visit museums independently do not know how to access the range of resources that are available to them beyond that of the museum's galleries and exhibitions. They often lack a full range of skills and tools for object-based learning in the museum (Durbin 2002). Equally, many tutors may lack the appropriate skills to teach from objects in a museum context and see the role of the museum as an academic facilitator or enabler of this process (Speight 2007).

It is increasingly evident that through partnership, and with some adjustments to their infrastructures, museums could offer help and guidance to HE students and tutors by promoting and providing access to their resources and offering tools, skills and methods for learning from objects. At the present time, museums are ill-equipped to facilitate this, and will need further support and training for staff to develop and deliver the nuanced services contemporary learners need.

Learning about Design in the Museum

Little is known about the specific learning needs of design students in the museum, and understanding more about how they learn would be helpful to museum professionals working in design-related settings (Caban and Wilson 2002).

Table 2.1 Baseline methods and sample size

Method	Sample	Number	Subject Specialism	
Focus Group	Tutors	7	Ceramics Graphic Design	3D Design History of Design
	Students	9	Ceramics Fashion Design with Business Studies Animation	Textiles Architecture Design Products
Accompanied Visit	Students	15	Ceramics Animation Textiles	Architecture Design Products
Online Survey	Tutors	35	Fine Art Painting Fine Art Sculpture Three-Dimensional Design Diploma in Architectural Studies Performance and Visual Art Sequential Design and Illustration Fine Art Printmaking Fashion Design with Business Studies	Graphic Design History of Design and Material Culture Architectural Studies Interior Architecture Historical and Critical Studies Interior Design Wood Metal Ceramics and Plastic
	Students	77	Fashion Textile Design with Business Studies Illustration Interior Design Fine Art Printmaking Digital Music Editorial Photography Graphic Design Sequential Design and Illustration History of Design, Culture and Society Wood Metal Ceramics and Plastic Visual Culture Architecture Interior Architecture	History of Decorative Arts and Crafts Three-Dimensional Design Printed Textiles Curating Contemporary Art Ceramics and Glass Photography History of Design Fashion Womenswear Industrial Design Engineering Fashion Menswear Accessories Design Products Design Interactions

As part of the CETLD initiative, a baseline research programme was conducted at the V&A in 2006 which sought to explore how tutors and students from the University of Brighton and the Royal College of Art (RCA) engage with museum collections when learning about design. The aim of this programme was to provide baseline evidence about the way design tutors and students think about and use museums when learning about their subject and to explore ways in which this experience could be improved. This included understanding how students *learn to see* and interrogate the museum and how they make connections between visual research and the construction of visual material and the design process.

The research programme took an evidence-based approach using a range of qualitative and participatory research methods (see Table 2.1). This included interviews, focus groups, hypothesis testing[4] and accompanied visits where a researcher (in the role of participant observer) accompanies students on a tour of the V&A's galleries.

This next section highlights findings from the research programme including students' patterns of exploration, and strategies and methods for interrogating the museum space in relation to the wider research literature (see also Chapter 7).

Design Students' Patterns of Exploration

Our research identified that design students use museums for a range of different purposes including ideas and inspiration, research projects, drawing objects from life and designing and creating objects. In most instances, they visit independently rather than as part of an organised visit or tour led by tutors. It is often the case that students do not prepare for their museum visit because the visit itself is seen as preparation for other things. They have different motivations for visiting museums at different stages of their course.

It was the view of tutors from the University of Brighton and the RCA that postgraduate students are able to interpret the museum and its collections for themselves because they have a sophisticated level of knowledge about their own subject and a level of familiarity with the museum environment. The student's ability to 'read the museum', that is to critically interrogate what they see, is dependent on their level of understanding about their own subject: 'Postgraduate students are familiar with contemporary museums; they know their own niche and specialist territory' (tutor). Tutors felt undergraduate students

4 We formulated a series of hypotheses based on design students' use of museums and their collections. This formed part of a group activity in focus group sessions with students and tutors. Our broad assumptions included:
- Students need help getting to know the museum
- Students need better strategies to use collections
- Students appreciate information expressed to them in different modes
- Learning to look is a prime skill that everyone needs help with

were more inclined to need extra help when visiting museums. Research by Moussouri (1997) explored different motivations for visiting museums and how these influence the visitor's agenda and experience when they get there. This includes visitors devising their own strategies before visiting the museum. She distinguishes between a focused and unfocused strategy. A focused strategy is where a visitor has planned their visit beforehand, and has identified particular exhibitions or galleries they would like to see. An unfocused strategy on the other hand is where the visitor is unaware of the collections or exhibitions a museum is offering. Commentators have argued that visitors with unfocused strategies are more likely to be receptive to what the museum has to offer (Brookfield 1986; Moussouri 1997).

Our research identified that design students have a moderately focused strategy; they will embrace some level of uncertainty but most will have a specific goal in mind that triggers their visit, whether they are visiting for reflective thought and inspiration or for more directed research. It is often said that it is difficult for creative practitioners to 'switch off' because they are constantly analysing the sensory as well as the political, social and cultural worlds around them, a factor which distinguishes them from most from students of other academic disciplines.

If practice-based designers demonstrate different learning styles at different stages of their course and in the design process (Wilson 2000), it is likely that they will experience the museum in different ways depending on their motivation for visiting or what stage in the design process they are at. The work of Kolb (1984) is helpful here.

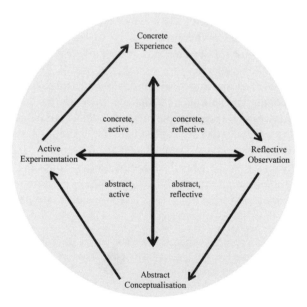

Illustration 2.1 Kolb's experiential learning cycle

Designers are said to be good accommodators and divergent thinkers (Caban and Scott 2000). Accommodators are described as being drawn to concrete experiences and to testing concepts in new situations. They learn from 'hands-on' experiences and prefer acting on feelings or through their senses rather than logical analysis (Kvan and Yunyan 2004). Divergent thinkers are best at viewing concrete situations from different points of view, using trial and error and looking for multiple meanings. Accommodators and divergent thinkers coincide with three characteristics of Kolb's learning cycle: immersion in a concrete experience (concrete experience), observation and reflection (reflective observation) and testing new experiences (active experimentation).

An individual student may at one moment be willing to accept a level of uncertainty and adopt a more random approach to their roaming (possibly reflecting a divergent thinker) but at a different time may reflect convergent characteristics and want more a more concrete and focused visit. This aligns with Kolb's theory that learning styles are shaped by individual experience and may change over time or even throughout the course of a project (Kolb 1984). Museums can offer support and inspire design students, providing them with an experience that is memorable because it takes place outside the formal environment of the classroom, studio or workshop and by doing so, offering them space for reflection. It may be more difficult to offer the third option of 'active' experimentation because there is less space and opportunity for providing hands on examination, although some museums are developing studio environments and resource centres for practitioners to use.

Design tutors encourage students to value museums as places for inspiration and reference but also to see them as cultural authorities to be questioned (Walker 2008). Students are encouraged to critically interrogate the museum's methods of interpretation and display through a process known as 'deconstructive' inquiry (Moore Tapia and Hazelroth Barrett 2003). The reason that some design tutors object to museums is because they are seen as places of 'establishment', places that reflect 'orthodoxy' or outmoded perspectives: 'There was a philosophy endorsed by tutors and absorbed by students that museums represent orthodoxy, and the V&A strongly so. It was the role of the HE art and design departments to undermine this orthodoxy' (Fisher 2007: unpaginated).

Deconstructive inquiry challenges modernist education principles and the traditional didactic approach to learning where information is conveyed through the transmission of knowledge from expert to learner. Design students are encouraged metaphorically to 'pull apart' what they see and to ask questions. They are trained not to accept authority but to challenge it, as responses from the CETLD baseline research identified:

- 'It's a convention. Can it be subverted?' (tutor).
- 'You can't engage in critical discourse' (student).
- 'It's the Authority, the establishment' (student).

The ability of students to critically reflect and undermine the museum's orthodoxy increased with their own knowledge and understanding of their subject area. The relationship of the HE art and design departments to the V&A was therefore ambivalent. On the one hand the museum was seen as 'a labourer in the same vineyard and on the other, as an orthodox institution to be undermined' (Fisher 2007: unpaginated).

Students find museums, especially large ones like the V&A, overwhelming at the beginning of their course. At these early stages, they are building a treasury of ideas, objects and images (Fisher 2007). For practice-based design courses, the studio critique or 'crit' provides an opportunity for students to practise their analytical, critical and creative skills by presenting their understanding of the subject verbally and visually. For design students these are skills that can be transferred to the museum environment. Students appear more confident about this process of engagement at later stages of their course as Illustration 2.2 shows.

Young, browsing
Treasury of ideas
Need the **MANY**

Maturing, focusing
Dissertations, papers
Making objects
Need the **ONE**

Illustration 2.2 Learning about design in the museum (Fisher 2007)

Throughout the duration of their courses students become increasingly more dedicated to a particular material or medium such as ceramics and textiles. They become more highly motivated about their career, they are stimulated and sometimes feel pressurised to develop a unique contribution to design as their course progresses: 'You see how it's made. You find a piece and relate it to your personal designs' (student).

In turn, they become more 'museum savvy', confident about narrowing their focus and more able to articulate the learning processes they encounter:

- 'Objects as venerable puts people off' (student).
- 'The underlying doctrine. You're told what's right. The cracks start to form when you're too close' (student).

Strategies and Methods for Understanding the Museum: Learning How to See

Design students say that they require help getting to know the museum and appreciate information presented to them in different ways. Studies by Bourdieu, and Bourdieu, Darbel and Schnapper. indicate that the majority of visitors require direction and support in the museum (Bourdieu 1984; Bourdieu, Darbel et al. 1997). As free-choice learning environments, visitors have control over what, when and how they learn in the museum (Falk and Dierking 2000). The difficulty with this assertion is that it focuses too much on visitors' making their own choices and assumes that they have the confidence to decide what and how they learn in the museum.

Our research identified that design students, however skilful they are, require some initial support and strategic assistance with learning how to see and understand the museum environment. The act of seeing goes beyond looking and is about actively engaging and understanding the object.

Students learn to see objects throughout the duration of their study. They may have different purposes for doing this at different stages of their course – for example, if they are problem solving or making an object they may want to see an object in fine detail. The word 'see' refers to the visual aspects of understanding an object but also handling it and valuing different perspectives:

- 'It's frustrating not to touch' (tutor).
- 'Please don't touch. It's behind glass. When it's out of the cabinet you can relate more' (student).

'Learning to see' was a sensitive area and both students and tutors felt they had a lot to learn: 'They do need help, even we do' (tutor).

There was an assumption made by some tutors too that design students are already equipped with the skills and knowledge for interrogating objects in the museum compared to other specialist groups (Fisher 2007). It was also the view that such skills are simply innate and cannot be taught. Bourdieu and Darbel's theory of cultural capital is tied into theories about class structure and reproduction of power within societies (Bourdieu and Darbel 1991 [1969]). It may offer some explanation here. Based on research conducted into the way visitors behave in an art museum, they argue that only a section of the museum's audience are equipped with the necessary skills with which to decipher or decode works of art on display. Gunther has also argued that adult visitors need help with this process and that museums should offer courses on language or symbols to help decode the museum

(Gunther 1999). Bourdieu and Darbel define such skills as 'cultural capital' correlated, they say, to visitors' level of educational attainment (Bourdieu and Darbel 1991 [1969]). They argue that there is an expectation made by museums that visitors already have the appropriate level of knowledge and skills with which to decode the museum and make sense of their experience. A situation appears to have evolved where museums may expect visitors to have been taught the necessary skills to understand them; tutors believe that their students do not need such instruction; and students are left with inadequate guidance.

This is supported by the fact that traditionally museum interpretation in the form of text panels and object labels was written for the default audience of academic peer. However times have begun to change. In the UK, museum interpretation is now often written for the default audience of everyman, as the text guidelines from the V&A's British Galleries project identify: 'Most visitors are not art specialists. The majority of our visitors have no particular knowledge of art and design… This means that our text should be accessible to a wide readership and to people from different cultural and educational backgrounds' (V&A 2003: 5).

The challenge for any museum is about sustaining a learning process from its initial 'hook' to what Csikszentmihayli calls the 'flow' experience, where visitors are 'fully enjoying an intrinsically motivated activity'(Csikszentmihalyi and Hermanson 1995). Langer (1993) termed this process 'mindfulness', a state of being that results from being subsumed wholly into an activity, exploring information from different perspectives and being open and sensitive to different contexts (Csikszentmihalyi and Hermanson 1995). The implications for the design student are twofold. Firstly, at what point does a transformation occur between a process of divergence and grazing to one that is convergent and more intensively focused; and secondly, do these experiences occur in a sequential fashion or in parallel with one another?

It remains unclear how design students learn how to see although evidently it does happen. Clearly this process occurs through a series of activities that require the student to concentrate and analyse an object through a process and sequence of observational drawings that are assigned by their tutors: 'You investigate the object [by drawing it]. You have to look at it and often you don't really look' (student).

Drawing from objects as a practice can trace its history back hundreds of years. The acts of drawing and observing an object consist of a complex series of integrated processes and embodied practices that are parallel to those of designing. Perhaps in age where so much is now virtually replicated, drawing and all forms of embodied practice have become increasingly important in creative learning (see also Chapter 7).

In the first of a series of annual lectures at the V&A's Sackler Centre for Arts Education in 2008, Sir Christopher Frayling, Rector of the Royal College of Art, drew upon John Ruskin's description of the education of the young artist, '…a matter of the head, the heart and the hand':

> No machine yet contrived, or hereafter contrivable, will ever equal the fine machinery of the human fingers. Thoroughly perfect art is that which proceeds from the heart, that which involves all the noble emotions – associates these with the head, yet as inferior to the heart, and the hand, yet as inferior to the heart and head; and thus brings out the whole man. (Ruskin 1858–9)

To this day, such a process remains firmly intact and is one that has particular salience for the way design students learn from museum collections.

Conclusion

As museums move away from their modernist origins, they are rethinking the relationships they have with their audiences and the services they provide. They offer a wide range of learning domains from archives to exhibitions as well as access to expertise in collections-based knowledge. Research into the learning opportunities offered by museums suggests that although they are well placed to meet the pedagogical demands made on them by different groups, little is known about the needs, knowledge and experience of HE students in the museum.

For students to be successful learners both during and beyond HE, consideration will need to be given as to how their learning can be enhanced in the museum. Students, like the majority of adult learners, need help with 'decoding the museum' including understanding its space, ways and methods of working. This knowledge and the processes required for its delivery will require further attention. Such preparation would also be significantly enhanced through advancing museum-university partnerships. Tutors would then be better supported to develop object-based scholarship and embed this skill in the creative practice community.

The challenge for museums in supporting the needs of HE students is to offer activities and resources that encourage a more responsive and intensive learning experience. Museums will find it hard to offer a specialist service for this group without access to both the resources and networks that facilitate partnerships and collaboration with other academic partners. In the following chapters of this book, examples of resources developed for HE students are explored further. These demonstrate ways in which approaches to aspects of a specialist service have begun to benefit both museums and HE.

Bibliography

Anderson, D. (1997) *A Common Wealth: Museums and Learning in the United Kingdom*. London, Department of National Heritage.

Bourdieu, P. (1984) *Distinction: A Social Critique of the Judgement of Taste*. Cambridge, MA, Harvard University Press.

Bourdieu, P. and Darbel, A. (1991 [1969]) *The Love of Art*. Cambridge, Polity.

Bourdieu, P., Darbel, A., et al. (1997) *The Love of Art: European Art Museums and their Public*. Oxford, Polity.

Brookfield, S. (1986) *Understanding and Facilitating Adult Learning*. San Francisco, Jossey-Bass Publishers.

Bruner, J. (1986) *Actual Minds, Possible Worlds*. Cambridge, MA, Harvard University Press.

Caban, G. and Scott, C. (2000) Design Learning in Museum Settings: Towards a Strategy for Enhancing Creative Learning among Design Students. *Open Museum Journal 2: Unsavoury Histories*.

Caban, G. and Wilson, J. (2002) Understanding Learning Styles: Implications for Design Learning in External Settings. In Davies, A. (Ed.) *Enhancing Curricula*. London, RIBA.

Csikszentmihalyi, M. and Hermanson, K. (1995) Intrinsic Motivation in Museums: What Makes Visitors Want to Learn? *Museum News* 35–38.

DCMS (2005) *Understanding the Future: Museums and 21st Century Life*. London, DCMS.

Durbin, G. (2002) Interactive Learning in the British Galleries 1500–1900. Paper presented at Interactive Learning in Museums of Art and Design. London, 17–18 May. Retrieved 27 October 2009, from http://www.vam.ac.uk/vastatic/acrobat_pdf/research/gail_durbin.pdf>

Falk, J. and Dierking, L. (1995) *Public Institutions for Personal Learning: Establishing a Research Agenda*. Washington, DC, American Association of Museums.

Falk, J. and Dierking, L. (2000) *Learning from Museums: Visitor Experiences and the Making of Meaning*. Walnut Creek, CA, Altamira Press.

Fisher, S. (2007) *How do HE Tutors and Students Use Museum Collections in Design?* Qualitative Research for the Centre of Excellence in Teaching and Learning through Design. Unpublished report.

Gunther, C.F. (1999) Museum-Goers: Life-styles and Learning Characteristics. In Hooper-Greenhill, E. (Ed.) *The Educational Role of the Museum*. London, Routledge, 118–130.

Harvey, D. (1990) *The Condition of Postmodernity: An Enquiry into the Origins of Cultural Change*. Cambridge, MA, Blackwell.

Hein, G. (1995) Evaluating Teaching and Learning in Museums. In Hooper-Greenhill, E. (Ed.) *Museum, Media, Message*. London, Routledge.

Hein, G. (1998) *Learning in the Museum*. London/New York, Routledge.

Hooper-Greenhill, E. (1992) *Museums and the Shaping of Knowledge*. London, Routledge.

Hooper-Greenhill, E. (Ed.) (1999) *The Educational Role of the Museum*. London/New York, Routledge.

Hooper-Greenhill, E. (2007) *Museums and Education: Purpose, Pedagogy, Performance*. Oxford, Routledge.

Hooper-Greenhill, E. and Moussouri, T. (2001) Researching Learning in Museums and Galleries 1990–1999: A Bibliographic Review. Retrieved 05

May 2009, from <http://www.le.ac.uk/museumstudies/research/Reports/researchinglearning.pdf>

Karp, I. and Lavine, S. (1991) *Exhibiting Cultures: The Poetics and Politics of Museum Display.* Washington, Smithsonian Institute.

Kolb, D. (1984) *Experiential Learning: Experience at the Sources of Learning and Development.* Englewood Cliffs, NJ, Prentice-Hall.

Kvan, T. and Yunyan, J. (2004) Students' Learning Styles and the Correlation with Performance in the Architectural Design Studio. *Design Studies* 26/1.

Langer, E. (1993) A mindful education. *Educational Psychologist* 28/1, 43–50.

MGC (1999) *Lifting the Veil: Research and Scholarship in United Kingdom Museums and Galleries.* London, Museums and Galleries Commission.

Moore Tapia, J. and Hazelroth Barrett, S. (2003) Postmodernism and Art Museum Education: The Case for a New Paradigm. In Xanthoudaki, M., L. Tickle and V. Sekules (Eds) *Researching Visual Arts Education in Museums and Galleries: An International Reader.* Dordrecht, Boston and London, Kluwer Academic Publishers.

Moussouri, T. (1997) Family Agendas and Family Learning in Hands-On Museums. Unpublished dissertation, unpublished report.

Ogbu, J.U. (1995) The Influence of Culture on Learning and Behaviour. In Falk, J.H. and L.D. Dierking (Eds) *Public Institutions for Personal Learning* Washington, DC, Association of American Museums.

RIN (2008) *Discovering Physical Objects: Meeting Researchers' Needs.* Research Information Network.

Roberts, L.C. (1997) *From Knowledge to Narrative: Educators and the Changing Museums.* Washington, DC, Smithsonian Institute.

Ruskin, J. (1858–9) The Unity of Art. In Ruskin, J. (Ed.) *The Two Paths – Being Lectures on Art, and its Application to Decoration and Manufacture.* London, Smith, Elder and Co.

Silverman, L.H. (1995) Visitor Meaning-Making in Museums for a New Age. *Curator* 38, 161–170.

Speight, C. (2007) *Online Survey Report.* CETLD Baseline Research. Retrieved from <http://cetld.brighton.ac.uk/research/museum-research/v-a-baseline-data>

Travers, T. (2006) *Museums and Galleries in Britain: Economic, Social and Creative Impacts.* London, Museums, Libraries and Archives Council (MLA) and the National Museums Directors' Conference (NMDC).

V&A (2003) *British Gallery Text Guidelines.* Unpublished report.

Walker, K. (2008) StreetAccess 'iGuides' Summative Evaluation. Retrieved 5 May 2009, from <http://cetld.brighton.ac.uk/projects/current-projects/iGuides/iguides-evaluation/iguides-summative-evaluation-report>

Wilson, J. (2000) Change, Change and More Change: Redefining the Student Profile in Design. *International Conference on Design Education.* Curtin University.

Witcomb, A. (1998) On the Side of the Object: An Alternative Approach to Debates about Ideas, Objects and Museums. *Museum Management and Curatorship* 16/4, 383–399.

Witcomb, A. (2002) *Re-Imaging the Museum – Beyond the Mausoleum*. London, Routledge.

Chapter 3

Bridging Perspectives – Approaches to Learning in Museums and Universities

Beth Cook and Catherine Speight

When considering the ways in which museums can better support students, and how universities can equip students to use museums, it is of vital importance that both sectors develop an understanding about what and how the other communicates. There are different approaches to pedagogy in museums and higher education (HE), some of which, as this chapter argues, are complementary. The terms used to describe learning in both sectors are frequently misunderstood, leading to what Boys calls the *gaps and slippages* in between (see Chapter 4). These have impeded the effectiveness of museums and universities working together.

The aim of this chapter is to lay out some of these terms, providing context and further explanation. It will explore the application of pedagogy within universities and museums, and the different ways it is understood by both sectors. By acknowledging their differences and similarities, museums and universities can approach new and complementary ways of supporting the HE learner in all facets of their development.

Understanding Pedagogy

> *Pedagogy: (n) the principles, practice, or profession of teaching* (Collins English Dictionary 2006)

The open-endedness of this standard definition of pedagogy necessarily requires that different terms are used to describe the specific principles, practices, methods, events, and theories that have developed within the practice of pedagogy.

Firstly, though, we need to understand the word itself. The word pedagogy translates from French and Latin adaptations of the Greek words for 'boy' and 'leader' – 'to lead a child'. This literal understanding gave rise to an argument in the late 1970s and into the 1980s that pedagogy referred only to 'the art and science of teaching children'(Knowles 1981: 50), and that the theory and practice surrounding adult learning and teaching is distinct enough to warrant its own term – 'andragogy' (Knowles 1980) – a term first developed in the nineteenth century but only intermittently used since.

The theory of andragogy was based on the idea that adult learners have characteristics that are distinct and different from those of child learners. These are:

- self-concept or self-understanding;
- experience;
- readiness to learn;
- orientation to learning; and
- motivation to learn (Knowles 1984: 12)

Knowles proposes here that with maturity comes the ability to self-direct, to draw upon experience, to have intrinsic motivation to learn and the discipline to see a learning experience through to completion (Knowles 1984: 12). The attributes he outlines above constitute a particular type of learning experience.

There have been a number of criticisms levied against Knowles' definition of andragogy, one in particular being '... that he has changed his definition over decades of work' (Fry, Ketteridge et al. 2009: 14). A number of other researchers have made convincing arguments that the differences identified between pedagogy and andragogy are simplistic – each one of the five assertions has been the subject of debate (Jarvis 1987; Davenport 1993; Tennant 1996 [1988]). Others have questioned how far there really are theories of adult learning and the extent to which these differ from children's learning (Fry, Ketteridge et al. 2009: 14). In our experience it is more widely agreed now that the term pedagogy can usefully be applied to both child and adult education and this is the position that this volume takes. However, it is useful to reflect upon the different ways in which children and adults have historically been viewed as learners. HE students often find themselves caught between two different educational worlds, especially when in a museum context.

HE students who go directly to university are adults, and the HE sector is seeing a large number of mature and diverse students applying to university – 28 per cent of first year full time undergraduates were mature students in the academic year 2007/08 – 'mature students' defined as individuals who are 21 years of age and older when beginning their studies (HESA 2009). It is important that the different learning styles and experiences of students entering HE are taken into account by museums and universities, and that new ways of teaching and learning are found which can help students critically engage with resource-rich environments like museums.

By distinguishing and articulating the different approaches to learning in the museum and university context, both institutions can reflect on and better equip students to understand and use the museum as a learning resource. It may also be the case that new ways of teaching with HE students in the museum can be developed and explored.

There is a vast pedagogic literature in HE and much work has been conducted into the nature of learning and learning theories in museums. Research into

pedagogy in both the museums and HE sectors has evolved independently over much of the twentieth century despite their interlinked histories. This is of course, obvious in a way. All too frequently, terms such as informal and formal learning, or free choice and structured learning are used to describe learning in the context of both the museum and university. Their meanings are often contested, leading to them sometimes appearing as opposites. The next section will discuss some of these terms and explain conversely how they may be reconciled.

Museum Pedagogy

The structure of learning in museums is qualitatively different to that of schools, colleges and universities. Unlike formal learning, museum learning is self-directed and open-ended, where the learner is able to follow unpredictable learning paths (Hooper-Greenhill 1999). Falk and Dierking describe a free-choice learning environment as one where learners have control over what, when, why and how they learn, as is usually considered to be the case in a museum situation: 'Free choice learning is a term that recognises the unique characteristics of such learning: free-choice, non-sequential, self-paced and voluntary. It also recognises the socially constructed nature of learning, the dialogues that go on between the individual and his or her socio-cultural and physical environment'(Falk and Dierking 1998: 2).

This definition acknowledges the interplay between the types of different learning opportunities that can exist in museums, and other aspects such as the form of its buildings, its collections and its exhibitions. Not all theories discussed here are unique to museums but they are all important within the field of museum education.

Free-choice learning is also sometimes referred to as 'informal learning', which may appear opposite to the idea of 'formal learning'. This will be explored in more detail in the following section, but it is important to acknowledge that there are differences between the idea of formal education which encompasses the highly structured, National Curriculum-guided provision found in primary and secondary schools, and the less formal tutor-guided modular system that makes up taught courses in higher education. Learning is most often led by a professional who guides the learner in the development of basic to advanced skills and who introduces new realms of knowledge (Falk 2002). It is not the case that learning processes are necessarily formal in this sense, since students (in HE and in museums) will learn as much through informal (unguided) processes. Hein, in his introduction to *Learning in the Museum*, states that: 'Formal and informal adequately describe the administrative attributes of educational settings; the terms should not be used to describe pedagogic qualities' (Hein 1998: 7).

The lack of a unifying structure in the way taught courses are delivered in universities causes difficulties for museums when attempting to design a service for HE. The requirements of the National Curriculum for students up to the age of 18 help museums to design resources and events that are transferable to a

large number of groups. In contrast higher education has benchmark statements formulated by the Quality Assurance Agency (QAA). These statements aim to help universities make outcomes more explicit and to encourage debate in and across different contexts. They are defined broadly to allow course leaders flexibility when designing courses. It is difficult for museums to respond to the needs of different subject groups, especially when there is so much variation within individual subject areas. Museums currently respond to this dilemma by offering learning materials that are created for the 'general' adult visitor in the museum. In order to answer the question 'why might it be inappropriate to include HE services in adult educational provision?' we need to consider a number of educational theories or models.

Informal learning in this context focuses on the choices an individual makes in the museum, and assumes that a visitor is knowledgeable and confident enough to decide what, when and how they learn in the museum. This is strongly linked to ideas developed by Hein (1995) regarding the constructivist nature of the museum learning experience.

The principle of constructivism is based on work conducted by Piaget and Vygotsky in the mid-late twentieth century, and developed into a key theory of learning that was also extended by 'contemporary biologists and cognitive scientists' (Twomey Fosnot and Perry 2005: 8). The works of Bruner and Dewey were also an important influence (Vanderstraeten and Biesta 1998: 3; Greene 2005: 111). As a theory, it applies to all learning and emphasises that learners construct knowledge with their own activities, building on what they already know (Biggs and Tang 2007). In the museum environment, constructivism relates to the key principle that 'knowledge is actively constructed' (Twomey Fosnot 2005: 276) by the learner within a social and cultural framework – that there is not one truth about something, waiting to be discovered, but that it has 'an adaptive function' (Von Glaserfield 2005: 3). In other words, by focussing on experiences, individuals can construct an understanding of the world they live in. The work of Hein has been critical to this debate (Hein 1991; Hein 1995; Hein 1998). He developed his educational theory based on learning theory (how people learn) and a theory of knowledge (an epistemology), which he considered to underpin 'what a museum does as an educational institution' (Hein 1998: 16). His theory identified four different domains of educational theory – didactic and expository; discovery; stimulus-response; and constructivism – which each relate to a different understanding of epistemology and learning theory (Hein 1998).

In a museum context, the changes wrought by constructivism can be seen as related to two dominant communication theories that have characterised the way information is presented in the museum.

The *transmission model* employs a didactic approach to the transmission of information between the teacher and the learner. If we assume that knowledge is external to the learner, and to the learning process, then the task of teaching is simply a case of transmitting that information to the learner and the learner

receiving it. This assumes that the learner is an 'empty vessel', and cognitively passive – the accepter of knowledge which merely fills the empty space.

The *transactional communication model* has evolved from constructivist learning theory and acknowledges that visitors are active in making meaning (Hooper-Greenhill 1994: 25). It recognises that learning is complex and multi-directional rather than linear (Hooper-Greenhill 1999).

As keepers of collections, museums disseminate information about objects through a number of established methods – most often through object or gallery labels, but also through guidebooks, curator talks, and gallery-based interactives. The transactional communication model has had a major impact on museums' understanding of the visitors' learning experience.

Most museums embrace some form of constructivism but there remains a difficulty with its position. For example, it makes a number of assumptions about the learner as an active seeker of knowledge: 'learning requires active participation of the learner in both the way that the mind is employed and in the product of the activity, the knowledge that is acquired' (Hein 1998: 34). Constructivism requires that the learning that occurs is not judged against an 'external standard of truth' but is validated by 'whether [it] "make[s] sense" within the constructed reality of the learner' (Hein 1998: 34). All museum visitors differ in their motivations for visiting a museum, as well as in their ability and desire to learn from different experiences and construct meaning. It is therefore very difficult for museums to evaluate the kind of constructivist learning that they have come to value, and there is currently limited evidence about the impact museum experiences may have on visitors in the longer term.

Linked to the growing understanding about the complex nature of the learning process is the idea of learning styles. Kolb's theory of experiential learning (Kolb 1976; Kolb 1981) is relevant to museum learning because it involves a 'direct encounter with the phenomena being studied' (Borzak 1981: 9; Brookfield 1983). In conjunction with this model Kolb also developed an inventory of 'learning styles' (Kolb 1976) which has been influential among museum educators. There are a number of different learning style definitions but Kolb's interpretation has been used widely in the museum context (the interpretive scheme for the flagship British Galleries at the V&A that opened in 2001 was developed with specific learning styles in mind). Kolb and Fry identified four learning styles – converger; diverger; assimilator and accommodator (for further explanation see Chapter 2). Further research by Hinton for the V&A Silver Galleries refined these definitions and identified the following learning styles: analytical learners (assimilators), common-sense learners (convergers), experiential learners (accommodators) and imaginative learners (divergers) (Hinton 1998). In 2005 an evaluation was carried out using the Kolb Learning Style Inventory in order to ascertain whether the interpretative devices in the Galleries were achieving their designed and desired objectives (Buss 2005). One interesting finding of the report, not directly related to the main aim, was that:

> It would seem that Learning Style Theory [LSI] is a useful tool for developing self-awareness of one's learning, but is not necessarily reliable or useful as a test. Kolb himself states in the LSI that it is a useful tool for helping learners to recognise different modes of learning, understand the learning process, and how they learn, but does not clearly state the LSI's usefulness as an accurate test of learning style. (Buss 2005: 43)

This highlights a central aspect of constructivist approaches to learning which emphasises the importance of students' involvement in their learning process. Acknowledging that the idea of a person having a single learning style is simplistic, and that people may range between styles depending on different contexts, does not invalidate the usefulness of understanding the concept of different learning styles. Nor should thinking about these learning styles lead to a narrowing of options for learners. By providing interpretation specifically designed for different kinds of learners a potentially wider visitor audience may be reached. This also relates to the idea of deep and surface approaches to learning that are discussed later in this chapter.

Csikszentmihalyi and Hermanson identify that learning in schools or universities relies on what they call 'extrinsic motivation' to enforce how and what students learn (Csikszentmihalyi and Hermanson 1995). Museums, on the other hand, rely on intrinsic motivation such as visitors' own interest and curiosity, although both 'intrinsic' and 'extrinsic' motivations for learning can apply in any setting. This relates to Falk's idea that formal learning is led by a professional and that informal learning is voluntary and self-led. There are some difficulties with this assertion because visitors differ in their ability to understand complex ideas, to adapt effectively to their environment, to learn from experience and to engage in various forms of reasoning (Marsh 1996). However, research conducted into the nature of the learning experience has found evidence that individuals do construct their own meanings according to their personal experiences and that they learn by accumulating experiences from different sources (Hein 1995). Recently the idea of 'intrinsic motivation' in all areas of learning has increased and there is growing emphasis on students acknowledging and understanding their own model of how they learn, and the activities involved in that process. The motivations and the requirements of an HE student visitor may be different from that of a highly motivated informal adult learner, and different again to a casual adult visitor, all of who may fall under the museum's general adult learning provision.

This forms the basis of empirical research conducted by museums into their audiences with a wider aim of understanding this process more fully.

HE Pedagogy

In this section, we look at areas of HE pedagogy we have encountered in our own work exploring how HE design students use museum collections. HE is part of

the formal education sector, which includes schools, colleges, further and higher education and other credit-based systems of learning that lead to an academic qualification. Universities are the prime purveyors of tertiary education in the UK.

As HE has moved towards a system where students pay for their tuition and regard themselves as consumers, universities have had to become more responsive to the different ways in which students learn, and the ways that this translates into teaching practice. Universities increasingly recognise the importance of the student voice and a number of government agencies including HEFCE, the QAA and the Higher Education Academy (HEA) and its regional partners have been established to support this.

Learners in HE are taught in timetabled sessions, but they are required to be much more independent and self-directed than they are in other formal education settings. A specific approach to teaching and learning in HE includes a requirement to work on individual resource-based projects that emphasise learning facts and concepts as they are used. Another key aspect includes recognition that both formal (or academic) and informal (social) environments are of central importance to learners. Learning in HE 'may involve mastering abstract principles, understanding proofs, remembering factual information, acquiring methods, techniques and approaches, recognition, reasoning, debating ideas, or developing behaviour appropriate to specific situations; it is about change' (Fry, Ketteridge, et al. 2009: 8).

Within HE there is a commonly accepted paradigm for defining and understanding student learning (Fry, Ketteridge, et al. 2009: 10), known as deep and surface approaches to learning. In the deep approach to learning, students aim to understand ideas and seek meanings in the tasks they undertake. They may have an intrinsic interest in the task and an expectation of enjoyment in carrying it out. In the second part of this paradigm, known as surface learning, students seek to meet the demands of a task with minimal effort and they may adopt particular strategies, such as learning by rote, to deal with the task in hand. The extrinsic motivation and strategic approach to learning is the pass mark. Within art and design, however, the concept of deep and surface approaches to learning has been challenged for being too simplistic and not mapping easily onto practice (Bailey 2002). It has also been challenged as reflecting presuppositions about academic work. Haggis argues that '... the research discussed here [i.e. the 'approaches to study' research] has constructed a model of student learning which is based upon a set of elite values, attitudes and epistemologies that make more sense to higher education's 'gatekeepers' than they do to many of its students' (Haggis 2003: 102).

Student approaches, both deep and surface, have been found to be associated with their preconceptions of learning, related to prior experience, enjoyment, and expectation (Prosser and Trigwell 1999). HE teaching aims to encourage a deep approach to learning. However, a key issue that both museums and universities need to consider in relation to the deep/surface learning paradigm is one of context. A student who displays a deep approach to learning in one context, such as the studio, may display a surface approach in another context, such as a museum or library. Whilst a surface approach to learning in HE is considered

undesirable, the question we have to ask ourselves is whether such an approach may be appropriate in the museum context. It would be interesting to research further whether information gathered in one context through a surface approach is later used in a different context for deeper learning. This also questions the relative importance of different types of knowledge and the choices that are applied by the learner in the context of the design process.

Approaches to Pedagogy in Museums and Higher Education: Similarities

Despite the differences between their approaches to learning, museums and HE do share important areas in common. Both are focused on the role of the learner and what learning means, and have become drawn into government policy, particularly in areas such as widening participation and social inclusion (See Chapter 1).

Both sectors have increasingly prioritised individual and personalised modes of learning (Anderson 1997). Greater emphasis has been made by tutors to help students develop an awareness of their own learning styles, and to become independent and self-directed in the way they approach their work.

The concept of self-directed study is prioritised in most QAA benchmark statements for HE courses. In art and design this concept is given particular prominence – it states that 'the practice of art ... demands high levels of self-motivation, intellectual curiosity, speculative enquiry, imagination, and divergent thinking skills' (QAA 2008: 3.8).

The free-choice nature of the museum environment makes them ideal locations for self-directed study. Museums have always offered visitors a level of freedom in how they approach their visit. However, they can be overwhelming places where some guidance may be necessary if a visitor comes with a specific aim in mind. In the past few decades, however, most museums have begun to offer more support and direction, provided by growing education departments. Gallery talks, handling opportunities, events and symposia are all examples of this kind of support. The fact that education has become one of the areas considered a vital part of a museum's work is an important step forward, as Speight's chapter identifies (see Chapter 2).

There are several difficulties associated with encouraging self-directed learning approaches. In the museum, it may be difficult for students to access resources and only a few museums may have adequate facilities or services for studying objects that are not on display. Museum education staff are not fully trained to support self-directed study (Anderson 1997). Similarly, it is rare that university tutors have worked with museum objects and therefore lack the appropriate skills themselves to pass on to students. The issue of how museums can facilitate self-directed study for students who are externally assessed has not yet been resolved.

The increased emphasis and value placed on the role of the learner also needs to take into account the learner's need for support. Boys argues in her chapter that further research is necessary to explore the conceptual spaces around the nature of

learning in order to improve understanding about productive ways for both sectors to work together (see Chapter 4).

It is often the case that the teaching activities that take place in both sectors are defined by the space that is available to them. Learning in museums is offset by the physicality of the building as well the collections housed within it. Museums do not always offer specifically-designed learning spaces in the way that formal learning providers do, such as classrooms and lecture halls in schools and universities. Instead, they offer a different kind of learning space, one that is public and social, where views can be discussed and challenged (Jackson and Meecham 1999). However, museums are increasingly investing in specifically-designed educational spaces, although access to these is still not always easy.

Approaches to teaching and learning in museums have long been synonymous with school-based education. Schools constitute an enormous part of the museum's audience and as a result, a great deal of research about learning has been undertaken into their needs: 'Educational theories used as a theoretical framework … have concentrated on children's development and socialization … Most of the research in human development has focused on the period that ends with adolescence' (Hooper-Greenhill and Moussouri 2001: 3).

This has resulted in some museums with limited time and resources primarily working on schools-based programmes. In addition, museums offer a range of services which are available by choice to the general public, elements of which are highly valued by HE students even if they are not designed specifically with this audience in mind. This includes guest lectures, curator's talks, access to resources, libraries and specialist collections as well as exhibitions, demonstrations, handling opportunities and tours. Some of these, such as demonstrations or curator talks, have direct parallels to teaching and learning methods in HE, such as workshops, demonstrations and group work (Dineen and Collins 2005) and are relatively easy for HE students to access. Others, such as tours or exhibitions are not always so immediately seen as 'learning' opportunities, because of their unfamiliarity. The difference between both sectors is that in museums, visitors can choose what type of learning opportunity they want to take advantage of whereas in HE this is more strictly defined.

Assessment of Learning in Museums and Higher Education

The final area we need to consider in more detail is that of assessment. The assessment of museum education activities is often ad hoc, relying on visitors to self-select and self-report. When evaluation takes place it often concentrates on information of immediate relevance to the museum, such as visitor demographics or practical issues. Evaluation is often based on evidence that is captured in the museum at one moment in time, for example, immediately after visiting an exhibition. The assessment of what learning has occurred at these events is often not addressed.

It is difficult to measure learning in museums for a number of reasons. These include the diverse nature of visitors' experiences, the often unarticulated 'learning outcomes' of an exhibition or event, and the difficulty of measuring 'how far their general users have moved forward in their understanding and abilities' as a result of visiting the museum (Hooper-Greenhill 2007: 24). There is some evidence that the Generic Learning Outcomes, developed for the Museums, Libraries and Archives Council, are providing useful guidelines for evaluating individual learners' experiences. Further information about this initiative is outlined in Chapter 4.

HE assessment is part of the curriculum. Students enrolled on formal credit-based courses of education must meet a desired standard in order to pass their course. Students may be aware of what the planned learning outcomes are prior to starting their course or module. Details are provided at the beginning of each module. This influences students' motivation for learning and the strategies they adopt because it is linked to the extrinsic purpose of gaining credit. Research conducted by Gibbs and Simpson identified that the conditions in which assessment supports learning are more complex than this (Gibbs and Simpson 2004). They argue that assessment can be used to drive learning, but only if certain conditions are met including study time and orienting students' effort to the most important aspects of the subject by engaging them in productive learning activity. Some commentators have suggested that extrinsic motivation is detrimental to learning and that motivation and learning decrease when there is an externally imposed grade or mark (Amabile 1996). However, there must be external judgement in order to situate and assure the quality and value of the HE qualification and experience.

Evidence of HE students' learning from museums may be assessed by course tutors, if it is part of a formal course task. This will have specified learning outcomes, and students will know what these are beforehand. The learning that occurs from self-directed visits is much harder to quantify, as students may visit without defined objectives, and may or may not use any of the knowledge or ideas gained for many months or years afterwards. This causes difficulty because students prioritise their time and if they do not feel they are suitably 'rewarded' with recognition for work they do outside of university, whether in a museum or not, their motivation to continue may diminish.

In relation to art and design, there are specific issues relating to assessment, including the presentation and examination of a collection of student work in a portfolio that contains evidence of project process, research, drawings, artefacts, samples, sketches, thoughts, developmental ideas and finished products or recording of performances (Shreeve, Wareing, et al. 2009: 350). However, for the student, what often remains unclear is what is actually being assessed. Shreeve, Wareing et al (2009) describe the variation in belief which can give rise to discrepancies in practice and subsequently students' confidence in their learning (Shreeve, Wareing et al. 2009: 350). Other forms of assessment include the 'crit' and the final show. An interesting question here is to what extent (if it at all) do the distinctive forms of assessment used in the arts impact on students actual or potential attitude to learning in museums?

Conclusion

This chapter has demonstrated that both museums and universities have different ways of approaching the concept of pedagogy but it also indicates that there are significant points of convergence. The differences in the way they apply their use of pedagogy need not be a barrier to working together.

HE learners often find themselves caught between the academic environment of the university and the more informal learning environment of the museum. In a museum context, for example, students (used to more direction) may not be aware of what resources the museum can offer them, or even how to start finding this out.

Empowering the student to understand how they approach learning is a step towards solving this problem, and is a key feature of constructivism. HE institutions will need to continue to equip their students with this kind of transferable skill so that they can make the best use of a wide range of resources. In turn, if the museum was able to be more explicit about its role as a learning environment for HE, it would also be easier for students and tutors to direct themselves and their learning within it.

Both types of institution are interested in the value and role of learning, and what it means from both an informal and formal perspective. Greater understanding between sectors has the potential to enrich the student experience immeasurably as well as bringing new and innovative ideas into both educational arenas.

Bibliography

Amabile, T.M. (1996) *Creativity in Context.* New York, Springer-Verlag.

Anderson, D. (1997) *A Common Wealth: Museums and Learning in the United Kingdom.* London, Department of National Heritage.

Bailey, S. (2002) Student Approaches to Learning in Fashion Design: A Phenomenographic Study. *Art, Design and Communication in Higher Education* 2/2, 81 95.

Biggs, J.B. and Tang, C. (2007) *Teaching for Quality Learning at University.* Maidenhead, Open University Press/McGraw-Hill Education.

Borzak, L. (1981) *Field Study. A Source Book for Experiential Learning.* Beverly Hills, Sage Publications.

Brookfield, S.D. (1983) *Adult Learning, Adult Education and the Community.* Milton Keynes, Open University Press.

Buss, J. (2005) An Evaluation of Interpretative Devices in the British Galleries to Ascertain to what Extent they are Meeting their Learning Objectives. Unpublished report.

Csikszentmihalyi, M. and Hermanson, K. (1995) Intrinsic Motivation in Museums: What Makes Visitors Want to Learn? *Museum News*, 35–38.

Davenport, J. (1993) Is There Any Way out of the Andragogy Mess? In Thorpe, M., R. Edwards and A. Hanson (Eds) *Culture and Processes of Adult Learning*. London, Routledge.

Dineen, R. and Collins, E. (2005) Killing the Goose: Conflicts between Pedagogy and Politics in the Delivery of a Creative Education. *International Journal of Art and Design Education* 24/1, 43–52.

Falk, J. (2002) The Contribution of Free-Choice Learning to Public Understanding of Science. *Interciencia* 27.

Falk, J. and Dierking, L.D. (1998) Free-choice Learning: An Alternative Term to Informal Learning? *Informal Learning Environments Research Newletter* 2, 2. Retrieved 29 October 2009 from <http://www.umsl.edu/~sigiler/ILER-Newsletter-0798.pdf>

Fry, H., et al. (Eds) (2009) *A Handbook for Teaching and Learning in Higher Education*. London, Kogan Page.

Gibbs, G. and Simpson, C. (2004) Conditions under which Assessment Supports Students' Learning. *Learning and Teaching in Higher Education* 1, 3–31.

Greene, M. (2005) A Constructivist Perspective on Teaching and Learning in the Arts. In Twomey Fosnot, C. (Ed.) *Constructivism Theory, Perspective and Practice*. New York and London, Teachers College Press, 110–131.

Haggis, T. (2003) Constructing Images of Ourselves? A Critical Investigation into 'Approaches to Learning' Research in Higher Education. *British Educational Research Journal* 34/1, 89–104.

Hein, G. (1991) *Constructivist Learning Theory – The Museum and the Needs of the People*. Jerusalem, ICOM/CECA.

Hein, G. (1995) Evaluating Teaching and Learning in Museums. In Hooper-Greenhill, E. (Ed.) *Museum, Media, Message*. London, Routledge.

Hein, G. (1998) *Learning in the Museum*. London/New York, Routledge.

HESA (2009) Students in Higher Education Institutions: 2007/08. London, HMSO.

Hinton, M. (1998) The Victoria and Albert Museum Silver Galleries II: Learning Style and Interpretation, Preference in the Discovery Area. *Museum Management and Curatorship* 17/3.

Hooper-Greenhill, E. (1994) *Museums and Their Visitors*. London, Routledge.

Hooper-Greenhill, E. (Ed.) (1999) *The Educational Role of the Museum*. London/ New York, Routledge.

Hooper-Greenhill, E. (2007) *Museums and Education: Purpose, Pedagogy, Performance*, Oxford, Routledge.

Hooper-Greenhill, E. and Moussouri, T. (2001) Researching Learning in Museums and Galleries 1990–1999: A Bibliographic Review. Retrieved 05 May 2009, from <http://www.le.ac.uk/museumstudies/research/Reports/researchinglearning.pdf>

Jackson, T. and Meecham, P. (1999) The Culture of the Art Museum. Toby Jackson in conversation with Pam Meecham. *Journal of Art and Design Education* 18/1, 89–98.

Jarvis, P. (1987) Malcolm Knowles. In Jarvis, P. (Ed.) *Twentieth Century Thinkers in Adult Education*. London, Croom Helm.

Knowles, M. (1980) *The Modern Practice of Adult Education. From Pedagogy to Andragogy*. London/Englewood Cliffs NJ, Cambridge/Prentice Hall.

Knowles, M. (1981) Andragogy. In Collins, Z.W. (Ed.) *Museums, Adults and the Humanities: A Guide for Educational Programming*. Washington, DC, American Association of Museums, 49–60.

Knowles, M. (1984) *Andragogy in Action. Applying Modern Principles of Adult Education*. San Francisco, Jossey Bass.

Kolb, D.A. (1976) *The Learning Style Inventory: Technical Manual*. Boston, MA, McBer.

Kolb, D.A. (1981) Learning Styles and Disciplinary Differences. In Chickering, A.W. (Ed.) *The Modern American College*. San Francisco, Jossey-Bass.

Marsh, C. (1996) Visitors as Learners: The Role of Emotions. Retrieved 12 May 2009 from <http://www.astc.org/resource/education/learning_marsh.htm>

Prosser, M. and Trigwell, K. (1999) *Understanding Learning and Teaching: The Experience in Higher Education*. Buckingham, UK, The Society for Research into Higher Education and Open University Press.

QAA (2008) *QAA Guidelines: Art and Design*. Gloucester, The Quality Assurance Agency for Higher Education.

Shreeve, A., Wareing, S., et al. (2009) Key Aspects of Teaching and Learning in the Visual Arts. In Fry, H., S. Ketteridge and S. Marshall (Eds) *A Handbook for Teaching and Learning in Higher Education*. London, Kogan Page, 345–362.

Tennant, M. (1996 [1988]) *Psychology and Adult Learning*. London, Routledge.

Twomey Fosnot, C. (2005) Constructivism Revisited: Implications and Reflection. In Twomey Fosnot, C. (Ed.) *Constructivism Theory, Perspective and Practice*. New York/London, Teachers College Press, 276–291.

Twomey Fosnot, C. and Perry, R.S. (2005) Constructivism: A Psychological Theory of Learning. In Twomey Fosnot, C. (Ed.) *Constructivism Theory, Perspective and Practice*. New York/London, Teachers College Press, 8–38.

Vanderstraeten, R. and Biesta, G. (1998) *Constructivism, Educational Research, and John Dewey*. The Twentieth World Congress of Philosophy. Boston University.

Von Glaserfield, E. (2005) Introduction: Aspects of Constructivism. In Twomey Fosnot, C. (Ed.) *Constructivism Theory, Perspective and Practice*. New York and London, Teachers College Press, 3–7.

Chapter 4

Creative Differences: Deconstructing the Conceptual Learning Spaces of Higher Education and Museums

Jos Boys

Whilst most art and design tutors and students in higher education (HE) would agree that museums are a very valuable learning resource, all sorts of things seem to get in the way of museums and universities working together in a long-term, robust and embedded relationship. There are many examples of individual enthusiasts developing activities, and of museums offering supplementary materials for use in HE, but overall these collaborations have been piecemeal and difficult to maintain. In this chapter I will suggest that this is because museum and university learning occupy different 'conceptual spaces' which – despite similarities – have subtle and often over-looked differences and tensions. It is the resulting gaps and slippages between how academics and museum educators frame learning that have restricted the effective integration of learning activities across both institutions.

In a way it is obvious that museums and galleries have developed their learning provision differently to universities and colleges. In the contemporary period learning in museums is usually articulated as being about enriching the experience of visiting, and inspiring diverse audiences to engage positively and productively with collections through both one-off and extended relationships (Hooper-Greenhill 2000). Learning resources are primarily built into the selection, combination and curation of available material. Whilst collections and exhibitions are often supported by specialist educators (and sometimes by dedicated spaces for education as well), it is the displays and spaces themselves that enable learning:

> Museum pedagogy is structured firstly through the narratives constructed by the museum displays and secondly through the methods used to communicate these narratives. (Hooper-Greenhill 2000: 3)

HE, in contrast, is a process of orchestrated activities in a defined sequence over an extended period of time. Learners must first choose a particular subject (and submit to specific recruitment procedures in order to gain access), and then accumulate a succession of units or modules. These are offered at increasingly difficult levels of achievement and usually taken over a number of years so as to result in a recognised award. Learning here is thus a highly structured and long-term process, mediated

directly by educators and supported by a variety of specially designed physical and virtual learning spaces for different activities (see also Chapter 3).

In recent years differences between various types of learning have been articulated via terms such as formal/informal and instruction/practice; as well as through critiques of the terms themselves (Lave and Wenger 1991; Lave and Wenger 1998; Hooper-Greenhill 2000). While these debates have been very useful, they have also tended to make general arguments *for* and *against* one form of learning rather than another. Here, I want instead to take the debate off in a different direction by exploring at a basic level some problematic 'conceptual spaces' around learning across museums and universities, which terms such as formal and informal do not necessarily expose.

These are raised as questions to inform further research rather than definitive statements; and are from the position of someone with a background in HE teaching art and design who has been trying to articulate why many educational resources provided by museums – despite being of the highest quality – often may not quite fit with learning activities at university.

This chapter will first examine some of these differences in 'conceptual spaces' about learning. It will then explore how unravelling these differences can help educators more effectively impact on the curriculum. The aim is to challenge some of the assumptions that we have – whether as university teachers, researchers, curators or archivists – about what learning is, and where it happens. This is not about proper ways of teaching and learning but about opening up creative and constructive debates between and across museum and higher education.

Exploring the Differences

It may be obvious that HE and museum learning operate in different contexts, have separate (though interlinked) histories and both implicitly and explicitly take the accomplishment of learning to mean slightly different things. But the complex impacts of these differences are too infrequently examined or unravelled. Of course, both institutions are also affected differently by wider contexts, such as government policy and funding regimes; as these are mentioned elsewhere in the book, this chapter focuses on how the learning process itself is articulated. This is not about setting up artificial oppositions or arguing that a particular mode of teaching and learning is better or worse than another. It is to open up various perspectives and approaches to view and debate, so as to better understand the implications of intersecting pedagogies across museums and universities, and to see what can be learnt from each other about our own assumptions and practices. The aim is not simply to align or share what we already do, but to deconstruct it. Here, I will concentrate on outlining four conceptual learning spaces which bridge museum and university pedagogies: emphases on learning *about* and learning *from* collection-based spaces; learning creative thinking; tensions in what

constitutes knowledge, authority and difference; and learning as inspiration and/or achievement.

Conceptual Spaces 1: Learning About and Learning From

Museums have become increasingly involved in more public, participatory education and interpretation beyond merely imparting expert knowledge about their artefacts. So, instead of (or as well as) labels with key facts defining and linking objects in a specifically art-historical manner there may be, for example, contextual material offering different perspectives on a place or time,[1] alternative labelling from non-experts,[2] or interactive materials that enable participants to engage with, question or develop personal meanings in relationship to the objects on display (Exploratorium 2009; NEMO 2009). This shift has been partly in response to government imperatives to make museums more socially inclusive and accessible; and partly as museum studies has become influenced by wider political and academic debates around information, knowledge and power (Vergo 1989).

If a central activity for any museum is enabling visitors to learn *about* its collection (both the individual objects and the underlying themes these inform), this has shifted decisively over the last 20 to 30 years from the offer of an objective authoritative explanation to a more open-ended interpretation that includes different perspectives, often incorporating those of the museum visitors themselves:

> The biggest challenge facing museums at the present time is the re-conceptualisation of the museum/audience relationship. After almost a century of rather remote relationships between museums and the public, museums today are seeking ways to embrace their visitors more closely. As museums are increasingly expected to provide socially inclusive environments for life-long learning this need for closeness to audiences is rapidly becoming more pressing. (Hooper-Greenhill 2000: 1)

As part of this process of opening up the authority of museum knowledge to question, many museums have been exploring how to support learning less as the simple transmission of cultural facts, and more as a personal process of meaning-making:

> The task ... is to provide experiences that invite visitors to make meaning through deploying and extending their existing interpretative strategies and repertoires, using their prior knowledge and their preferred learning styles, and testing their hypotheses against those of others, including experts. The task is to produce opportunities for visitors to use what they know already to build

1 For example, the Imperial War Museum centres on many different perspectives of warfare (IWM 2009).

2 At the Palazzo Strozzi in Florence 'every exhibition offers not only activities for children of all ages, but also special children's labelling in the exhibition itself' (PS 2009).

new knowledge and new confidence in themselves as learners and social agents.
(Hooper-Greenhill 2000: 139–140)

This includes developing ideas of what knowledge and skills might be learnt *from* the experience of a museum visit beyond finding out about its contents – for example, developing engagement and curiosity or simply becoming inspired by what they see.

HE is also concerned with these forms of learning *about* and learning *from*. But in addition, participants are being inculcated into specific subject areas, each with their own specialist knowledge and communities of practice. It is a central activity of the university or college to produce graduates with a set of useful and relevant capabilities, which they can provide evidence of achieving, for example through essays, presentations and projects. Thus, in learning *about* and learning *from* a museum collection, these participants are also learning *about* at least some aspect of the content, methods and processes of their own particular subject; and learning *from* the experience some aspect of the values and practices of that subject. The former might include for example, the history of ceramics, the contexts in which a particular pot came to be made, the ideas behind the design of an object, and an understanding of various material properties and technological processes. The latter might be about learning to look critically at objects, generating ideas, translating ideas into material forms, prototype testing, making an argument, or giving a seminar. This is complicated further in HE because it is not just about differences in knowing and learning *about* objects but also around what constitutes learning *from* objects. As students progress through a course their studies will increasingly emphasise intellectual skills centred on reflection and abstraction – that is, learning to think *about* and think *from*. University and college students, then, also need to be concerned with how museums frame their resources – with historiography, curation, narrative construction, and exhibition design, for example, as well as gaining understanding of the collections themselves.

For academics and their students this adds another layer – often difficult to articulate clearly – on top of what museums provide for their more general visitors. It also makes HE less amenable to the kind of topic-based and thematic resources (such as around individual displays, special exhibitions or specific collection categories) that can be so effective with schools and with other audiences. There is much less likelihood of a degree of overlap between the learning requirements of a specific subject and the framing of education around specific pedagogic themes. The evidence for this mismatch between museum educators and academics (and between the learning for visitors and for students) has been identified through the CETLD baseline research programme (see Chapter 2). It does suggest a slippage across the two conceptual spaces that can make it difficult to connect, even when willingness is there.[3]

3 This is exacerbated by core differences in culture – academics work individually or in small teams with a lot of autonomy, and with a tendency to just-in-time planning;

Conceptual Spaces 2: Learning Creative Thinking

In art and design subjects in particular, there is a strong belief that creativity includes an ability to think sideways. In this context, there can be a strong impulse to refuse the museum's selection, categorisation, combination of – and narrative about – objects, however open-ended this might be. Instead tutors and students may want to relate objects which initially appear disparate, to encourage the creation of deliberately disruptive relationships, to ask unexpected questions, or to interconnect only fragmentary aspects of different objects' properties and/ or associated data.[4] The objective here is again more about learning *from* rather than learning *about*. At one level, as Laurillard explains, this is a core aspect of university and college education generally, developing a capacity to operate with partial information and changing conditions:

> Practitioners have to make sense of uncertain, unique, or conflicted situations
> of practice through 'reflection-in-action', and they need to be able to go beyond
> the rules – devising new methods of reasoning, strategies of action, and ways of
> framing problems. (Laurillard 2002: 138)

At the same time, this kind of creative, lateral thinking is a central focus of art and design education in particular. Robertson and Bond have examined the different framing of knowledge, research, teaching and learning across various disciplines in HE and differentiate between the transmissive relation in subjects such as chemistry and economics, and those with hybrid, symbiotic or integrated relations (Robertson and Bond 2005).

While the various disciplines overlap categories here (and may, in fact, vary from tutor to tutor/learner to learner), creative subjects such as design clearly fall into the more questioning categories; not just interested in positioning new knowledge in the context of a wider picture, but in seeing things in a different way, in challenging and transforming the existing. It is not surprising therefore, that the CETLD researchers at the V&A found tutors and students in their study to be particularly interested in a behind-the-scenes relationship with the museum (CETLD 2009). This was both about literally being offered what is not available to other visitors and metaphorically about deliberately wanting to learn through non-conventional understandings. Exploring these various framings offers a potentially useful device to draw out some of the difficult-to-articulate beliefs about teaching and learning between museum educators and university tutors.

Requests for this kind of engagement are also made because, for art and design education, objects and spaces are their key reference points – their

whilst museum educators work to much longer time scales, involving major collaborative relationships, often with a variety of partners.

4 In the *iGuides from Streetaccess* project, the most selected tour by students was of this type (see Chapter 5).

Table 4.1 Adapted from Robertson and Bond in Ronald Barnett 2005: 85–86

View by discipline	View of Knowledge	View of Teaching	View of Learning
Transmissive (chemistry, economics)	An understanding of the world we live in; the sum of the pieces; the bigger picture.	Imparting knowledge and enthusiasm; distilling essentials; presenting information clearly; conveying how ideas are developed.	Memorising; acquiring skills; linking new information to current knowledge; positioning new knowledge in the context of the bigger picture.
Hybrid (art history, geography)	Shared system of concepts and beliefs; no longer absolute; can be contested.	Passing on research knowledge and skills modelling; encouraging students to become independent thinkers; induction into process of knowledge creation.	Asking and answering questions; knowing more; understanding; interpreting; seeing something in a different way.
Symbiotic (classics, philosophy)	Understanding; constructed in relationship with others; contested; perspectival.	Working alongside; developing critical thinking and lifelong learning skills; bringing people and ideas together; bridging.	A process of exploration in company of teacher and other learners; generating and 'owning' knowledge.
Integrated (French, history)	A journey; a community construction; an act of engagement with the world; power.	Engaging (with) students in research processes of interpretation; de/constructive critique and inquiry; challenging ways of thinking and seeing the world.	Understanding; engaging with the world; thinking differently; changing as a person; transformation.

books. Learning to make effective and creative use of such resources starts from questioning conventional divisions between landmarks and the everyday, classic and normal objects or high and low culture. The high street or shopping centre can be as important as the museum or gallery. In fact, because this kind of

looking is intimately connected to the experiential, to exploring through physical manipulation and tactility, museums may actually be at a disadvantage, both because (as mentioned elsewhere in this book) artefacts often cannot be touched and because they can feel much more like secondary rather than primary sources, being already encased with an associated interpretation.

In addition – and especially in art and design – a central component of learning emphasises the non-verbal. This is true both in learning to express their interpretations of objects/contexts through drawing/visual presentations, and in undertaking tasks which develop and practise visual and making techniques in order to analyse situations, visualise alternatives, model possibilities and realise creative forms. Hooper-Greenhill suggests that the non-verbal aspect of interpretation is also an issue for museum curators and educators because collections are predominantly visual and material, even where the core element in communication to visitors and learners tends to be textual whether through labelling or other resources (Hooper-Greenhill 2000: 4).

In art and design education drawing is one of the means for developing non-verbal knowledge and skills (see Chapter 2 and Chapter 7). It enables critical looking; that is, it lets you concentrate on, describe and analyse – without the use of words – what is actually going on. Drawing an ancient sculpture, for example, is an experiential and embodied engagement with what the sculptor was trying to do (how they carved, the expressiveness of shaped material, their language of form, etc.) which deepens and enriches verbal/textual information about the sculptor and the work, but which may be difficult to explain. This kind of critical looking is not straightforward, in fact can be counter-intuitive to how a student has learnt drawing at school,[5] and may not be well articulated by art and design academics. It may also be different to the way drawing is often used with school groups (to support description and interpretation for example) or with adults learning to draw, or make their own creative work.[6]

Conceptual Spaces 3: Knowledge, Authority and Inclusion

As with museums, in HE the status of knowledge and the authority of the expert has increasingly been opened up to question (see Chapter 2). Learning is no longer assumed to take place via the simple passing over of knowledge from tutor to student. Just as we are no longer viewed as the passive acceptors of museum labels and curatorial narratives, so we no longer assume that students should passively

5 This borrows from ideas about threshold concepts which argue that learning often involves moving beyond previous 'commonsense' understandings of the world (Meyer and Land 2006).

6 A famous – but still unusual example – of artistic appreciation and practice taught differently is the Ashington Group or 'pitmen painters', a group of UK miners in the 1930s. They worked with artist Robert Lyon at the Workers Educational Association (WEA) to produce paintings as a learning process for viewing the world around them (Feaver 2001).

accept what their teachers tell them. HE is increasingly interested in enabling more open-ended, informal and personalised forms of learning. But as Walker notes, this in turn has had an effect on how academics may view collections-based resources:

> ... tutors have a conflicted stance towards museums, recognising their role as cultural authorities but simultaneously questioning that authority. So the strategies for approaching museums that they impart to their students are geared as much towards developing individual and critical perspectives as promoting them as a source of historical information. (Walker 2008: 9)

So while many museum educators and curators are actually using collections to open up questions of curatorial authority and to offer alternative perspectives, tutors and students may still assume that museum spaces only offer old-fashioned knowledge and will thus be intimidating or dull. Or tutors may deliberately want students to challenge the museum context itself, as a deliberate questioning of even these more open approaches to collections and their meanings to different social groups.

In fact, museums and universities share a similar and problematic location in contemporary debates around knowledge, authority, expertise and inclusion. There have been many challenges to the status of the expert as a superior holder of special knowledge when this is used to exclude others – not just in knowing, but also in the kinds of meanings they might want to make (see Chapter 2). Educators in both sectors are increasingly sensitive to these issues and to how they should affect their practices. Both museums and universities are being asked to widen participation. For museums this is about opening up access to many who have not historically gone to museums and galleries, or to those whose interests and concerns have previously been under-represented in curatorial narratives. Museums are thus actively looking for ways to attract more diverse audiences, and to represent them in collections, for example, by examining aspects of black history[7] or disability.[8] In recent years HE has also become much more diverse, but there is less evidence that this is having such a direct impact on curriculum content. Whilst there are certainly many examples of good practice, the central focus in universities – inculcating a subject discipline into individuals through their successful achievement of a series of tasks set at increasing difficulty levels – does not necessarily involve rethinking the curriculum so as to include the concerns of previously excluded groups. In museums and galleries, partly because of government pressures, the connection between enticing a more diverse mix of people to visit their collections and the content of that collection has been made much more explicitly.

7 For example, October is currently Black History Month in the UK, with events across many museums and galleries. See, for example, the Liverpool Museums (NML 2009).

8 See, for example, University of Leicester Department of Museum Studies *Rethinking Disability Representation* project (UL 2009).

Conceptual Spaces 4: Learning as Inspiration and/or Achievement

Museum education is potentially available to everyone who can access its spaces (whether physically and/or virtually). For many individuals and groups it is a voluntary activity, engaged with in a variety of ways, which may include a self-assessed pleasure in learning. At the same time, museums have developed a variety of measures to evaluate success – also partly under pressure from government to quantify their take-up and effectiveness. This might be by recording engagement, for example, how much time people stay with an object or display, how often they look backwards and forwards, or how long they discuss an object or setting with others. It might be by finding out how much people remember from a particular visit or activity. Through the work of the Museums, Libraries and Archives Council (MLA) and others, some educators are looking at how to apply a learning outcomes model, equivalent to that currently used in HE, based both on Generic Learning Outcomes (GLOs) and Generic Social Outcomes (GSOs) (MLA 2004). GLOs are grouped around five themes, as shown in Illustration 4.1.

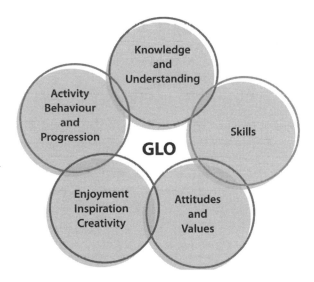

Illustration 4.1 Generic Learning Outcomes, MLA (MLA 2004)

Learning outcomes are statements which define what will be learnt from an activity, and the evidence which shows that learning has taken place. For example, a sample statement, 'being surprised', suggested by the MLA in relation to the generic learning outcome (GLO) 'enjoyment, inspiration and creativity' is evidenced by the following response from a school teacher after a visit:

Almost without exception the children thoroughly enjoyed the day – one particularly hard to please pupil claiming it was the best trip he had ever been on! It inspired some excellent recounts of the day prompting some to write more than ever achieved in class. (RCMG 2003: 16)

The learning outcomes model in HE grew out of a concern that students needed more adequate guidance about what they are expected to learn at different stages of a course, to enable different courses to be directly comparable, to enable transferability of learning units from one institution to another and to produce a process of quality assurance across universities and colleges in the UK. This learning outcomes approach has been much criticised within HE.[9] Currently, though, most university units of study do use learning outcomes to formally assess achievement. The example given here indicates the level of quite specific detail that such outcomes are meant to provide.

Table 4.2 **Learning outcomes and assessment criteria for MA Module *Issues and Debates in Inclusive Arts Practice*, University of Brighton 08–09**

Learning Outcome	Assessment Criteria
Have developed a wider theoretical, social and ethical engagement with some aspect of issues and debates in Inclusive Arts Practice.	Demonstration of engagement with current issues and debates in Inclusive Arts Practice. Evidence of ability to have critical, creative and constructive dialogues with peers and tutors. Evidence of critical understanding, academic rigour and awareness of broader theoretical, political, social and personal contexts. Evidence of ability to communicate ideas and to make persuasive arguments, both independently and in collaboration with others.

In addition, students are assessed in relation to levels from failure to high pass. Here, more generic assessment criteria are often used, based on evidence of the quality and sophistication of thinking, outcomes and outputs.

9 See, for example, arguments which suggest that learning is not appropriately captured through learning outcomes, because it is a repetitive and iterative process, not a series of structured steps (Meyer and Land 2006).

For education, these kind of mechanisms for highly granulated and differentiated statements of individual achievement are central, even if many academics would rather not have them. Museums, not surprisingly, are less focused on achievement than on much more open-ended concepts such as awareness and inspiration:

> We are privileged to have a wealth of culture, freely available, at museums
> and galleries throughout the country. Learners of all ages have the opportunity
> to take inspiration from some of the finest collections and museum education
> services in the world. (Anderson 2009: unpaginated)

This raises many difficult but interesting questions. What are the intended aims and outcomes of enabling inspiration? How can we be sure that a visitor or learner has been inspired? Is the idea of inspiration as learning of value to universities and colleges? Are there aspects of inspiring visitors or learners which can be formally taught and assessed? And how does this emphasis affect our ideas on what constitutes learning, and how – and whether – this should or can be assessed and evaluated? Why indeed is measurement in this context appropriate or essential?

Considering the Implications

As noted at the beginning of this chapter (and elsewhere in this book), museum and university collaborations still tend to develop from individual enthusiasts taking opportunistic advantage of particular situations and mainly engaging through the use of supplementary materials, rather than HE embedded or mainstreamed resources. At the same time, museums and universities share a considerable amount, such as a central concern with the importance of culture and education, the supply of high quality resources and services and a passion for their subjects. I have suggested that it is only by carefully unravelling the different 'conceptual spaces' of museum educators and HE academics that we can begin to see how the subtly different ways in which each operates tend to result in gaps, mismatches and collaborative difficulties.

Here, I want to propose three potential ways for building on and extending the good work that has already been done, independently and together. First, we can open up new discursive spaces where educators from both sectors can engage in constructive and creative debate – not aiming at consensus but valuing differences so as to fully explore the complexities of learning. Second, we can re-view institutional divides, so as to shift boundaries and remove the obstacles that conventionally separate the knowledge and experiences of museum and HE educators. Third, we can act together in building a strong community of practice around the shared contemporary concerns over the status of authority, knowledge and inclusion.

Bridging Perspectives

The most immediate problem is the slipperiness of common terminology around learning. Just as even the concept of the learner can be simplistically applied, so can the linking through analogy of associated terms which can lead to problematic assumptions, especially when used by practitioners from different disciplines. So, for example, formal and informal learning can be defined (see Chapter 3) but boundaries are easily blurred. It is simple, for example, to slip into treating informal learning as implying self-directed and unstructured, with formal learning becoming the opposite. Yet, we can learn informally through highly organised sequences of activities and undertake formal education through self-directed study. To add even more complexity, we may be most likely to develop competencies as self-directed and unstructured learners if we begin with a tutor-led approach and carefully orchestrated, highly structured activities.

The slipperiness of language is exacerbated by the tendency of museum and university educators to stay within their own disciplinary boundaries, each with their own histories, beliefs, assumptions and references. This means that rather than exploring the interesting complexities where the disciplines meet, dialogue is instead often mediated through limited (and often differently understood) terms. Here I have begun to suggest some other ways of framing key issues. What are the pedagogic implications for both sectors in supporting learning *about* and learning *from* via collection-based and university-based spaces? What is the relevance of, and what are effective methods for, learning creative thinking in different contexts? How can we constructively explore contemporary tensions in what constitutes knowledge, authority and difference; and learn lessons for both museum and university education? What are the differences in understanding learning as inspiration and/or achievement; how open-ended could learning be in HE (including the valuing of 'failure'), and how might museums develop more formal ways of assessing achievement for some of their audiences? Ultimately, how do we judge what counts as success for both teachers and learners? These are all questions that both museums and HE share an interest in; what we lack are contexts and networks in which such things can be debated constructively and creatively, so as to make a real difference to learning in both sectors.

For museum educators this also suggests that to impact more effectively on the HE curriculum, they need to think explicitly about how HE, researchers, practitioners and students are *not* merely an extension of their other audiences, with needs and interests which can simply be added on to existing services. Both the higher order knowledge and competencies central to university study and the unforgiving structures of a formal curriculum and yearly timetable require a different perspective, which engages with different views of knowledge, learning and teaching. Here I have already outlined some of the central competencies of art and design education at university level, for example, learning to look, looking to learn, learning to see, lateral thinking, creative re-combining and developing innovative strategies. To art and design tutors, this behind-the-scenes or sideways

approach to artworks, artefacts and spaces is central to the activity of creative thought and action; and has potentially a more liberating and general applicability to wider audiences. This is especially in a context where government initiatives see creativity as an important skill in all sorts of activities (HCESC 2007; AC 2009). Incorporating these issues requires explicit debate across both sectors and perhaps shifts in direction from museum and university educators. For museums, the orchestration of content and associated activities around coherent themes or topics is so embedded in how they view their role that to request instead a deliberate disruption can seem irrelevant, trivial or difficult. From the art and design academic's point of view, the value of making unexpected, lateral connections may appear so obvious that they can fail to see that it is a skill which has to be learnt, rather than one that can be just picked up by doing. Thus, what might (at least initially) need to be a quite structured set of tasks to build confidence and understanding may instead be unstructured and confusing. Working with museum educators, who have different assumptions about structuring learning activities, is a potentially valuable way of working out how to teach these creative skills effectively.

In addition, for university educators, understanding museum approaches to learning offers opportunities to take a more open view as to what constitutes achievement; and the potential of broadening concepts beyond the specific learning outcomes model, to more generic notions such as inspiration, surprise and pleasure. And museum approaches can also inform the development of a more inclusive pedagogy in HE. Museums have had to (as well as wanted to) engage very directly with the concerns of diverse audiences over recent years. Curating and designing the 3D textbooks of displays and exhibitions, they have become increasingly sensitive to engaging with multiple perspectives and to understanding how people bring their own interpretative strategies and repertoires to learning (Hooper-Greenhill 2000: 19).

Finally, to bridge perspectives, we need more research on the 'conceptual spaces' outlined here around learning in museums and universities, so as to understand better how to expand productive working together. And we need ways of training up more practitioners from both sectors who can collaborate creatively and productively across these different environments. We have already seen how government initiatives and funding for the museums and galleries sector have had a considerable impact on learning for more diverse audiences and in supporting schools. Similar initiatives are needed to support shared knowledge and cross-fertilisation between museum and university educational providers.

Beyond Institutional Divides

Building better connections between museums and universities is not just about enabling more collaboration on individual units of study. HE needs to think about how to develop more explicit, creative and sustained relationships with

institutions beyond the campus. Museums and galleries are already well advanced in making these linkages, particularly with schools and the wider community. In art and design education, in particular, learning already takes place in a multitude of different ways, such as project-based work in the community, study visits, office adoption and work placement schemes. There are also numerous examples of partnerships between universities and other cultural organisations and/or employers where traditional boundaries as to where education should take place have been deliberately blurred and re-cast.[10] But we still have little research on what relationships are possible, or on their effectiveness. In addition, this is not just about where learning takes place (literally outside the lecture theatre, classroom or studio) but also about types of learning enabled by these alternative situations. Rather than merely transferring what happens on campus to off-campus locations, museums offer the opportunity for tutors to envision other sorts of learning through collections, spaces, audiences, curators and educators.

At one level this is about supporting the bridging of perspectives as described above. At another, it relates to wider concerns with building social and civic links into educational processes; and with issues such as widening participation, employer and community engagement, social inclusion and health and well-being. As already mentioned, both HE and the museums sector have been asked to engage with access and widening participation; and a considerable amount of current educational theory is exploring models of interactive and socially engaged learning. Collaborating with museums and other cultural agencies can offer universities a powerful means in support of developing a curriculum that can 'play a major role in shaping a democratic, civilised and inclusive society' (Dearing 1997: 72).

In order for this to happen, academics (and their students) may need to explicitly reflect on their own preconceptions or anxieties about museums as bastions of establishment authority. Instead, working with curators, educators and their collections could help open up multiple perspectives on objects and their broader contexts to debate and reflection. Many museums are already concerned explicitly with their potential for affecting cultural life more generally:

> Subjectivity, meaning, knowledge, truth and history are the materials of cultural politics. Museums are deeply involved in these areas, and especially in their inter-relationships with power; the power to name, to represent common sense, to create official versions, to represent the social world, and to represent the past ... [we need to) think more deeply about the character and possibilities of museums for use in a more democratic society ... the reinvigoration of those practices which are useful, the rejection of those which are found to be discriminatory, and the development of new processes where gaps are to be found. (Hooper-Greenhill 2000: 19-21)

 10 See, for example, White Space (University of Abertay), which brings together work places, 'start-up' units, ideas development, commercial facilities and higher educational provision (UA 2009).

This could offer ways to creatively explore knowledge as a contested zone, both at the level of academic argument and of personal interpretation and meaning-making. In addition, bringing museum educators and art and design education into a new community of practice, beyond their traditional disciplinary divides, offers many possibilities for teaching and learning; as a shared domain, identity and competence where people can learn from each other; as a community where members engage in joint activities and discussions, help each other and share information; and as a collaborative *practice* together developing a shared repertoire of resources – experiences, stories, tools and ways of addressing recurrent problems (Lave and Wenger 1998; Wenger 2009).

Revisiting the institutional divide in this way through the concept of communities of practice also offers considerable potential for museums and/or museum-university partnerships to rethink how they offer services. New types of short courses/modules could bring together adult audiences interested in a subject, with students studying on a defined course and even academics undertaking staff development and practitioners engaging in Continuing Professional Development (CPD) within the same cohort, to share knowledge and experiences. As adult education remains seriously underfunded in the UK, there are potentially gaps in provision (both face-to-face and online) which might benefit from such a collaboration; especially if the funding complications that tend to be caused when attempting to integrate accredited with non-accredited provision can be overcome.[11]

Debating the Status of Authority, Knowledge and Difference

In addition, such explorations enable key contemporary issues about what constitutes authority and knowledge to be opened up and moved forward. For, as Walker summarises:

> Museums have always had problems with learner-constructed theories of learning because of their political role as perceived cultural authorities. To accord visitors the power to construct their own meanings is to undermine curatorial authority. In so doing according to Meszaros (2006), a museum absolves itself from interpretative responsibility for the meanings it produces and circulates in the culture. If this is taken to its logical conclusion, according to Fritsch (2007) then surely there is no museum knowledge except that which the visitor constructs in his or her head'. (Walker 2008: 34)

11 Examples of this kind of adult education in the UK, which mix formal and informal modes, are Birkbeck College University of London, the Open University, University of the Third Age, the Mary Ward Centre and the Workers Educational Association.

This is also a central problem for HE. Much current debate within contemporary education (particularly with the popular shift to Web 2.0 and social networking) emphasises the centrality of the learner view through personalised, peer and open learning; with an underlying assumption that we are in the process of an obvious and necessary shift from tutor-led to learner-generated content and contexts. Unfortunately this has had some, probably unintended, consequences, especially where those who focus on a shift away from experts to their audiences can all too easily perceive their position as both self-evident and radical. First, the debate can become artificially polarised and closed-down; between formal, passive transmission (equals bad) and informal, interactive and personalised learning (equals good), rather than as a means to open up to consideration the many variations inbetween, responsive to different contexts, learning situations and levels. Second, it tends to juxtapose personal meaning-making and interpretation (good) against top-down authority (bad), rather than seeing knowledge as something which is simultaneously shared, negotiated and contested through generations and across individuals and groups. Third, it can undervalue the importance of deep learning – of learning as something which requires dedication, commitment and long-term work rather than offering immediate satisfaction.

Finally, it tends to downgrade or avoid issues of what constitutes achievement and how and where it might be measured. Instead, assessment is all too often conflated with the problematic power of the expert and avoids aspects of learning which include the passing on of knowledge and skills from those who have learnt to those who are learning (and so ignores the making of judgements about what has been effective both by the teacher and for the learner).

In this context, we need to better understand the 'conceptual spaces' not just of learners but also of educational theorists; so as to better theorise relationships between those who have learnt and those who are learning (including the complexity of being positioned simultaneously as a 'have learnt' and a 'learner').[12] Instead of simplistic divisions between expert and novice, we need to explore how communities of practice not only pass on but also individually and together challenge, adapt, contest and shift the identity, knowledge and competencies that they share. Working across museum and HE offers an invaluable opportunity to build and critically examine a shared community of practice which nonetheless contains diverse participants and motivations for learning. This has the potential to have a much wider impact than just individual curricula. In its concerns with knowledge, authority and inclusion, it has the potential to affect government policies, educational strategies and even our understanding of what learning is.

12 Lave and Wenger call these different relationships and locations within a community of practice 'old-timers' and 'newcomers' and emphasise the importance of – and tensions in – learning as a process where old-timers will, in their turn be replaced by previous newcomers (Lave and Wenger 1991).

Bibliography

AC (2009) Creative Partnerships *The Arts Council*. Retrieved 30 April 2009, from <http://www.creative-partnerships.com>

Anderson, D. (2009) Online Art Can Tackle Lack of Aspiration. *Guardian*, 31 January 2009.

CETLD (2009) Centre of Excellence in Teaching and Learning through Design. Retrieved 29 April 2009, from <http://cetld.brighton.ac.uk/projects/current-projects/behind_the_scenes>

Dearing, R. (1997) *Higher Education in the Learning Society/The National Committee of Inquiry into Higher Education*. London, HMSO.

Exploratorium (2009) The museum of science, art and human perception at the Palace of Fine Arts. Retrieved 29 April 2009, from <http://www.exploratorium.edu/>

Feaver, W. (2001) *Pitmen Painters: Ashington Group, 1934–84*. Manchester, Carcanet Press.

HCESC (2007) House of Commons Education and Skills Committee: Creative Partnerships and the Curriculum. Retrieved 29 April 2009, from <http://www.publications.parliament.uk/pa/cm200607/cmselect/cmeduski/1034/1034.pdf>

Hooper-Greenhill, E. (2000) *Museums and the Interpretation of Visual Culture*. London, Routledge.

IWM (2009) Imperial War Museum. Retrieved 29 April 2009, from <http://www.iwm.org.uk/>

Laurillard, D. (2002) *Rethinking University Teaching: A Framework for the Effective Use of Learning Technologies*. Abingdon, Routledge Falmer.

Lave, J. and Wenger, E. (1991) *Situated Learning: Legitimate Peripheral Participation*. Cambridge, Cambridge University Press.

Lave, J. and Wenger, E. (1998) *Communities of Practice: Learning, Meaning and Identity*. Cambridge, Cambridge University Press.

Meyer, J.H. and Land, R. (2006) *Overcoming Barriers to Student Understanding: Threshold Concepts and Troublesome Knowledge*. London, Routledge.

MLA (2004) Inspiring Learning for All. Retrieved 29 April 2009, from <http://www.inspiringlearningforall.gov.uk/>

NEMO (2009) NEMO Science Centre. Retrieved 29 April 2009, from <http://www.e-nemo.nl/cn/>

NML (2009) International Slavery Museum. National Museums Liverpool. Retrieved 29 April 2009, from <http://www.liverpoolmuseums.org.uk/ism/bhm/>

PS (2009) Palazzo Strozzi. Retrieved 29 April 2009, from <http://www.palazzostrozzi.org/Sezione.jsp?idSezione=178>

RCMG (2003) *Measuring the Outcomes and Impact of Learning in Museums, Archives and Libraries: The Learning Impact Research Project*. Research Centre for Museums and Galleries. Retrieved 11 May 2009, from <https://lra.le.ac.uk/handle/2381/65>

Robertson, J. and Bond, C. (2005) Being in University. In Barnett, R. (Ed.) *Reshaping the University: New Relationships between Research, Scholarship and Teaching*. Maidenhead, Open University Press.

UA (2007) White Space. University of Abertay. Retrieved 30 April 2009, from <http://www.abertay.ac.uk/About/WhiteSpace.cfm>

UL (2009) Rethinking Disability Representation. University of Leicester. Retrieved 30 April 2009, from <http://www.le.ac.uk/ms/research/pub1129.html>

Vergo, P. (Ed.) (1989) *The New Museology*. London, Reaktion.

Walker, K. (2008) StreetAccess 'iGuides' Summative Evaluation. Retrieved 5 May 2009, from <http://cetld.brighton.ac.uk/projects/current-projects/iGuides/iguides-evaluation/iguides-summative-evaluation-report>

Wenger, E. (2009) Etienne Wenger. Retrieved 30 April 2009, from <http://www.ewenger.com/>

Chapter 5

Learning Paths: Museum-Based Learning Materials for Design Students

Rebecca Reynolds

Most museums do not have targeted learning materials for higher education (HE) students which engage with HE curricula in the way that they may well have for schools, for example in the form of teachers' packs (Anderson 1997). There may be doubt about the usefulness of such materials to students, or about how an HE audience might differ from adult learners. When in the museum, students also have different research strategies at different times and at different stages of their course, such as browsing and building up a 'treasury of ideas' (Fisher 2007: 22) or doing focused research for dissertations. This means that at certain times they will want to use areas of the collections directly relevant to current projects, rather than using generic learning materials.

Aim of this Chapter

This chapter will discuss a project at the V&A Museum which designed and evaluated resources for HE design students, accessed through mobile learning technology. These were designed for students to use in the galleries. As well as developing resources, the project produced research findings about design students' and tutors' needs in the museum, responses to the learning materials, and attitudes towards mobile learning technology. Students' responses to the materials are outlined. Findings from the project which have wider relevance include an outline of appropriate learning objectives for HE design students in museums, approaches to designing museum-based materials for an HE audience, and our experiences of using wireless-enabled PDAs as tools for accessing learning materials in the museum.

The Project

The project developed 20 web-based museum trails for design students, designed to be accessed on personal digital assistants (PDAs) inside the galleries. These used StreetAccess software and were held on the StreetAccess website (StreetAccess 2009). The trails could hold resources in the form of text,

audio, images and video and students could input content such as thoughts and responses in the form of text, images and voice recordings. The student could access the resulting 'personalised trail' on the web after the visit. This software had been used successfully with school students at Dulwich Picture Gallery (Beazley 2007) with text and images only. As part of the project, technology to enable wireless streaming was installed in nine V&A galleries and the V&A shop. My role in the project was to design and develop the trails, and manage the project. Evaluation of the project was in three stages: front end evaluation aimed to establish whether there were needs which might be met by the trails, and if so what they were; formative evaluation trialled the materials with students; and summative evaluation evaluated the success of the project as a whole. Front end and formative evaluation was carried out by CETLD Research Fellows Catherine Speight and Beth Cook; summative evaluation by Kevin Walker of London's Institute of Education. I also did independent research early on in the project which investigated the impact of one trail on students' learning in the museum.

My focus here is on the content of the materials rather than the technology used to access them, since this was the aspect of the project of most interest and relevance in an HE context. One of the key findings of this project was also that any resources should be adaptable to different media and tools, due to the rapidly changing nature of new technologies.

Students and Tutors' Needs in the Museum

Possible learning objectives for the trails were identified through informal conversations with tutors, the front end evaluation, experience of project staff, and QAA (Quality Assurance Agency for Higher Education) benchmark statements for art and design students. The QAA benchmarks offer guidelines for curriculum development, while aiming to be broad enough to allow 'flexibility and innovation in programme design' (QAA 2008).

For the front-end research, ten design tutors were interviewed to find out about the place of the museum in design students' education. From this, motivations for design students' visiting the museum were established and learning objectives clarified (see Illustration 5.1).

These reasons complement guidance in the QAA benchmarks. For example, the benchmark statements say undergraduates' work must be informed by 'an understanding of the context of this practice', since knowledge of how one's own work relates to that of others is 'the cornerstone of originality and personal expression' (QAA 2008: 11). This is close to the learning objectives in the diagram below – 'to gain contextual information about making' and 'locate their [design students'] practice within a wider context'.

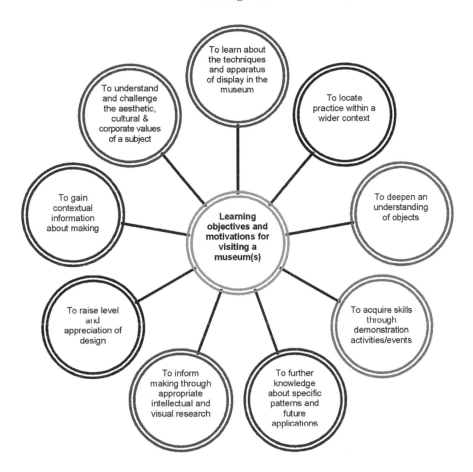

Illustration 5.1 Motivations and learning objectives for design students visiting museums (Speight, 2007)

Museum Learning and Design Students' Needs

One topic of debate in pedagogy is around the depth of learning that occurs in museums. If the museum is seen primarily as an arena for informal learning then this affects our perceptions of the depth of learning which happens there. For example, it is speculated that most learning in museums is likely to be 'rather unfocussed: leisure-learning, a stirring of interest' (Hooper-Greenhill 1999: 24), or teaching what is already almost known (Falk and Dierking 2000).

Whether and how visitors can progress from an initial engagement with objects on display to deeper knowledge is debated. For example Csikszentmihalyi and Hermanson recommend that museums use an initial 'hook' to arouse visitors. The hook should be followed by opportunities for sensory, intellectual

and emotional involvement, and then by challenges matched to the audience's skills, which give opportunities for 'the kind of deep absorption that leads to learning' (Csikszentmihalyi and Hermanson 1999: 156). Hein also looks at ways of converting visitors' enthusiasm into 'connected, engaging, integrated activities that lead to growth' (Hein 1998: 3). It would not be feasible for museums to try to provide interpretation in support of these aims for all their various audiences as part of their displays. Mobile technology is one solution to the need to provide interpretation tailored to different audiences.

If we look back at the diagram of learning objectives, those such as 'raise the level of appreciation of design' and 'inform making through appropriate intellectual and visual research' imply, I would suggest, a need for greater depth of engagement than might be understood if the museum is taken primarily as a site for informal or leisure learning. To give a further example, here is a design tutor describing how drawing helps students' appreciation of objects:

> ... so it's not just about recognising something: 'Oh yes, that is a bust', or 'Oh yes, that is a chair' – that's an extremely limited part of visual perception. What we really want to do is slow down our engagement, allow the rhythms or content or nuances of something to actually enter our consciousness (Chris Rose, personal communication, 31 October 2007)

Similarly, in an article on multimedia design for undergraduate art history students Tim Benton, Professor of Art History at the Open University, notes: 'Most teachers will recognise the value of any exercises which encourage students to engage with artefacts beyond the initial identification, recognition, and pigeon-holing which constitutes everyday looking' (Benton 1996: 208). One question examined by the two-year long project discussed in this chapter was whether learning materials on PDAs could contribute to deeper engagement such as this in the museum environment.

A related point is that the primacy of individual choice is often emphasised in museum learning theory; the visitor should be free to follow their own path (Falk and Dierking 2000), which may be unpredictable (Hooper-Greenhill 1999). However, as Brookfield points out, successful self-directed learners are not those who are most independent of guidance (Brookfield 1986). One conceptualisation of such guidance is as 'scaffolding'. This term was first used by Bruner in the 1950s to describe children's acquisition of language. It has since become a common word for a conceptual framework offered to learners to help them to acquire knowledge. This can take many forms – for example, questions for students to respond to, mini-tasks which prepare students for larger tasks and so on. Such guidance has been shown to be important and effective in HE learning (Laurillard 2002; Brabazon 2008) and it would be wise to consider using it in the museum for HE students.

One theorisation of such scaffolding is Diana Laurillard's 'conversational framework', which she developed as a description of 'the minimal requirements for supporting learning in formal education' (Laurillard 2007: 161). The framework

Illustration 5.2 The conversational framework for supporting the informal learning process

Note: Processes referred to by numbers 1, 2, 3, 4, 11 and 12 are missing from this diagram since they are part of the conversational framework for formal learning. (Laurillard 2007: 171)

takes interaction between student, teacher and other learners as offering the entire range of activities that together facilitate effective learning, such as the teacher stating a concept, the student asking questions or making comments, reformulating their concept, testing it against the concepts of other learners and so on. She recommends this model as a way of assessing the capacities of new technologies to support learning at HE level in effective ways.

A diagram of the conversational framework for informal learning – i.e. without the teacher present – is shown in Illustration 5.2. Most technologies will only cover part of the diagram. The part that iGuides covers is the bottom left section of the diagram. The trails can offer the learner a goal (function 5), and the learner can act in pursuit of that, for example by responding to comments about particular objects in the museum in the light of comments they have read or listened to on the PDA (function 7). The materials cannot give individual feedback, of course, although some of them include comments against which students can compare their responses (function 8, to a limited extent). The learner may revise their responses in light of these comments and revisit their work afterwards (function 9). The technology has no facility for enabling interaction between learners. Of

course, the technology could be supplemented so that other parts of the framework are covered, for example by setting up discussions between learners in other ways, or providing a web-based forum for pooling responses.

Laurillard's comment on the framework is a good description of the advantages of such scaffolding:

> The [conversational framework] takes us beyond the typical endorsement of a technology resource, the 'you can …' approach to design [of digital learning resources] which offers the user a wide range of options and opportunities. Instead, it proposes the 'try this …' approach, which provides a default pathway through the environment, engaging the student explicitly in tasks that elicit the kind of cognitive activity it takes to learn that idea, concept or skill. In the former approach, the student 'can' engage with difficult ideas in a variety of ways, but may not. Without guidance and motivation they may choose to take a cognitively easier pathway, thereby failing to engage properly with complex or difficult ideas … it is not sufficient for the teacher just to 'tell' the story of their subject in book or lecture. (Laurillard 2007: 168)

A 'you can' approach as described above – i.e. offering the user a range of options – is common in gallery-based interpretation such as audioguides or gallery interactives. Some of the materials in this project aimed to move a little nearer to offering the 'default pathway' Laurillard describes above, for example in encouraging students to engage with ideas about decontextualisation of objects or to vote in a debate on the relative merits of pairs of objects. More detail is given below.

Materials Design

I will now outline some of the considerations informing the development of materials for the iGuides project, look in detail at some examples of materials design and show how they try to respond to some of the requirements and challenges outlined so far.

Trails were divided into four groups according to the type of content. These were:

1. One person's perspective on a gallery or selection of objects. This could be seen as an 'alternative curation', using actual resources in the galleries and virtual resources on the PDA. One example is *A Potter's Eye* in which ceramicist Alison Britton chooses various objects in the Jameel Gallery of Islamic Art and, using images of her own pieces on the PDA, shows how these interact with her own practice.
2. Multiple perspectives on the galleries or collections. An example is *A Taste of Plaster*, based in the V&A's Cast Courts, in which comments from a senior lecturer in 3D design at Brighton University are put side by side with

comments from sculpture curators. (Chapter 10 develops this idea into a conversation between a design tutor and a curator).

3. Strategies for looking, without a focus on particular objects. For example, *Shopping for Ideas* which compares the identity of objects in the Jameel Gallery and the shop and compares the roles of buyers and curators.

4. Trails which take you from object to object and give extra information. For example, *Fighting for Design* which gives context to some twentieth century designs connected with war or revolution.

In addition there was a trail called *Soulus,* designed by Royal College of Art tutor Brendan Walker, which invited students to experiment with various states of mind such as embarrassment and anticipation through activities such as playing a video on the PDA and displaying it to other visitors. There was also a practice trail for students to use to become familiar with the PDAs.

Some trails encouraged imaginative leaps, others focused on historical context and others juxtaposed different perspectives. Most of the trails aimed to do more than supply information about the collections. This was partly because different parts of the collection would be relevant to different students, and partly because the materials needed to encourage the development of generic visual research skills. They therefore aimed to encourage learning outcomes such as reflecting on the way one learns in the museum; comparing different ways in which other people interpret objects and situating one's own response in this context; and considering the way the museum environment affects one's understanding of objects there. They thus aimed at the 'classic pedagogic function of transferring guided experience into transferable skills' (Benton 1996: 210) and to suggest 'lines of enquiry' (Benton 1996: 211).

One example of attempting to encourage a 'line of enquiry' is *Inside the Cast Courts*, a trail set in the V&A's Cast Courts, which hold plaster casts of sculpture and architectural detailing from churches and other buildings in Europe. This trail encourages students to spend time exploring the room and to record their first impression of the Courts. They can read or listen to a summary of other people's initial responses to the space, and compare their own. They can also access information about the Courts' formation. They are then asked to imagine the objects in their original setting and to consider a comment from philosopher John Dewey that decontextualising fine art in museums distracts from their significance: 'When an art product once attains classic status, it somehow becomes isolated from the human conditions under which it was brought into being and from the human consequences it engenders in actual life experience' (Dewey 1934: 8).

This is contrasted with the opinion of Chris Rose, a 3D Design tutor, who suggests that if objects are seen away from their functional setting we are likely to study them more closely. It then includes comments from Chris Rose on various objects in the Courts, and finally asks the user to reflect on the comments and on which they found most useful. The student can input their own thoughts at any stage in the trail.

The trail attempts to 'scaffold' the user's response beginning with first impressions, leading to a consideration of alternative views on the way objects are presented; followed by an insight into someone else's understanding of the objects; and finally a reflection of which insights they found most interesting. The inclusion of multiple, sometimes conflicting, viewpoints is intended to open up a space for the student's own response by making the experience more like a discussion than a presentation of an authoritative view. For example, it contains both a criticism and an affirmation of decontextualisation of objects in the museum. At the same time, the trail offers a more directed experience than students might usually expect in a museum.

Other trails contain differing perspectives on objects or galleries, encouraging students to consider whose perspectives they found most interesting and situate their own in response. An example of this is *Stripping the Galleries*, which contains comments on the V&A Cast Courts and Islamic Middle East Gallery, also known as the Jameel Gallery, from University of Brighton architecture tutor Jos Boys and V&A and RIBA Architecture Education Officer Catherine Duncumb. Students are asked to consider the different emphases of the speakers – for example, who was most interested in the architectural history and structure of the building, who was more interested in other people's responses and so on. They are then invited to explore other galleries and to think about the way they respond to these.

For example, Catherine Duncumb describes her response to the Jameel Gallery:

> Unlike walking into the Cast Court, where my first impression was 'wow', I think my first impression after walking into the Jameel Gallery, after a feeling of reverence, is an intellectual response.
>
> The objects are precious, they're gorgeous, they're like jewels, rich with detail and invested with culture and context and geography and power so it's ... rather than a physical response, I think I'm having, definitely more intellectual, so I seek information perhaps in a different way, to understand them ... and the information is there, so quite quickly I can learn about what I'm looking at.

Jos Boys comments on the layout of the same gallery:

> ... this is where I get into difficulties personally. To me, the new exhibition elements such as the display cases are not so successful in 'standing back' from the objects they are meant to display. They somehow get in the way.
>
> Perhaps because I trained as an architect, I see the different boxes and their relationships not their contents. I have trouble focusing on the decorative arts I am meant to be looking at.

... I feel a bit old-fashioned arguing for museums how they used to be; for gallery spaces at the V&A to feel accidental and jumbled up, perhaps allowing for more personal interpretations.

In response to these comments, students could, for example, think about their responses to the galleries and compare them with Catherine Duncumb's description of her 'intellectual' response here. They could also consider the relationship between the display techniques and the objects, or how the museum's interpretation stimulates or interferes with a personal response. Both speakers analyse their responses metacritically, and the students are encouraged to decide whose approach they prefer, and to explore further galleries, thinking about the different ways they respond.

A more structured use of multiple perspectives is in a trail called *Design Debate*. Here two Product Design MA graduates, Simone Brewster and Henny van Nistelrooy, choose three objects from the V&A's British Galleries, pairing each one with a modern object for design-related reasons. For example, the Melville Bed, made in about 1700 as a luxury item to accommodate the monarch, is compared with Joe Columbo's Cabriolet bed from 1969, which was designed as a technologically-enhanced micro-environment which could function as a complete living space. The graduates give reasons for making the comparison, then each graduate says which one they prefer, supporting their reasons with references to design history and theory. The user is then asked which they prefer. This exercise was suggested by the graduates themselves, perhaps a version of one they had used during their course. As well as being something which can be used on PDAs inside the museum, it aims to offer a generic task which is easily adaptable to other objects, both inside and outside the museum.

Including input from tutors, students and so on was one way of providing a bridge between the university and the museum. It aimed to encourage a conception of the museum as a learning environment connected to that of the university, rather than a separate environment in which their usual object-based learning skills would not apply.

Multiple perspectives are also recommended by Csikszentmihalyi and Hermanson, who comment that a 'fixed presentation of the material in museums' (Csikszentmihalyi and Hermanson 1999: 155) thwarts further exploration of it. One aim of the use of these multiple perspectives is to encourage an extended engagement by 'unfixing' museum displays through differing interpretations. This approach tries to encourage an extended interaction with the museum and the collections and encourage what Langer termed *mindfulness*: 'the state of mind that results from drawing novel distinctions, examining information from new perspectives, and being sensitive to context' (Csikszentmihalyi and Hermanson 1999: 155).

It is important that these perspectives include curatorial museum-based and collections-based expertise since HE design students, as researchers, need access to the object-based scholarship which a museum provides. In addition, including a mix

of perspectives may help students to identify the museum's type of expertise and compare it with the type offered by the university, and perhaps clarify the museum's particular role in their studies. Including multiple perspectives in this way was a response to the students' need to challenge authority as well as the need for the authoritative scholarship provided by the museum. As Fisher says: 'The V&A will be criticised for trying to have the last word ... It would do better to use its authority to create an arena for different perspectives and debate' (Fisher 2007: 21).

During the project the word 'trail' was found to be inadequate. This was because many of the trails did not travel from object to object – for example, some were about whole galleries or did not include objects. In addition, some students did not like the word 'trail', associating it with children's activities.

Evaluation

Formative evaluation was carried out to gauge students' responses to the trails and to inform further materials development. For the first stage of formative evaluation, 16 students took two trails, one in the Cast Courts and one in the Fashion Gallery. They took them once on paper to evaluate trail content, followed by the same trails on a PDA to evaluate the functionality of the devices. Students were accompanied in the galleries and asked questions to prompt responses about their experience, then were interviewed afterwards. For the second stage of formative evaluation, 36 design students chose from a menu of eight trails, took one on a PDA, and were interviewed afterwards. The students in this second stage took an introductory trail introducing them to the PDA functions and the way the trails worked (for example, how to access audio and upload photographs and voice recordings).

Student responses reported below were elicited as part of qualitative data and were therefore not quantified statistically. The student's year of study is included here if recorded in the analysis (it was recorded for the first stage, since one of the aims of this stage was to see if students in different years responded differently, but this was not an aim of the second stage). Independent evaluation consisted of accompanied visits and interviews with 20 students, and this is also quoted from once. The evaluation did not examine any possible consultation of the trails by students on the web after the visit.

A summative report produced at the end of the project brought together and analysed findings from the previous evaluations.

Content

Trail content received a broadly positive response from students. Trails successfully offered different ways of looking at, thinking about, and linking together objects. For example:

- 'It's nice to hear an in-depth description of what someone feels about the object. I would say it prompts you to describe in your own mind how it looks and what it feels like' (second year student).
- 'The combination of Chris Rose's opinions and the historical information certainly made me think how I interpreted the objects' (third year student).
- 'You're making it more interactive instead of blankly looking at something and you're not really sure what you're supposed to be gaining, but you're kind of kick-starting some ideas about what they should be gaining like the design processes, the technical processes ...' (second year student, independent research).

These comments show that the different perspectives encouraged these students to make their own interpretations of the galleries, rather than accepting others' at face value, 'kick-starting', in the words of the last student, being an evocative term for this. This coincides with findings from a trial of mobile learning devices at the Uffizi Gallery in Florence. This found that participants who were better informed about art used the content on the devices as 'the beginning of a conversation or argument about the pictures' (Sharples, Taylor, et al. 2007: 238) taking the gallery interpretation as a starting point for their own thoughts.

Individual students differed in their preferences for viewpoints; with the two postgraduates responding well to comments from other students but less well to comments from sources with more authority: 'I don't mind hearing students just flowing their conversation ... whereas if someone's held up as this person knows about ... like a design tutor or someone who's a design historian then I don't really want to hear them' (postgraduate student).

In contrast, other students welcomed this: 'an educated opinion which informs ... especially with students, we have this kind of inherent trust in our tutors ... I think it makes us listen to what they're saying a bit more' (second year student).

As well as prompting students' own responses and setting curatorial insights in the context of other interpretations, multiple perspectives can therefore be one way of appealing to different people.

Trails also worked as a way of navigating and becoming 'acclimatised' to the galleries. For example:

- 'I found the gallery overwhelming but the trail brought me closer to the objects' (student).
- 'It de-formalises [the space of the gallery]. You don't feel as intimidated; you can explore on your own level and make up your own kind of stories' (third year student).

Trails also stimulated a desire to find out more, and students asked many questions about the collections after taking the trails: 'what was the original source ... why were they brought into the museum maybe ... why these are in the same place? Is

it because they were made at the same time, the same place or because they look good together?' (student).

On the one hand this shows that the trails did not meet all the students' needs for information. On the other hand, students' appetite to know more was stimulated. Good practice here is to indicate further sources of information at the end of the trail, such as archives, study rooms and further galleries.

Some aspects of the content which students were most equivocal about were framing questions and direct invitations to respond in certain ways. Some students appreciated these; however, other students found questions patronising or intrusive, for example:

- 'Questions force you to think and find things out' (student).
- 'I'd just rather have the quote and think about it myself rather than being asked to respond to it' (student).

In response to this finding, questions were offered on optional links. It may also be the case that a question which would be welcomed in a formal learning context, for example by a tutor, was not so acceptable to some students on a multimedia guide in an informal learning context. In these cases, the default pathway mentioned by Laurillard was too directive or too simple.

Technology

Students' responses to the PDAs as devices were more mixed than responses to the content. Some found them exciting to use, and preferred them to paper:

- '… it was quite straightforward once you got used to it … I think I'd want a little more out of it' (postgraduate student).
- 'I think using pictures and the sound worked a lot better when it was put together, like that made more sense' (postgraduate student).

Others found the PDAs a distraction from the galleries, both because of the multimedia interpretation offered and because operating the PDAs took up attention that could have been devoted to the collections:

- 'I would alter the technology slightly there was so much going on and it did slightly distract me from the art' (student).
- 'I was more engaged with the PDA than the gallery … I felt very disconnected with things because I didn't look at them so much' (third year student).

There is a trade-off between interacting with the objects and with the learning resources; some students prefer minimal interpretation while others see the content

of the learning resources as a worthwhile compensation for less time looking at objects.

Some students did also report a sense of isolation using the PDAs, a problem familiar to users of audio guides: 'It's almost impossible to have an interaction with anyone else with this plugged into my ears ... having a conversation, it's just not possible' (second year student).

Having all content in written as well as audio form was one solution to this. However, if collaboration with other learners is seen as central to students' learning, as it is in the conversational framework, then provision would have to be made for this outside the use of PDAs in the galleries.

Although students often referred to themselves and their own thinking and working processes in relation to the materials, they did not generally put a high value on being able to record responses on the spot by inputting them into the PDA, although the camera was picked out as a useful function. They perceived it much more as a device for accessing information than as a recording device. This may be because they did not find the input functions easy to use, or it may be that as part of their courses students have developed their own ways of recording information and responses, and reflecting on these.

Wireless Connectivity

The project has also been marred by technical problems. Throughout the project there have been varying connectivity levels in the galleries, meaning that audio and video links worked inconsistently, and there was slow connection time between web pages or complete lack of connection. Poor connectivity was due to inadequate processing power in the PDAs (laptop connectivity was better), intermittent faults in the wirelessing infrastructure and the irregular shape of many V&A rooms, combined with the gallery contents – for example the large objects in the Cast Courts. There is other evidence to show that wireless connectivity is impaired if users are mobile (Bai and Williamson 2004). The PDAs themselves proved unreliable during the project, for example, often resetting themselves when turned off and sometimes proving difficult to turn off and on.

Conclusion

There is no doubt that an important role of the museum is to constitute a pool of resources for tutors and students to draw on as they see fit, in subject areas and with approaches tailored for their particular students. However, findings from this project suggest that there is also a place for targeted learning resources for HE students in museums, and the project shows some factors to be taken into account in the design of these.

Recommendations from evaluation of the project include the need to keep trails brief and focused and provide opportunities for students to make links with their personal experiences. Audio should also be available as text (some students preferred text as they could browse it more quickly, or preferred reading as a way of taking in information). Where possible, interpretation should not depend on one particular technological platform, since devices quickly become obsolete (Walker 2008).

The project has identified approaches to learning from museums used by design students and tutors and has developed and evaluated museum-based materials in response to these. On the basis of this research I would suggest that such materials increase students' engagement with museums and add to the ways in which students use museums in research, as well as offering information about the collections. Museum-based materials are a means of enhancing the way HE students use museums and offer approaches and strategies for learning in the museum to a large number of students.

Possible uses of such materials are: helping students focus on a particular way of using the museum collections; helping students to be more aware of parts of the museum they might not otherwise visit; encouraging particular object-based learning skills or linking a part of the collection to an area of study. Some of the approaches to designing the content of the trails can be used in other object-based learning activities – for example using multiple perspectives, or debating the merits of pairs of objects, or using the museum shop as a way into understanding the roles of objects in museum displays.

I would argue that the findings also show that some pedagogical approaches used in formal education are useful in the museum. If such materials develop academic and scholarly skills which can be applied in a variety of contexts, this places the museum firmly in a scholarly infrastructure along with universities.

However, I would also argue that such materials are best considered as an additional tool for HE design students visiting museums, not a better alternative to visiting without guidance. The opportunity to wander, make accidental discoveries and follow one's own learning path are important aspects of museum learning. More directive guidance provided by resources such as these should not replace this experience, or replace the student's own aims for museum visits.

In theory, the handheld technology backed by the particular brand of software used in the project (StreetAccess) would seem to be optimal. The two-way nature of the software facilitates a dialogic approach to learning. In addition, students often visit outside formally organised trips (Fisher 2007). Therefore technology which can be used in the museum, with student input which can be consulted and modified afterwards, may be an optimal way of linking an informal museum visit with a formal education course. For example, student responses to one trail could be looked at together as part of a course session.

In practice, however, it is not yet clear whether the technology – both the PDAs as devices and the wireless technology on which they depend – can live

up to these expectations, in terms of either usability or reliability. In addition, students' and tutors' motivation to use the devices as part of an independent museum visit has not been tested.

Through such resources, expertise built up in partnerships between individual staff in the HE and museum sectors can be shared with a wider HE audience. They can be one 'channel for the flow of ideas between the two sectors which invigorate and strengthen the departments involved, and change the intellectual climate throughout each institution' (Anderson 1997: 57).

Bibliography

Anderson, D. (1997) *A Common Wealth: Museums and Learning in the United Kingdom*. London, Department of National Heritage.

Bai, G. and Williamson, C. (2004) *The Effects of Mobility on Wireless Media Streaming Performance*. Wireless networks and emerging technologies, Calgary, AB, Canada, 596–601. Retrieved 22 April 2009, from <http://pages.cpsc.ucalgary.ca/~carey/papers/2004/wnet2004.pdf>

Beazley, I. (2007) *Spectacular Success of Web-based, Interactive Learning*. Museums and the Web, San Francisco, California. Retrieved 22 April 2009, from <http://www.archimuse.com/mw2007/abstracts/prg_325001001.html>

Benton, T. (1996) Multiple Media and Multimedia: Some Possible Options for the History of Art and Design. *Journal of Design History* 9/3, 203–214.

Brabazon, T. (2008) Transforming Learning: Building an Information Scaffold. *Networks*, 4, 16–21.

Brookfield, S. (1986) *Understanding and Facilitating Adult Learning*. San Francisco, Jossey-Bass.

Csikszentmihalyi, M. and Hermanson, K. (1999) Intrinsic Learning in Museums: Why Does One Want to Learn? In Hooper-Greenhill, E. (Ed.) *The Educational Role of the Museum*. London, Routledge, 146–160.

Dewey, J. (1934) *Art as Experience*. New York, Minton, Balch.

Falk, J. and Dierking, L. (2000) *Learning from Museums: Visitor Experiences and the Making of Meaning*. Walnut Creek, CA, Altamira Press.

Fisher, S. (2007) *How do HE Tutors and Students Use Museum Collections in Design?* Qualitative Research for the Centre of Excellence in Teaching and Learning through Design. Unpublished report.

Hein, G. (1998) *Learning in the Museum*. London/New York, Routledge.

Hooper-Greenhill, E. (Ed.) (1999) *The Educational Role of the Museum*. London/New York, Routledge.

Laurillard, D. (2002) *Rethinking University Teaching: A Framework for the Effective Use of Learning Technologies*. Abingdon, Routledge Falmer.

Laurillard, D. (2007) Pedagogical Forms for Mobile Learning: Framing Research Questions. In Pachler, N. (Ed.) *Mobile Learning: Towards a Research Agenda*. London, WLE Centre, Institute of Education, 153–175.

QAA (2008) Subject Benchmark Statements. Retrieved 23 October 2008, from <http://www.qaa.ac.uk/academicinfrastructure/benchmark/default.asp>

Sharples, M., Taylor, J., et al. (2007) A Theory of Learning for the Mobile Age. In Andrews, R. and C. Haythornthwaite (Eds) *The Sage Handbook of E-Learning Research*. London, Sage Publications, 221–247.

Speight, C. (2007) 'iGuides from StreetAccess, front end evaluation. Unpublished report. Retrieved 15 October 2009, from <http://cetld.brighton.ac.uk/projects/current-projects/iGuides/iguides evaluation/evaulation2> [sic – please note there is a spelling mistake in the actual web address]

StreetAccess (2009) StreetAccess Website. Retrieved 15 May 2009, from <www.streetaccess.co.uk/vandacetld.html>

Walker, K. (2008) StreetAccess 'iGuides' Summative Evaluation. Retrieved 5 May 2009, from <http://cetld.brighton.ac.uk/projects/current-projects/iGuides/iguides-evaluation/iguides-summative-evaluation-report>

Chapter 6

Student Use of a University Museum

Rhianedd Smith

They [university museums] are uniquely placed to initiate and support experimental and interdisciplinary activity, although this capacity is largely under-exploited by non-museum academics and, often, by the museums themselves. (UMG 2004: iii)

As this quote suggests university museums have great potential to reinvigorate the traditional higher education (HE) curriculum. However, this potential is rarely harnessed. The following chapter will examine a project at the Museum of English Rural Life (MERL 2007), University of Reading, which has explored this opportunity through the creation of a series of interdisciplinary collections-based modules. In it I will discuss the challenges posed by student learning with collections and examine the methodology which has been applied in this project. In doing so I will put forward a model of sustainable student engagement with collections: a model which is integrated with the traditional curriculum, whilst embracing an innovative pedagogic approach.

The project at MERL is financed by HEFCE's Centre for Excellence in Teaching and Learning funding stream (HEFCE 2009) through the University of Reading's CETL for Applied Undergraduate Research Skills (CETL-AURS 2007). This centre aims to improve students' research skills by engaging them in a process of active enquiry with primary evidence. One strand of this project seeks to enhance student learning in campus-based collections. The post of MERL Undergraduate Officer was created to oversee the design of a series of interdisciplinary modules and the restructuring of a campus-wide volunteer programme.

The modules in question attract students from history, classics, archaeology and history of art. Beyond facilitating engagement with collections, the project aims to develop undergraduates' research skills. The modules use museum collections, alongside archival and library-based resources to develop students' problem-solving abilities. However, the question of how to structure and support such an inherently 'messy' process as problem-solving is something that has challenged numerous learning theorists. This project has utilised elements of a number of pedagogic frameworks to create a structure which supports creative thinking in research.

Given the focus of CETL-AURS on 'the student as producer' [of research] it is perhaps not surprising that this project was always envisaged as a catalyst for active learning. The direction of the project was further cemented by the decision to employ a Museum Learning Officer as opposed to an academic as Undergraduate Learning Officer. This ensured that the project did not fall into the

trap of developing traditional lecture and seminar based modules that were simply *situated* in a museum. It also meant that teaching was based around the principles of interdisciplinary, hands-on museum learning, rather than discipline-specific discourse on a collections- related subject.

In addition to this, the focus on research encouraged us to embrace the full range of what visual literacy could mean. Visual literacy is based around the idea that images are a kind of a language and that learners need to understand how these symbols work to communicate ideas (Avgerinoun 2009). Thus, the development of visual literacy could be confined to looking closer and deconstructing images or objects. However, there is a crucial next step which can give greater depth to the 'reading' of an object. With a museum object, documentation files, photographs, other objects, archival documents and oral histories may all shed light on its meaning as a cultural artefact. Hence, our modules are aimed at developing students' ability to undertake research across these collections.

In trying to achieve this we found it difficult to identify a suitable pedagogic framework. While there are relatively few published case studies of student engagement with collections, there is evidence of good practice taking place.[1]

In this case study I will argue that if museums truly want to be relevant to HE it is not enough to simply get students through the door. By examining exactly what collections-based learning can offer students, museums could become better placed to develop sustainable and mutually beneficial collaborations with Higher Education Institutions (HEIs).

Collections and the Curriculum

Over the past 20 years provision for primary and secondary schools in museums has moved far beyond the curator's talk. Museums' school programming now offers interactive cross-curricular resources which cater to a range of learning styles (Hein 1998; Hooper-Greenhill 1999; Falk and Dierking 2000). However, when university students come to museums they are more likely to be offered a lecture by an expert than a session with a learning officer. We need to ask ourselves whether museums can offer something more to university students than a lecture with objects.

Most of the writing on museum learning focuses around the key audience of school groups. However, a possible model for student learning in museums could lie in concepts of lifelong learning. Research into free-choice learning suggests

1 Case studies presented at the ICOM UMAC Conference Mexico City provided some information <http://publicus.culture.hu-berlin.de/umac/> as have discussions with colleagues in the CETL initiative and University Museums Group UK. See also Caban and Scott's work with the Powerhouse Museum in Sydney (see Chapter 9). There is also an upcoming publication in the ICOM UMAC journal based on work being undertaken at University College London.

that we are limiting ourselves if we only target our learning provision at primary education (Falk and Dierking 1992). In recent years the MLA's Inspiring Learning for All framework has also promoted a learning strategy that embraces concepts of holistic, lifelong learning (MLA 2004). The framework utilises the central tenets of museum learning theory – that objects and museum spaces themselves are multisensory and polysemic (Pearce 1994) – to explore the range of learning experiences that can take place in a museum.

Hence, current thinking suggests that museums and collections are complex, interdisciplinary and multi-vocal spaces in which meaning is constructed by learners. In this way collections can be used to develop a range of lifelong learning skills and not simply act as vehicles for the transmission of content. However, this raises interesting questions about what we want students to learn from our collections. What does learning to see really mean for design, humanities and social science students?

Learning to See

It is interesting that Caban, Scott, et al.'s research at the Powerhouse Museum found that any kind of exposure to the museum had a positive outcome on creativity amongst design students (Caban and Scott 2000; Caban, Scott, et al. 2002; Caban and Wilson 2002). The results found little difference between those who had been supported through lectures and those who had experienced displays unaccompanied. However, further interrogation of the project illustrates that the students are never totally 'unaccompanied'. The exhibitions were designed to illustrate differences, show process and reconstruct the frameworks which give meaning to museum objects. While a facilitator was not physically present the museum's communication tools still helped to support student learning.

How much then do we need to support student interaction with collections? Csikszentmihalyi and Robinson's exploration of the aesthetic experience addresses this using Csikszentmihalyi's concepts of optimal learning states and flow theory (Csikszentmihalyi 1990; Csikszentmihalyi and Robinson 1990; Csikszentmihalyi 1996; Csikszentmihalyi 1998). In their study they break down the creative process and offer practical advice as to how museums may facilitate aesthetic responses from learners. They found that amongst experts a combination of knowledge, communication, emotion and perception were at play in responses to great artworks. One respondent noted that they needed to have additional resources such as a library and catalogues to hand in order to be able to become absorbed in the process of seeing. These sentiments are echoed by Leslie Cunliffe (1999) who notes that creativity has to be based on knowledge of process and wider cultural frameworks, so that you cannot really create until you have learned first how to understand (Cunliffe 1999). Hence archives and specialist libraries may play an important role in learning to see and museum learning could involve exploring beyond individually displayed objects.

I find this has particular resonance with my work. The dates, artisans, places and uses of many of the objects in the MERL collections can only be discovered through careful archival research. This is an issue no doubt echoed with other types of collections where a student cannot simply pick up a book in order to reconstruct the cultural context surrounding an artefact. This would suggest that students from any discipline need to be able to find and use comparable objects amongst collections, utilise collections' documents, and undertake research in specialist libraries and archives. In this way learning to see can also require the ability to navigate these complex overlapping information pathways. We need to support students as they learn how to work across different collections, but does museum learning offer a suitable structure for this work?

Enquiry-based Learning

Within museums learning officers are seen less as lecturers and more as facilitators. The constructivist tenets on which museum learning is based posit knowledge as something which is produced through an individual activity of meaning making (Hooper-Greenhill 1999). In addition, concepts of learning styles (Kolb 1984) and multiple intelligences (Gardner 1985) have been used to highlight differences between learners. This focus on the individual learner has also been tempered with social cognitive theories which explore the role that interpersonal communication plays in meaning construction (Gardner 1985). In practical terms the theoretical foundations of current museum learning have challenged rigid didactic approaches to learning and have underpinned the development of innovative new pedagogical models.

However, within museums, learning sessions are often envisaged as one-off interventions, such as the school outing. Provision for repeat visitors tends to focus on the supply of new content (e.g. a new temporary exhibition) rather than developing more in-depth analysis of existing themes. Hence, when designing a 10-week collections-based university module there are very few models of active museum learning available to work from. In light of this, we also turned to HE pedagogy to determine whether it could offer any guidance on the design of research-led modules.

Interestingly the impact of socio-constructivist thought was not confined to the museum world. Reconceptualisation of knowledge and learning has also led to a reframing of the role of the instructor in universities. For example, these concepts provide the foundations for models of active or student-centred learning, which seek to place the learner at the centre of the learning experience. Hence, like museums, HEIs are looking for new ways to foster the process of creative meaning construction by designing flexible structures which are sensitive to individual learner needs.

An approach to this challenge which has been utilised in our work is that of enquiry and problem-based learning (PBL). PBL was originally developed in medical

education to help doctors apply their knowledge in everyday life (Savin-Baden and Howell Major 2004; Barrett 2005b). However, in recent years this structure has been adapted for other disciplines (Hutchings 2005; Hutchings 2006; Hutchings 2007a; Hutchings 2007b) and enquiry-based learning (EBL) has emerged.

Within this pedagogical framework students are faced with a scenario or problem that they must work on as a group (Savin-Baden and Howell Major 2004; Barrett 2005b). They set the weekly schedule, identify the resources and organise their group activities. In this way they are covering 'basic content' while developing a range of transferable and discipline specific skills. This methodology also allows students to experience the complexity of real life interdisciplinary scenarios which are not solved by referring to a standard reading list.

This has strong parallels with some areas of design pedagogy where there has also been a perceived need to support an essentially creative problem-solving process. In this field, theories such as Kolb's work on experiential learning (Kolb 1984) and learning styles (Kolb 1976) have influenced the way that design facilitators have 'broken down' the creative process to support individual learners (Wilson 2000). While the process of solving a real-life problem might be familiar to design students, undergraduates from other disciplines are more used to the essay and exam question approach to assessment. In light of this, the need for a suitable support structure was even more urgently felt. In the subsequent discussion I will explore how in the design of the MERL modules we have combined the two pedagogical fields of EBL and museum learning to create a model of sustained and deep-level learning with collections.

Complementing the Curriculum

In the MERL project we began as we would with any audience development work, by establishing what the visitors wanted. We achieved this in the initial stages by meeting with departmental heads to establish how any offer could be embedded within the existing curriculum. Feedback suggested that research-focused modules would be especially welcomed within the humanities. Such departments are under ongoing pressure to prove their worth in vocational terms and to offer a richer learning environment for their students.

While we could offer added value to degree programmes through optional modules, we also had to ensure that modules met Quality Assurance Agency (QAA 2009) standards. This meant designing modules which had comparable contact hours and workloads to other disciplines. However, despite the overarching framework of QAA this still proved challenging, as there was some degree of variability even within related subjects. This highlighted the difficulties that might be faced by non-university museums when trying to navigate the university structure, and the need for solid research to underpin the design of learning resources.

Once we had satisfied the academic audience we had to design modules that students actually wanted. There was some initial reluctance to offer museum

studies since the market is currently flooded with heritage MA programmes. In addition to this, heritage courses do not always encompass substantial student research with collections. However, upon talking to staff and existing student volunteers we identified a significant cohort of humanities and social sciences students who wished to undertake museum and material culture modules, in part as a route towards a career in the arts or heritage sector.

Hence, while we identified some need for subject specific modules[2] we decided to opt for the more challenging approach of designing interdisciplinary modules. This allowed students to interact with peers from different subject areas and to explore the applicability of their discipline to new topics. Interdisciplinary teaching and research is something which is much sought after by universities but rarely achieved. In this way museums can offer something which academic departments desperately need but find hard to deliver.

Sustainability

We have found that despite the large drain on staff resources it is generally assumed that university museums would offer undergraduate teaching without reimbursement. There is no clear reason why this is the case but it is strange given that there are existing structures for funding teaching within HE.

In the MERL project it has had a direct impact. As has already been mentioned the museum needed to make sure that its modules met Quality Assurance Agency standards. We did this by affiliating ourselves with an academic department which could take care of this administration. In addition, we have come to an arrangement with the department in which the generated teaching income was shared. The museum does not have to develop the complicated infrastructure for administrating its own modules and the department acquires extra teaching income and a more extensive portfolio of modules to offer potential students. This system also provides financial resources and university-friendly evidence of student impact which the museum can use to lobby for the long-term funding of a currently short-term position.

Challenging the Curriculum

Out of this process of consultation and negotiation we elected to develop one optional module at every level of study, dealing with various aspects of museum

2 There is now a more specific module called 'Public Understanding of Countryside Issues' which attracts students from agriculture and geography and which utilises a similar learning framework.

and material culture studies.[3] Within all of these modules assessment and teaching is designed around specific aspects of museum theory and practice and involves hands-on research into particular issues. However, while we tried to create a structure that complemented the curriculum we have found that our pedagogic method has often challenged traditional HE concepts of learning.

This was most marked when it came to the issue of assessment. EBL practitioners have frequently questioned the efficacy of the 'big-bang' approach to end of module assessment (Savin-Baden and Howell Major 2004; Macdonald 2005). They argue that if assessment is to reach its full potential as a method of developing independent learning then the structuring of assignments should reflect this. Within EBL this involves the setting and assessing of a series of increasingly complex scenarios which students explore in groups (Gibson 2005), a concept likely to be familiar to any design student but less often used in other subjects.

The design of collections-based tasks for undergraduates was surprisingly challenging. In order to design problems we needed to assess the difficulty and time scale of specific tasks which were often integrated into a much wider pattern of staff activity. In picking a project for students the one that first sprang to mind was an exhibition. However, informal feedback from colleagues who supervised or marked student designed exhibitions suggested that this task can be a huge drain on staff resources and very rarely obtains high quality results.

In addition to this I had some concerns given the current state of the museum workforce (Davies 2007) about offering a project which only engaged students with one aspect of museum work. The Museums Association's *The Tomorrow People* research has found that the workforce is currently flooded with applicants who are generally educated to degree level and above. Students with Masters degrees are often battling for £17,000 a year jobs and 10 years later are lucky to be making £30,000 (MA 2008). This research also uncovered a lack of diversity in the workforce and a significant skills gap in terms of collections-based knowledge.

I decided that there was a need to design tasks which accurately reflected less exciting aspects of work with collections while still stimulating and engaging students. In order to achieve this, chosen tasks had to be in some way abstracted and simplified in order to make them assessable and achievable. For example, students are asked to study a single object, undertaking research on it in order to create a catalogue, label and exhibition/interpretation plan. However, this assessment structure raised another important issue about the level of attainment that we expected of students.

This is a problem that EBL practitioners have also highlighted, for enquiry is more often concerned with the acquisition of new skills than the ability to apply them to a professional standard (Savin-Baden and Howell Major 2004). In enquiry-based assessment there is a need to mark the process alongside the end product.

3 Part 1 Analysing Museum Displays; Part 2 Object Analysis and Museum Interpretation; and Part 3 Museum Theory, History and Ethics.

This is familiar to design students in the form of the crit but is not often used in the humanities. Traditional assessment methods tend to focus on the mastery of secondary evidence. One way that EBL and PBL practitioners have attempted to remedy this is through assessment of reflective writing such as logs or portfolios (LTEA 2006).

We have included reflective elements in the assessment of two of our modules. For example, in one module students keep log books and in another they are asked to write justifications for their decision-making process. Overall we have found that students in humanities and social science subjects are not used to reflective writing and that added support is needed to develop this skill.[4] This lack of engagement with process in HE assessment also impacts on marking. Luckily, our modules are administered by a department that includes various practical elements within its degree programme, so we have been able to adapt the practical marking criteria for our uses. This highlights the need to think carefully about relative weighting of product over process in collections-based assessment. Even for design students, who are used to an exploratory and reflective learning process, a museum is a new and challenging environment where gatekeepers are hard to track down and dead ends abound.

Hence, a significant amount of work needs to go into the design of collections-based assessment. With few good case studies to work from we found ourselves creating a flexible structure which could respond to student feedback. In the initial stages of the project, students were set individual research projects that they worked on outside of class. We found that students struggled with non-traditional assessment and, in their words, 'had trouble getting their heads around what we wanted'. Students often wrote narrative accounts of everything that occurred, theory heavy essays or disjointed combinations of the two.

Students also encountered problems related to the nature of primary sources. They would often neglect to cite archival or object-based evidence in bibliographies. They also had trouble grasping the contingent nature of primary evidence. Students would often take information or opinion, derived from primary evidence and present it as hard fact.

More worryingly, despite clear instructions that a percentage of the marks would be based on work with primary evidence, weaker students still relied on the internet for background information. Without the capacity to compare this work with their other writing it is difficult to ascertain whether this was due to the individual students or other factors. However, the inclusion of resource orientation sessions and workshops on different writing styles this year does seem to have had a significant impact on the quality of the research and the writing-up process.

4 The Learn Higher CETL is currently undertaking research and consolidating resources on this subject and assisted me with my work in this – see

The issue of 'getting their heads around' tasks has also been addressed by wording tasks as real-life scenarios[5] which students interrogate as a group. By identifying the parameters of the task, setting learning goals in groups and undertaking the requisite background research together students are able to support each other as they acquire the needed skills and knowledge. Marks for the module are still based on the individual writing-up of these activities but this may be changed in the future to a partial group mark system.

All this raises serious questions about the role of the lecturer in this process. Many museum learning officers classify themselves from a socio-constructivist perspective as facilitators. They are not there to impart received wisdom to a passive audience but to create an environment which enables others to learn for themselves. Within HE, despite ongoing discussion of student-centred learning, the concept of the 'sage on the stage' still has primacy (Horgan 2003). EBL research into the role of the lecturer in enquiry has highlighted the tension between the concept of facilitation and traditional notions of academia (Savin-Baden 2003; Barrett 2005a). However, feedback from my students and the findings of CETLD research suggests that the opportunity to work with a professional is something that students value.

This should not really come as a surprise. In 1981, Knowles made reference to this fact in one of the few books on the subject of adult learning in museums, *Museums, Adults and the Humanities* (Collins 1981; Knowles 1981). He references Tough's work which explored the range of different resources that adults accessed when trying to learn something new (Tough 1971). In his research Tough found that professionals often taught in a practical and student-centred way by highlighting application and practical skills rather than overwhelming with theory. In this way, they were often deemed to be much more effective teachers by adult learners. In my work I have found that abstract principles of analysis are usually much less effective in developing students' collections-based literacy than interaction with a professional who already has those skills. This tendency is also aptly demonstrated by the prevalence of practitioner- based teaching within the design curriculum.

In the MERL project, as well as having a museum professional designing and delivering the modules, students have guest facilitators talking about their work. I have found that Tough's assertions do ring true and that my colleagues deal with students in a very different way to the academic lecturers who I also occasionally bring in. I have tried to make more of this and fully immerse students in the process of learning in a collections-based environment. For example, this year our

5 An example of one such 'scenario': 'Visionary Text: The Royal National Institute of Blind People (RNIB) and the Group for Education in Museums (GEM) are collaborating on a new project to promote accessible and engaging museum text. The project seeks to raise standards in museum text in the UK by engaging future museum professionals with accessible text. As part of this project they are running a competition to find the best example of student designed text. Groups of students are being asked to research best practice in museum text writing and design in order to create a basic guide to writing text.

Reading Room is booked for hour-long sessions so that archivists and librarians can help students to use finding aids and to identify and evaluate evidence in situ. This may not be possible in every institution but from my own experience I have been impressed by how open colleagues are to the process and by how markedly it improves student research.

This supports our more general findings on the importance of social learning in developing collections and research literacy. As was mentioned earlier, EBL and PBL traditionally place students in groups to work on specific tasks. We found that even though assessment was based on individual research some students were creating their own small and unstructured research groups without any guidance from the facilitator. They were usually based on friendship groups and would often consist of no more than sharing photocopied articles of interest or booking into the Reading Room at the same time. However, we also observed some students who had used the collections before helping others to learn the ropes or having discussions related to specific points of interest.

This year while assessment is still based on individually submitted pieces of writing, the background research is undertaken in groups. For example, instead of asking each student to catalogue an individual object of their choosing, students are given an individual object within a similar group (for example all objects from the Women's Land Army). Assigning objects[6] means that we can be assured that there is sufficient archival information in the collections to support research on this set of objects. It also allows students to develop new skills collectively and to build on each others' strengths. We theorise that group work could also address some issues of threshold fear (Gurian 2005) with regard to approaching professional staff or working in an academic reading room. And finally this process of group work on a shared problem emulates the real processes of interaction, exchange and group activity which takes place in museum work. In this way we are starting to explore how not just objects, but museums, libraries and archives as institutions can be used to inspire creative approaches to problem-solving and to understanding the processes of research.

Conclusion

In conclusion, this project highlights some important questions about the role that university museums and affiliated museums can play in HE. In combining

6 Please note that the EBL research referenced thus far does tend to advocate a degree of choice in tasks in order to create a sense of ownership amongst students. While there is not enough space to discuss this issue at length here we have found that student choice has to be limited in some ways in a collections context in order to ensure that research projects are challenging but not demoralising or too great a drain on staff resources. I plan to write an EBL-focused paper to complement this case study which explores the challenges that collections-based learning can present to this pedagogical methodology.

both enquiry-based learning and museum learning I hope to have illustrated areas of complementary pedagogy. However, I have also drawn attention to the gaps which exist in both methodologies. For, although EBL offers structures for student research, it has yet to grapple with the challenges of supporting student research in the specific professional context of the museum. Equally, museum learning theory needs to look beyond the school visit to examine models for sustained engagement across collections. More research needs to be undertaken into potential areas of cross-fertilisation between these various theories. However, I have found that the assimilation of these approaches has definite merits.

I hope that this case study has also illustrated the need to ask ourselves what we want students to learn when they enter a museum. From my own experience I have found that there is some prejudice against museum learning as *glitter and glue*, which might make a move away from the curator's talk challenging. However, student feedback and the offshoots of constructivism within HE illustrate that complex, interdisciplinary, real-world learning spaces are better for developing lifelong learners than packed lecture halls. From my own experience I don't believe that embedded change can be brought about solely through the creation of generic learning resources. The challenges faced in our project suggest to me that museum professionals also need to work to develop mutually beneficial partnerships with specific HEIs. Hence, university museums do have the potential to lead the way. For by navigating the complex structures of their home HEIs, university museums can develop models of sustained student engagement with collections for the rest of the museum sector.

Bibliography

Avgerinoun, M. (2009) What is Visual Literacy? *International Visual Literacy Association.* Retrieved 29 April 2009, from <http://www.ivla.org/org_what_vis_lit.htm>

Barrett, T. (2005a) Lecturers' Experience as Problem-based Learners: Learning as Hard Fun. In Barrett, T., I.M. Labhrainn and H. Fallon (Eds) *Handbook of Enquiry and Problem-based Learning: Irish Case Studies and International Perspectives.* Galway, All Ireland Society for Higher Education (AISHE).

Barrett, T. (2005b) Understanding Problem-based Learning. In Barrett, T., I.M. Labhrainn and H. Fallon (Eds) *Handbook of Enquiry and Problem-based Learning: Irish Case Studies and International Perspectives.* Galway, All Ireland Society for Higher Education (AISHE).

Caban, G. and Scott, C. (2000) Design Learning In Museum Settings: Towards a Strategy for Enhancing Creative Learning among Design Students. *Open Museum Journal 2: Unsavoury Histories*, 2.

Caban, G., Scott, C., et al. (2002) *Museums and Creativity: A Study Into the Role of Museums in Design Education.* Sydney, Powerhouse Publishing.

Caban, G. and Wilson, J. (2002) Understanding Learning Styles: Implications for Design Learning in External Settings. In Davies, A. (Ed.) *Enhancing Curricula*. London, RIBA.

CETL-AURS (2007) CETL in Applied Undergraduate Research Skills. Retrieved 29 April 2009, from <http://www.reading.ac.uk/cetl-aurs/>

Collins, Z.W. (1981) *Museums, Adults and the Humanities: A Guide for Educational Programming*. Washington, DC, American Association of Museums.

Csikszentmihalyi, M. (1990) *Flow: The Psychology of Optimal Experience*. New York, Harper and Row.

Csikszentmihalyi, M. (1996) *Creativity: Flow and the Psychology of Discovery and Invention*. New York, Harper Perennial.

Csikszentmihalyi, M. (1998) *Finding Flow: The Psychology of Engagement with Everyday Life*. New York, Basic Books.

Csikszentmihalyi, M. and Robinson, R.E. (1990) *The Art of Seeing: An Interpretation of the Aesthetic Encounter*. Los Angeles, J. Paul Getty Trust.

Cunliffe, L. (1999) Learning How to Learn, Art Education and the 'Background'. *Journal of Art and Design Education* 18/1, 115–121.

Davies, M. (2007) *The Tomorrow People: Entry to the Museum Workforce*. Retrieved 28 April 2009, from <http://www.renaissancewestmidlands.org.uk/domains/museumwm.org.uk/local/media/downloads/Entry%20to%20the%20museum%20workforce_April07.doc>

Falk, J. and Dierking, L. (1992) *The Museum Experience*. Washington, DC, Whalesback Books.

Falk, J. and Dierking, L. (2000) *Learning from Museums: Visitor Experiences and the Making of Meaning*. Walnut Creek, CA, Altamira Press.

Gardner, H. (1985) *Frames of Mind*. London, Paladin.

Gibson (2005) Designing Projects for Learning. In Barrett, T., I.M. Labhrainn and H. Fallon (Eds) *Handbook of Enquiry and Problem-based Learning: Irish Case Studies and International Perspectives*. Galway, All Ireland Society for Higher Education (AISHE).

Gurian, E.H. (2005) Threshold Fear. In MacLeod, S. (Ed.) *Reshaping Museum Space: Architecture, Designs, Exhibitions (Museum Meanings)*. London, Routledge.

HEFCE (2009) Higher Education Funding Council for England, *Centres for Excellence in Teaching and Learning*. Retrieved 29 April 2009, from <http://www.hefce.ac.uk/Learning/TInits/cetl/>

Hein, G.E. (1998) *Learning in the Museum*. London/New York, Routledge.

Hooper-Greenhill, E. (Ed.) (1999) *The Educational Role of the Museum*. London/New York, Routledge.

Horgan, J. (2003) Lecturing for Learning. In Fry, H., S. Ketteridge and S. Marshall (Eds) *A Handbook for Teaching and Learning in Higher Education*. London, Routledge Falmer.

Hutchings, B. (2005) *Designing an Enquiry-Based Learning Course*. Centre for Excellence in Enquiry-based Learning, University of Manchester.

Hutchings, B. (2006) The Principles of Enquiry-Based Learning. Retrieved 29 April 2009, from <http://www.campus.manchester.ac.uk/ceebl/resources/papers/ceeblgr002.pdf>

Hutchings, W. (2007a) Enquiry-Based Learning: Definitions and Rationale. Retrieved 28 April 2009, from <http://www.campus.manchester.ac.uk/ceebl/resources/papers/hutchings2007_definingebl.pdf>

Hutchings, W. (2007b) The Philosophical Bases of Enquiry-Based Learning. Retrieved 28 April 2009, from <http://www.campus.manchester.ac.uk/ceebl/resources/papers/ebl_philbases.pdf>

Knowles, M. (1981) Andragogy. In Collins, Z.W. (Ed.) *Museums, Adults and the Humanities: A Guide for Educational Programming*. Washington, DC, American Association of Museums, 49–60.

Kolb, D. (1984) *Experiential Learning: Experience at the Sources of Learning and Development*. Englewood Cliffs, NJ, Prentice-Hall.

Kolb, D.A. (1976) *The Learning Style Inventory: Technical Manual*. Boston, MA, McBer.

LearnHigher (2009) LearnHigher Centre for Excellence in Teaching and Learning. Retrieved 29 April 2009 from

LTEA (2006) Learning Through Enquiry Alliance. Retrieved 29 April 2009, from <www.ltea.ac.uk>

MA (2008) *Why Museums?* Museums Association. Retrieved 29 April 2009, from <http://www.museumsassociation.org/ma/10557>

Macdonald, R. (2005) Assessment Strategies for Enquiry and Problem-Based Learning. In Barrett, T., I.M. Labhrainn and H. Fallon (Eds) *Handbook of Enquiry and Problem-based Learning: Irish Case Studies and International Perspectives*. Galway, All Ireland Society for Higher Education (AISHE).

MERL (2007) Museum of English Rural Life, University of Reading. Retrieved 29 April 2009, from <http://www.reading.ac.uk/merl>

MLA (2004) Inspiring Learning for All. Retrieved 29 April 2009, from <http://www.inspiringlearningforall.gov.uk/>

Pearce, S. (Ed.) (1994) *Interpreting Objects and Collections*. London/New York, Routledge.

QAA (2009) The Quality Assurance Agency for Higher Education. Retrieved 29 April 2009, from <http://www.qaa.ac.uk/>

Savin-Baden, M. (2003) *Facilitating Problem-based Learning: Illuminating Perspectives*. Maidenhead, Open University Press.

Savin-Baden, M. and Howell Major, C. (2004) *Foundations of Problem-based Learning*. Maidenhead, Open University Press.

Tough, A. (1971) *The Adult Learning Projects*. Toronto, Ontario Institute for Studies in Education.

UMG (2004) University Museums in the United Kingdom: A National Resource for the 21st Century. Retrieved 27 April 2009, from <http://www.umg.org.uk/media/Text.pdf>

Wilson, J. (2000) *Change, Change and More Change: Redefining the Student Profile in Design.* International Conference on Design Education. Curtin University.

Chapter 7

The Design Student Experience
in the Museum

Beth Cook

One of the main issues this book addresses is that of how museums can better support students studying design and related subjects, and how university tutors and students can utilise the resources available to them in museums. The next four chapters look at ways in which museums and their resources can be central to design education, and examine the key issues surrounding object-based learning, and the development of object scholarship. 'Looking to learn' and 'learning to see' are important aspects of this kind of scholarship.

Object-based learning is central to an understanding of museum-based learning, as visual research is to the subject of design. There are differences between the two concepts, but this chapter demonstrates that there are also more similarities than are often acknowledged between the two sectors. The ability to 'look critically' is a key threshold that design students must master in order to progress in their studies. Design students need to develop intellectual and physical skills that help them to critically and creatively interrogate objects, images and spaces that surround them. This may be both through understanding more *about* a particular object, and by using that object to generate lateral thinking through and *beyond* it. Museums not only hold in one place a huge number of objects, images and texts to browse. They also have resources that support knowledge and information, and students need to learn how to access these effectively. As introduced by Speight (see Chapter 2), the research collaboration between the University of Brighton and the V&A has allowed specific engagement with the experiences of design students, and has demonstrated that higher education (HE) students want and need different things from a museum compared to other adult audiences.

This chapter will look specifically at the experience of design students in the museum. It examines contemporary understandings of object-based learning, and how museums can support the specific needs of design students by exploring examples from CETLD-funded research.

Object-based Learning and Visual Research

Looking, Seeing, Drawing

The exact role of objects in a design education, and the development of the skills of 'looking' and 'seeing' have historically been the subject of much debate. In 1959 the National Advisory Council on Art Education was established, with Sir William Coldstream as its chairman. The establishment and work of the Council was the culmination of over 300 years of recurring and unresolved argument over two key aspects of art and design education – what it was for (its purpose) and how it should happen (its form). This chapter concentrates on aspects of the latter, in the context of the experience of the design student in the museum.

The Council produced a report in 1961 which outlined a new award for art and design studies, the Diploma in Art and Design (Dip.AD). This award was intended to bring art and design in closer alignment with other HE subjects. It required students to 'have obtained at least five O-level passes in the General Certificate of Education' (Macdonald 2004 [1970]: 355) and was intended to be equivalent to a Bachelor's degree. The 1966 White Paper, *A Plan for Polytechnics and other Colleges*, developed this further and led to a number of art colleges merging with other institutions to form the basis of the new polytechnics – of 16 schemes approved in 1968, nine included art colleges (Macdonald 2004 [1970]: 363). In 1974 the Dip.AD became an undergraduate Bachelor of Arts course, and under the 1992 Further and Higher Education Act, polytechnics become universities.[1]

Before this period, art and design education developed largely independently of other subjects. Until the sixteenth century the two concepts of 'art' and 'craft' were considered synonymous – it was only during the Renaissance that art became recognised as 'a product of the intellect rather than the skilful hand' (Macdonald 2004 [1970]: 17). There was a resulting move away from the apprenticeship system, which was intended to produce craftsmen, and towards a system of academies, where the purpose was to teach skills such as perspective (Macdonald 2004 [1970]: 24).

Despite a great deal of debate within the art and design community about the purpose of an education in art and design,[2] there has been an element of uniformity in the way that it is taught. The fundamental belief that success in design, sculpture

1 In 2005 the Art Design and Media Higher Education Academy (ADM-HEA) commissioned a report, *The History of Art and Design Education,* which identified key publications of the 1960s and 1970s including *The History and Philosophy of Art Education* by Stuart Macdonald (2004 [1970]) and *The Schools of Design* by Quentin Bell (1963). This paper also cites later developments such as the 1992 Further and Higher Education Act, and the fact that little research has been conducted in this area since the work of Macdonald and Bell (Speight 2005).

2 Macdonald's book provides a great deal of detail about this (Macdonald 2004 [1970]).

and painting is based on drawing and representational skills and a firm knowledge of anatomy, composition and perspective recurs throughout the history of design education (Candlin 2001: 303; Macdonald 2004 [1970]: 227). The eighteenth-nineteenth century Royal Academy of Arts, for example, and many other private art schools and institutes concentrated on the skills of drawing and painting, placing emphasis on figurative study through drawing the art (sculpture) of the Ancient Greeks (Bell 1963: 8). The School of Design in 1835 aimed for a very different curriculum, instructing students to draw and copy from architectural ornaments and historic motifs (Macdonald 2004 [1970]: 74). Both curricula agreed that the form of a design education should be drawing – by which they, at least initially, meant copying or iteration. By 1852 Henry Cole, recognising the importance of learning from objects, and following on from the Great Exhibition of 1851,[3] had secured government support for a reformed School of Design (Bell 1963: 248-249). Integral to Cole's vision was the creation of the Museum of Manufactures (now the V&A), which would house examples of good design and allow students access to study them. Museums, as keepers of objects, have thus been understood for a long time as a key resource for students of art and design.

In a nineteenth-century context, it seems that the purpose of drawing was to encourage students to learn design conventions though iteration so they could apply these accepted principles to their own work, either in terms of figurative poses or ornamental devices (it was often believed that each kind of material was suited to a specific 'type' of design or form that was then merely applied to the material). The more contemporary concept that 'design could evolve directly from experience and use of materials' (Macdonald 2004 [1970]: 312) – in other words through an iterative engagement with a material rather than the interrogation of form – is a relatively recent realisation. In 1970, Macdonald stated that a basic art or design course must aim to 'free students ... from previous art knowledge, and make them re-learn from direct experience' (Macdonald 2004 [1970]: 370). He speaks of learning a 'visual grammar, and a standard terminology', as has historically been important, but critically he also emphasises training students 'to look critically and analytically' (Macdonald 2004 [1970]: 370). CETLD research showed that design tutors often believe that such skills of interrogation are inherent and cannot be taught. Conversely students often welcome guidance and structure to a museum visit (Fisher 2007).

The student experience in the museum is frequently focused on drawing. With guidance, this is valuable and important as an interrogative process, for referencing, and as a way of developing ideas. However, drawing as iteration, in the way that it was originally conceived, is not making full use of the potential of a visit to a museum. Despite similarities in some of their approaches, students of design have a different relationship to the objects that make up museum collections than humanities or science-based students have to historic or scientific collections.

3 The Great Exhibition publicly displayed and celebrated the changes wrought in art, design and manufacture by the Industrial Revolution through the display of objects.

Distinctions can also be drawn today between practice- and theory- based design students with regard to both the ways they are taught and their relationship to objects. The differences between 'learning to look', 'looking to learn', and 'learning to see' are subtle, but it is important to try and understand them.

The material world is a key source of information for both practice- and theory-based design students, although it is used and interrogated differently. At the core of design student research is the need to learn how to understand, conceptualise, create, make and reflect on objects. Students need to learn to interrogate objects with a critical faculty and to gather a number of different types of information from this interrogation, sometimes without reference to written records. This is what museums frequently refer to as object-based learning. Kjolberg uses the term visual research to describe what students do in the museum, and discusses the issue of haptic learning (learning through moving, handling, trying out and trial and error) in more detail (see Chapter 9). Design students need to learn different ways of understanding *about* a particular object, and they must also learn to use and apply that knowledge to generate lateral thinking *beyond* it, considering material and process knowledge as well as historical and social contexts, for example.

The growth of photography as a recording medium has recently challenged the importance of drawing somewhat, but it achieves a distinctly different kind of record. A photograph of an object takes a few seconds to achieve, and can be referenced later as a record in order to consider the form, shape, colour, or other detail of the object. This ability to record has an important place in a museum visit. However, the time that it takes to record one of these details through drawing gives students an opportunity to consider a number of different aspects of the piece. It also requires further thought and reflection in order for students to understand why they are recording particular aspects of the piece. This is critical to 'looking to learn' and 'learning to see', and demonstrates why drawing remains so important to design education; it is certainly, however, not the only potential purpose of a museum visit.

In the Museum

The application of learning theory within a museum setting in order to create a specific environment is relatively recent (Anderson 1997). There are areas where a straightforward, drawing-focused visit to a museum does not achieve all that design students need. Their experience is mediated through what museum staff think is necessary or appropriate guidance for a more general audience, such as museum labels, and there is increasing evidence that museums need to consider different modes of access to their objects than the methods that have been used to date. Students often feel frustrated as a result of being limited to drawing in a museum – the issue of handling is one that has occurred again and again in the work of CETLD. Practice-based students, in particular, do not just need to learn about the finished object, which is perhaps what the phrase 'object-based learning' initially implies, but the processes that led to it as well. They may ask many of

the same questions as other visitors: How was it made? Who made it? Why was it made? They will also ask other, more specific questions: How were the buttons attached? How does the surface feel? How was that surface achieved? Why did one designer/maker decide on one shape, when another decided on a totally different shape for objects with a similar function?

The CETLD-funded project, *Exploring the relationship between teaching and learning through practice*, reported some important findings about the nature of student learning. This project was run by three members of the University of Brighton teaching and technical staff working in the BA and MDes Materials Practice course (a four-year masters course), and included collaboration with the Royal College of Art (RCA) and the Jewellery Department at the V&A. The project is referenced here as an illustration of how the design student engages with their practice, and how this can translate in a museum environment.

The project was designed to investigate how using and handling objects, and demonstrating the process of making, might complement and build upon existing methods of teaching, both theoretical and practical. It investigated two specific aspects – technical demonstrations that take place in a university context, and handling sessions of objects in museum collections (a trip was organised to the V&A's Jewellery Department). The project research was mainly qualitative in nature. The project report states that: 'We [the tutors] collected data by observation; both as participant observers working as demonstrators, and taking part in the demonstration itself, and as detached observers present at the demonstration. Information was recorded by video and audio and we have also interviewed and used questionnaires with students and examined 3D work made' (Boyes, et al. 2008: 5).

The BA and MDes Materials Practice course at Brighton is described as 'a craft based course where creativity is expressed through object making' (Boyes, et al. 2008: 2). The craft disciplines are 'characterised by the object's physical presence and materiality' (Boyes, et al. 2008: 3). What became apparent in this project was that visual interrogation is only one of a number of key skills that students need to develop. The project report emphasises the importance of all the senses in the learning experience, not just that of sight – 'touch ... sound and smell played an important role in the collection of information and as a connector to the process of making' (Boyes, et al. 2008: 30). This was in the context of the teaching of technical skills by demonstration. The skills of looking and seeing may appear secondary in this instance to the skills associated with making, but this project emphasises that they are all of great importance, and are all interlinked.

The project also makes clear the potential value of student interaction with museum collections. The handling session provided at the V&A was considered to be successful by the students and the tutors who attended. The students were required to undertake research into the objects they would be looking at before they visited, and were then able to touch them, and pick them up – feeling their weight and seeing the backs of pieces, which other research has demonstrated is important (RIN 2008) – as well as to look at them very closely. The students commented on the importance of this, and were fascinated by both the pieces and

the experience of being able to actually touch them. However, this kind of access is very labour intensive on behalf of both the museum and the university staff who organise it, and museums therefore often find it difficult to facilitate the practice of skills other than looking.

It is important to consider the role of museums as supportive to the learning process of the student. Observing demonstrations and working with materials in studios allows students to experiment with materials, using the skills of touch, smell, sound and sight. Visiting museums is, and should be, about something different and complementary to this experience, but over time the student can begin to bring the two kinds of experience together within themselves and draw on the richness of both.

If at university design students learn 'how to make an object', visiting a museum should perhaps be considered as related more to them investigating 'what they might make or what they have made' – it represents the reflective (rather than reflexive) purpose of such an education rather than the form. This may be part of the internal development of students as researchers with a conceptual position as much as it may be about their consideration of material skills. It is their chance to see what other things are possible with the materials that they use, to find out what other people who have studied as they study have achieved – to see how the techniques and skills they are learning have been used and adapted in a far wider context than is possible in the university.

This access to objects is where museums can perform a critical function. The object's 'physical presence' as described by Boyes, Cousens and Stuart is mediated by the glass case that protects the object, and separates the visitor from a sensual, haptic engagement with the object. This is a factor that students have complained about before (Fisher 2007). However, compared to other places, where students can look at and touch objects, such as shops, the museum provides considerable and invaluable scholarship and knowledge about the objects it displays. Despite these findings about how students learn, the area where museums are most equipped to help students is with the skill of looking to learn and learning to see, and it is in this context that these skills become key to a successful experience.

Object-based learning in the museum offers at least two distinct benefits to design students. First is the supply of information about their objects that museums offer, and second is the opportunity for making conceptual connections between apparently unrelated objects or subjects: using objects to generate lateral thinking beyond the obvious, through a process of visual research.

Museums are generally very good at supplying information about their objects for a variety of audiences. This often includes factual information about dates, place of manufacture, make, and purpose of an object. There is often contextual information that may include facts such as the original ownership of the object, any alterations made to the original, and its place within a wider series of objects or a collection. The most easily accessible information, such as some or all of the above, is available on the labels that accompany the objects on display. This is usually constrained by a strict word limit – often between 60–100 words. The

4 **FIGURE OF TOUCH**
from a set of The Senses

1750-1755

This figure is from a set representing The Five Senses, shown
wearing Chinese dress. Under French influence, mid-18th
century designers introduced an elegant, new Chinoiserie
figure type. They simply added Chinese details of dress
and hair to figures whose postures and style were otherwise
wholly European.

Soft-paste porcelain
Made at the Derby porcelain factory

Lent from Schreiber Collection
Museum no 414:140-1885

Illustration 7.1 Label text from the British Galleries, V&A

example above, from the British Galleries at the V&A, is 71 words in total – the
description itself is 46 words long.

This information helps students, and other visitors, to learn about the objects
on display. The differing text size demonstrates the relative importance that
the museum places on the information it provides – name of object; date; main
descriptive text; information about materials, manufacture, techniques etc; and
finally acquisition or loan details and the museum number. The figure itself
appears to be a white glazed ceramic. The label does not give information as to
the technique of this finish, or of the method of producing 'soft-paste porcelain'
figures, but concentrates instead on the social aspects of the design. This example
demonstrates the difficulties that museums face in providing information about
their complex objects through the medium of the museum label. Design students
often have many more questions than information labels can answer.

As well as the objects on display and the accompanying labels, museums often
have other publicly-available resources that support knowledge and information.
These include libraries, archives, and web-based resources. These can contain a
huge amount of material that may help students to learn about the objects in their
collections, but students at different stages of their education require guidance and
help to both know what is available, and learn how to access it effectively (see
also Chapter 2).

Object-based learning in the museum can also be considered in a second way, which relates more directly to the object itself, and not the accompanying information supplied or held by the museum. Practice-based design students spend a great deal of their 'learning time' in a workshop context. They learn about materials such as fabric, metal or clay by using and experimenting with them. One postgraduate ceramics student in an early focus group tried to explain the importance of handling by describing the 'tension' that a fine porcelain cup embodies – and the impossibility of understanding this unless you can actually hold the cup and feel the tension of the material in your hand. He was talking about one of the reasons why a trip to a museum is often frustrating for design students. It follows that it is through bringing an understanding of materials to the museum experience that students are able to use objects to generate lateral thinking beyond the initial information provided.

Two further examples from CETLD research demonstrate the range of potential student-museum interactions. They both took place during accompanied visits as part of the baseline research programme (see Chapter 2). This is where a researcher visits a gallery or exhibition with a visitor (in this case a student), and asks the visitor to talk about their visit as it occurs. This research method has proved very valuable in understanding the ways that students experience the museum and the galleries, and has also been commented on by students as helping them to focus on what they might achieve during a visit.

First is an example of an interesting interaction between a postgraduate ceramics student and an object during the course of a visit. The student was drawn to a huge silver fruit bowl in a gallery that she did not usually visit, but was held there by the way a tiny detail at the edge of the dish was attached – relating it to a problem she was experiencing in one of her own projects. The point here is that the knowledge the student took away with her was not to do with any of the usual information that a gallery presented, but was entirely to do with her ability to interrogate an object and a detail of it and, looking beyond the information immediately available, to think laterally about the possibility of a solution to an immediate problem she faced in her own work.

The second example is of another accompanied visit with a second year student in a temporary photography exhibition. The student frequently commented on the design of the show itself, and the way the lighting was arranged to create an atmosphere and to highlight specific aspects of particular photographs. The student talked about the exhibitions that they had to produce as part of their course, and about the experience of visiting an exhibition, as well as about the objects on display. This is another aspect of lateral thinking that a visit to a museum may engender but that the museum does not specifically guide a visitor towards.

When we speak about object-based learning, the experience of the design student in the museum, and the experiences that museums can facilitate, it would therefore seem that museums need to consider further ways to help students

understand the range of possibilities inherent in a single visit and how they might capitalise on these more fully.

Access in the Museum

The *Behind the Scenes at the Museum* project evolved from the conclusions of the CETLD baseline research project, which identified the following barriers for students getting the most out of a visit to the V&A:

- A lack of knowledge about what the museum contains, and how it is organised.
- Navigation problems – getting lost.
- High exhibition charges, an expensive café.
- A lack of handling opportunities, considered vital for makers.
- Practical concerns of time, distance and cost. (Fisher 2007)

The issue of access, both to museums and the objects in them, was clearly a key concern for students. The experience of students in the museum is often mediated by the resources provided by museum staff, and this research is included here to demonstrate a museum understanding of the student experience.

The project aimed to investigate two things: what the V&A and other museums currently offer in the way of behind-the-scenes access, and what this is considered to be; and what students and tutors believed they needed from the museum, and the value to them of behind-the-scenes access. The project was led by the author, in collaboration with Cynthia Cousens (Senior Lecturer) of the University of Brighton. It used a form of grounded theory, where initial research identified concepts or emerging themes, which are later analysed, tested and refined by subsequent data collection. A key aspect of this evidence-based empirical research was its 'bottom up' approach, drawing on methods from the social sciences – starting with the students and their responses, and developing our theories or resources in response to this.

Access is not, of course, just an issue with regard to design students. Two separate reports published in 2008 highlighted the issue of access to museums. The first, University College London's *Collections for People* (Keene 2008) investigated the use of stored collections by the public, and made recommendations for ways to improve this. While acknowledging the range of provision available, 'from open stores to individual appointments for researchers', and the difficulties faced by museums, the report concluded that 'users, especially the interested public, too seldom experience access to the 200 million items in the collections of English and Welsh museums as a public right. This is a service in which museums should excel' (Keene 2008).

The second report, *Discovering physical objects: Meeting researchers' needs,* was produced by the Research Information Network (RIN 2008). It looked at researchers in four subjects (archaeology, art history, earth sciences

and social and economic history), at the importance of objects and collections to their research, and at how museums are supporting this need (RIN 2008: 5). The report emphasises the importance of 'seeing and handling the objects themselves, rather than relying on a description or a digital image' (RIN 2008: 13). These researchers from the RIN project, like the design students that worked with the CETLD, emphasised the importance of handling the object in order to feel things like its weight and how it fits in the hand (RIN 2008). Handling an object also gives the opportunity to look at and see details only visible from, say, an upside-down perspective. The role of curatorial staff, literature about the objects, and online catalogues in providing a complete picture was also emphasised, as was the importance of personal contacts within institutions (RIN 2008). The report makes a number of recommendations, including the following: '2. Getting catalogue records online quickly ... 3. Clear and open policies on access ... 6. Engaging with researchers' (RIN 2008: 45–47). These findings support CETLD findings from the baseline research programme (Fisher 2007) and subsequent research.

The *Behind the Scenes* project looked at the different ways that museum staff conceive of their roles in providing access, and considered how this museum response affects the design student experience. The answers also have relevance for museum visits other than those which might be understood as strictly behind the scenes.

The first stage of research involved interviews with curatorial and education staff from a range of national, university, large and small museums: the V&A, the Pitt Rivers Museum in Oxford, Manchester Museums, Brighton Museum and the Geffrye Museum in London. These were semi-structured interviews with open-ended questions. Two members of staff were interviewed from each museum, one from each 'type' of job (curatorial and educational). The first question all museum staff were asked was 'What does the phrase 'behind-the-scenes access' mean to you?'

There was an obvious divide between the two kinds of staff, who all have contact with the public as part of their job. Curators tended to give very practical answers, focused on the actual spaces involved (though not always); while education staff seemed to focus more on the experience: 'Stores, exhibition preparatory areas, offices for staff ... conservation, technical services' (curator); 'stuff you wouldn't normally see ... it would have to be pre-booked, and would need specific objectives that were planned' (educator).

The interviews demonstrated that museum staff are often aware of the value of behind-the-scenes access, but are also very aware of the constraints they face in offering such access. There are clear issues within museums surrounding the provision of the kind of access that students require. These include factors such as limited space to carry out handling, and a lack of staff time to facilitate such access. They also include important arguments relating to a museum's duty of care to its collections, and the often fragile nature of the objects themselves. However, when discussing what they did offer, it was clear that there is a great

deal more on offer than many visitors are aware of. With regard to the Prints and Drawings room at the V&A, for example, one curator commented 'People don't think they can just walk in', although the nature of this access is advertised in museum literature.

As well as museums considering ways in which to advertise their services better, it is also important that museum staff consider the range of potential requirements of their visitors. One educator commented that 'the nicest things are out on display, so why look at the things that are not as nice?' It is clear from the research in various projects that we have done, and in the examples given in this book, that aesthetic issues of 'niceness' are a contested view and a matter of perspective and are not always a key consideration of design students (or, indeed, other visitors). While it is understandable that, given a number of examples of a similar type of object, a museum would choose to display the most aesthetically pleasing one (whether the ultimate purpose of display is of aesthetic, socio-historical, or cultural significance, for example), there can also be a great deal of value in providing access to objects that are not quite as 'nice' to look at but may demonstrate specific qualities and ideas. The issue as to how museums can provide access to these different kinds of objects is important. The experience of design students as they develop interrogative skills and learn to create or realise objects often relates directly to what they go on to do after graduating.

Conclusion

The *Exploring the relationship between teaching and learning through practice* report concluded that in the context of learning through demonstration 'students employed several methods of learning: imitation, emulation, tacit learning through observation and employment of other senses; intuition through sharing work with the demonstrator, theoretical through verbal instruction, experiential through practice, analysis and the process of application' (Boyes, et al. 2008: 31). In the wider context of learning about materials practice, this list would be broader still. It is clear that drawing is only one of a number of skills that a successful design student must develop, and that are useful in a museum context. Both design tutors and museum staff need to consider a wider range of ways that museums can complement other areas of a design education. This need not be to the detriment of other visitors. The temporary introduction of a series of object labels written by a different profession (than curatorial), for example, could provide an interesting alternative perspective to a number of objects (see Chapter 5).

Museums need to consider how they can offer students the extra information that they need. 60–100 word labels, though used for very important reasons, may not provide adequate information for the design student. This information may be available in other places, but museums need to be clear about how students and other researchers can gain access to it. Alternative ways of displaying objects are also worth considering. Displays that allow the backs of objects to be seen, for example,

would provide valuable information – not just when the back has aesthetic value, but when it displays information about, for example, the construction of the item. Design students also need to take responsibility for finding this information out.

As design students 'learn to see' they may use a combination of skills and previous knowledge to visually dissect an object. The more of the object they can see the more successful this process is. The more the student can bring their experience to the museum and then take this back to the studio, the more enriched design education might become. This relates to a wide range of information such as the number of pieces that any object might be made of, the order in which decoration was applied, or the kind of sewing stitch used to attach pieces together. This is all information students can apply to their own practice, and demonstrates the significant role that museums can play in their development as designers and makers.

As well as learning to interrogate, students and tutors are also interested in developing relationships with both museum contents (individual objects) and museum processes (what happens behind the scenes, or in a placement situation). However, students and tutors need to consider what museums offer them, as well as what they do not. Museums offer the opportunity for 'imitation', 'emulation' and 'tacit learning through observation' (Boyes, et al. 2008) – seeing key and iconic examples of work in their field, and accessing information about those objects. The practice of drawing, fundamental to the development of art and design as a discipline, remains key as a way of analysing and recording details, impressions and the form and structure of objects, and allowing students to document their experiences. Drawing is an experience that museums are well equipped to facilitate.

One of the key things that has emerged in CETLD research is the importance of developing interrogative skills, and the difficulty of articulating ways of doing this.

It is nonetheless important that both looking to learn and drawing are understood by students and tutors (and museum staff) not just to be about recording the object. The examples given in this chapter demonstrate that a visit to a museum can provoke responses that go beyond the gleaning of approved knowledge that Cole and his contemporaries considered vital to a design education. They also make clear the potential value of student engagement with museum collections and exhibitions, and that museums can potentially have a great influence on design education and on the development of design students by providing opportunities for object-based learning and visual research to take place.

The challenge in understanding remains in balancing ideals and reality. Museums will need to consider and exploit the range of possibilities inherent in a student visit, and the ways in which they advertise and communicate these to this audience. Equally, students often need to consider in more depth what they gain from a visit, perhaps looking to learn and learning to see; understanding, interrogating and engaging in a wider sense with the relationship between their studio and workshop practices. They need to draw on those experiences in learning about other objects, and consider how the amalgamation of these experiences

and embodied knowledge helps them develop their wider skills as designers and makers.

Bibliography

Anderson, D. (1997) *A Common Wealth: Museums and Learning in the United Kingdom*. London, Department of National Heritage.

Bell, Q. (1963) *The Schools of Design*. London, Routledge and Kegan Paul.

Boyes, A., et al. (2008) Exploring the relationship between teaching and learning through practice. Retrieved 30 April 2009, from <http://cetld.brighton.ac.uk/projects/completed-projects/through-practice/final-report>

Candlin, F. (2001) A Dual Inheritance: The Politics of Education Reform and PhDs in Art and Design. *International Journal of Art and Design Education* 20/3, 302–310.

Fisher, S. (2007) *How do HE Tutors and Students Use Museum Collections in Design?* Qualitative Research for the Centre of Excellence in Teaching and Learning through Design. Unpublished report.

Keene, S. (2008) *Collections for People: Museums' Stored Collections as a Public Resource*. London, UCL Institute of Archaeology.

Macdonald, S. (2004 [1970]) *The History and Philosophy of Art Education*. London, The University of London Press.

RIN (2008) *Discovering Physical Objects: Meeting Researchers' Needs*. Research Information Network.

Speight, C. (2005) The History of Art and Design Education. Unpublished report.

Chapter 8

Design Learning in an Australian Museum: A Partnership Project Between the Powerhouse Museum and the University of Technology, Sydney

Geoffrey Caban and Carol Scott

This chapter describes an Australian case study that explored the role museums can play in design learning. It begins with the research question that provided the impetus to the project and then examines the results of a pilot study involving museum visits undertaken by first year university design students. It concludes that the museum setting offers a rich laboratory for students to construct their own frameworks for learning about design and creativity.

Every good research project begins in a spirit of enquiry. In the case of a collaborative pilot study initiated by the School of Design at the University of Technology, Sydney (UTS) and conducted at the Powerhouse Museum in Sydney, Australia, the project arose from questions about what design students need to learn to be effective creative practitioners, how they learn and what conditions are required to facilitate that learning.

Underpinning the university's interest was a view that design graduates need to be prepared to embrace emerging opportunities for design thinking skills within the new knowledge and creative economies. It was suggested that, by giving design students greater control over what, when, why and how they learn, it might be possible to broaden the scope of the design graduate.

Research conducted by Wilson at UTS found that the capabilities and learning styles of design students can shift significantly during the four years of a university design course, and that design students become independent and effective learners through access to a larger and more diverse range of educational resources and experiences (Wilson 2000). In later research, Caban and Wilson argued that the design learning process is enhanced when students have developed an understanding of their personal learning styles (Caban and Wilson 2002). The findings from these studies had some resonance with constructivist learning theory which maintains that individuals construct their own meanings according to their personal experiences and that they learn by accumulating experiences from a wide range of sources and settings (see Chapter 3).

Learning settings for design education have followed a predictable pattern. There has been some appreciation by design educators of the value to the learning process of industry and workplace experiences, and the curriculum of most design schools includes industry-based projects and some form of workplace experiences. But the magnitude of learning experiences that can take place outside the academic setting and the studio has not been appreciated fully by design educators, many of whom continue to believe that the learning experience takes place almost totally within the design school, and who have developed the design curriculum on the basis of this belief. This contradicts the considerable body of evidence that most learning experiences occur in settings that are external to the university. Falk, for example, identified three domains that comprise a learning superstructure: the school, the workplace and the 'free choice' learning sector where, in contrast to the more formal environments of the school and the workplace, the type of learning that occurs is characterised by learners' control over what, when, why and how they learn (Falk 1998). The museum is one of Falk's 'free-choice' learning domains and the domain referred to by Hein in his discussion of constructivist learning (Hein 1995). Hein argues that the visitor constructs personal knowledge from an exhibit, and that the process of gaining knowledge is itself a constructive act.

It was felt that it would be in the best interests of design educators to know more about design learning in free-choice settings, about the degree of compatibility between designers' learning styles and free-choice experiences, about the potential of particular free-choice settings for design learning, and about ways in which design schools can enhance free-choice learning experience. With these issues in mind, the university sought a partnership with the Powerhouse Museum to explore these research questions. The Powerhouse is the brand name for the Museum of Applied Arts and Sciences. Located in Sydney, it is the largest museum in Australia, with a collection which spans science and technology, social history, design, decorative arts, industry and communication. As such it was aptly positioned to assist.

A brand audit conducted in 1998 had revealed that the overriding attribute associated with the Powerhouse Museum was 'creativity'. A rebranding strategy undertaken in 2000 had capitalised on this finding and promoted the design side of the museum. Audience research conducted in 1994 had identified design students as a growth market for the museum and the presence of an in-house evaluation and audience research team was available to support the project. The study commenced as the museum was planning to build a new permanent gallery to display its considerable design and decorative arts collection and reinvigorate the Sydney Design Festival, an annual city-wide program for which the museum was the coordinator and creative programmer.

A pilot study conducted in 2000 as part of the UTS-Powerhouse study involved 38 first year design students studying a range of design disciplines and distributed across four cohorts. Two of the groups were pre- and post-tested for change in their understanding of design as the result of visiting exhibitions at the Powerhouse

Table 8.1 Methods used in study

CONTROL 1		CONTROL 2	
Group A Visit to *1000 Years of the Olympic Games and Bayagul: Contemporary Indigenous Communication*	Group B General museum visit: self selection of any/all exhibitions	Group C Presentation by designer of *1000 Years of the Olympic Games*	Group D Presentation by designer of *Bayagul*
Personal Meaning Mapping	Personal Meaning Mapping	Personal Meaning Mapping	Personal Meaning Mapping
View exhibition with audio guide	View exhibition	Presentation by designer	Presentation by designer
Personal Meaning Mapping	Personal Meaning Mapping	Personal Meaning Mapping	Personal Meaning Mapping
Mastery test	Mastery test	Mastery test	Mastery test

Museum (Groups A and B). Two others were tested before and after listening to lectures by two exhibition designers (Groups C and D).

The methodology and outcomes of the pilot study have been reported fully elsewhere (Caban, et al. 2002). In this context it is important, however, to reiterate that the purpose of the pilot exercise was to compare the impact of museum visits on student learning with the learning of the traditional academic studio. For both cohorts, the research question focused upon the relationship between museums and design. Personal Meaning Mapping, a methodology designed by Dr John Falk to measure the extent, depth, breadth and mastery of concept change, was applied to this study.

Design Learning in Two Settings

Every effort was made to ensure parity in terms of the quality and standard of experiences offered to the two cohorts. The two lectures were delivered by exhibition designers who were engaging, experienced, knowledgeable and well organised in their presentations. As a result, both cohorts demonstrated positive changes in the extent, breadth and depth of their understanding about museums and design. A distinction was identified between the type of learning that occurs within the context of the free-choice environment and the constructivist framework of the museum, and the learning that takes place in the academic setting.

Learning in the Academic Setting

Nineteen students listened to lectures by exhibition designers. A selection of their comments following the designers' presentations is offered here.

Respondent Two associated museums with innovation in design. After listening to the presentation by the designer, this student realised that you could be 'innovative in designing the areas around the objects – to see them in a new way' and was impressed by 'the way he designed the exhibition space … Seeing things in ways you wouldn't normally see. Linked to placement and lighting'.

After hearing the lecture, Respondent Six also became more aware of the designer's use of 'sensory displays and ambience … using light and different structures to create a mood'.

Respondent Nine saw museums as offering a space within which to experiment. The lecture made the student aware that the designer has to

> … gain an understanding of the nature of the space and how to take their design elements and incorporate them into the exhibit space (integrity of the area museum how their existing spaces can strengthen the design). The viewer is not only experiencing the exhibit but the museum as well – creating a balance between the two and how they can compliment each other.

Respondent 15 was interested in the concept of creating an appealing style through design. After listening to one of the lectures, this student became aware of the important role that materials can play to evoke a style. The indigenous designer who discussed her work impressed this student with her use of materials to make symbolic statements: '[She used black] glass in the floor of Bayagul. Making can show you a lot about what you're trying to represent. Also symbolism e.g. glass in floor actual glass casing to represent fragile nature'.

In this cohort, the students learned something about the design process, the choices and the selections that are made by designers in the course of their work. Their learning base was, however, constructed for them and their increase in understanding was related to the content selected by the lecturer.

Learning in the Museum

The students in this cohort were interviewed prior to and immediately after their museum visit. Their responses are qualitatively different to those of their colleagues in cohort two. The learning is more individualized and personal with greater variety between respondents depending on what each selected to see and what elements of the exhibition caught their attention. There is an element of discovery about many of the comments and evidence of people coming to terms with the nature of free-choice learning in a museum setting even though this was not identified as a focus question.

Respondent 25 wandered into an exhibition about the building of a major post-World War Two irrigation scheme by migrant labour and realized the 'effects – good/bad of past decisions. Some people were benefited by the Snowy River scheme but farmers didn't benefit – able to show wasn't all good and bad – effects on immigrants how it was hard living – exhibit museum design allows you to tell these 2 sided stories.'

When asked to think about museums in relation to design, Respondent 26 associated museums with 'places that generate ideas', a notion associated with the idea of the museum as a creative and inspirational archive. 'A lot of people can't automatically generate ideas. Museums can stimulate ideas, museums can be a base, can build ideas from the work of others.

Respondent 27 associated museums with 'learning'. The museum visit confirmed this but the student was more aware that the experience of learning in museums is carefully constructed and designed.

> I still believe that's true it's offered to you with little signs and displays mostly in a sequential way. This is a good thing (for my brain) and for small people (children) because it's easy to understand mostly visual communication and if it is affective you'll go up and look further. Museums must attract people first through the display.

'Discovery, just develops as go along – pretty impressive how it unfolds' was the comment of Respondent 36.

An exhibition about the Olympic Games in Ancient Greece stimulated another respondent to ponder an object and see its associations and uses beyond the display: 'Those cleaning things from the Greeks stirgles – got me thinking – it says, "the curved shape fits the contours of the body" – got me wondering what were they scraping off- looked horrible. Interesting that it was scraping, they didn't use water at all'.

Respondent 30 was fascinated by the interactive displays and noticed '… schoolchildren pressing the section and not just itching to get outside and have lunch. Most of the ones [exhibitions] I saw today were quite interactive and included whole branch of media, film house.'

Respondent 33 responded to the 'variety of interfaces' and 'a whole lot of different approaches to presenting the information. By "interface" mean print, moving image, interactive, footage.'

Another student respondent experienced first-hand the issue of visitor paths in exhibitions and started to think about the issues involved in designing visitor flow:

> Like walking through an exhibition not too many people around it – get to one spot and lots of people around it listening to the same exhibit. Designing exhibits that are opened so if the one exhibit is going to take longer there should be more area around it. I think flow is important so that when you walk in that you know

where you're going so don't miss anything – as I think about, not sure that I agree with it – because sometime go in and find a little bit unexpectedly and then whither a little bit.

What impressed Respondent 39 was the power, the potential and the accessibility of the visual: 'We don't know about – read about things. Exhibitions present those – better in exhibitions – visually rather than words – tends to get you more interested if not really interested in first place'.

Discussion of the Findings

The responses from the two museum visiting groups in this study suggest that museums as free-choice settings facilitate a constructivist approach to learning. 'Because meanings are embedded in the experience rather than explicitly stated, the individual can gain an entirely new perspective on the world and how he or she perceives it' (McCarthy, et al. 2004). This experiential learning is deeply personal and can produce many types of cognitive and affective outcomes. Scott found that these outcomes can include perspective, reflection, enlightenment, discovery, inspiration, awareness, empathy and joy and that it is the unique experience of the museum – engaging, sensual, visual, non-formal and mediated by objects – which facilitates this learning and is highly valued by the public (Scott 2003).

Museums can contribute to design learning in three ways. In the first instance, they offer the optimal conditions for the type of constructivist learning described by Hein (Hein 1995) (see Chapter 3) and facilitate the independent learning advocated by Wilson (Wilson 2000). In addition, however, they are ideally suited to address the specific needs of design learners.

Travers suggests that a key dimension of the value of museums lies in public access to the ideas archive, in the inspiration that the archive provides and in the potential it offers for new products, processes and solutions (Travers 2006). This is a view shared by the Independent Working Group for the Prime Minister's Science, Engineering and Innovation Council (PMSEIC) in Australia, which recommended that: 'the role of the cultural sector should also be taken into account alongside the creative industries. The Working Group considers that this inquiry necessitates inclusion of the public access role undertaken by these sectors such as libraries, archives, galleries, museums and arts organizations' (PMSEIC 2005). Travers concurs, stating that 'the role of museums and galleries ... in promoting and encouraging creativity should not be overlooked' (Travers 2006: 11). Future, high value-added economic activity may be based on ideas stimulated by museums. 'Thus, the sub-sector will help in the development of new services, products and even manufactured goods' (Travers 2006: 7).

Importantly, public respondents to Scott's Australian study had these opinions of museums: '[Museums provide] stimulus to the creative process, by exposing original ideas and experiments they lead to future developments (Public cohort:

male, non-visitor, 55–70, urban resident) … museums help us to foster our creative imagination in a multitude of ways. Passionate people are productive people' (Public cohort: male, non-visitor, 35–50, urban resident)

Implications for Design Educators

For design educators, the museum setting would seem to offer a unique experience outside of the academic studio. This setting is visually rich, spatially complex – a space where students can construct their own meanings about what it means to design for an end-user. While many educators have sensed that some valuable opportunities for design learning are available in museums and other 'free-choice' settings, they have so far lacked evidence of the distinctive learning outcomes. The UTS-Powerhouse study provides encouragement for further research in this area, and for more formal learning and teaching links between the museum and the academy.

Outcomes for the Museum

This study occurred at a 'tipping point' in the Powerhouse Museum's strategic planning and positioning. The findings became part of an internal conversation which ultimately resulted in an added investment into attracting the design community, both student and professional. An annual Sydney Design Festival, coordinated by the Powerhouse and engaging partner venues across the city, now attracts over 100,000 visitors during two weeks each August. A monthly late night 'conversation' about design has forged an established place with design students from the University of Technology, Sydney, other university design centres and the professional design community. And the partnership continues. When the Powerhouse initiated a design hub website (Powerhouse 2009) to provide an online resource to the design community, it sought to engage UTS as one of the principal partners.

Conclusion

The positive outcomes of this pilot study suggest directions for future research. There is scope to explore how the museums sector can enhance the work of designers and design educators and ultimately raise the quality and creativity of design by: providing structured access to design collections; showcasing design innovation; promoting conversations about design; building better public awareness and understanding of design culture and its contribution to creative economies.

The most successful economies and societies in the twenty-first century will be creative ones. It remains for museums to discover the full role that they can play in contributing to this world.

Bibliography

Caban, G., et al. (2002) *Museums and Creativity: A Study into the Role of Museums in Design Education*. Sydney, Powerhouse Publishing.

Caban, G. and Wilson, J. (2002) Understanding Learning Styles: Implications for Design Learning in External Settings. In Davies, A. (Ed.) *Enhancing Curricula*. London, RIBA, 128–143

Falk, J. and Dierking, L. (1998) *Understanding free choice learning: a review of the research and its application to Museum websites*. Museums and the Web, Annapolis. Retrieved 15 October, from <http://www.archimuse.com/mw98/papers/dierking/dierking_paper.html>

Hein, G. (1995) Evaluating Teaching and Learning in Museums. In Hooper-Greenhill, E. (Ed.) *Museum, Media, Message*. London, Routledge, 189–203.

McCarthy, K., et al. (2004) *Gifts of the Muse: Reframing the Debate about the Benefits of the Arts*. Santa Monica, Rand Corporation.

PMSEIC (2005) *Imagine Australia: The Role of Creativity in the Innovation Economy*. Canberra, PMSEIC.

Powerhouse (2009) D*hub website. Retrieved 15 May 2009, from <http://www.dhub.org/tlc.php?id=1>

Scott, C. (2003) Using Values to Position and Promote Museums. *The International Journal of Arts Management* 11/1, 28–42.

Travers, T. (2006) *Museums and Galleries in Britain: Economic, Social and Creative Impacts*. Museums, Libraries and Archives Council (MLA) and the National Museums Directors' Conference (NMDC).

Wilson, J. (2000) *Change, Change and More Change: Redefining the Student Profile in Design*. International Conference on Design Education. Curtin University.

Chapter 9

Museums and Material Knowledge: The V&A as Source in Fashion and Textile Design Research

Torunn Kjølberg

'The artefacts we have received in turn influence the artefacts we choose to make' states the anthropologist Daniel Miller; as human beings 'we order things and are ordered by things' (Miller 2007: 167, 169). For few is this more apparent than for designers and design students. The world's mass of objects can simultaneously inspire and crush those who try to imagine their transformation. The awareness that design is more re-design than the inception of an entirely new artefact seems to be a source of both comfort and frustration to aspiring designers.

A national museum of design and decorative arts can make this especially palpable. Here, layers of disciplinary traditions, aesthetic values and aspirations, and ideologies and priorities, are embedded in the thousands of artefacts on display, though the objects' discordant voices are muted by curatorial order. Still, museum objects are continuously sought out by artists and designers, students and professionals, as sources of inspiration and material knowledge. We do not know much about how this group of visitors engage with museums in their creative practice despite the surge of emphasis on visitor studies and museum learning[1] and debates concerning what constitutes research in art and design (Rust, et al. 2007).[2]

This chapter will examine the role of the V&A as a resource for fashion and textile design students in their design projects. This case study forms part of an ethnographic PhD project examining students' visual and conceptual investigations which feed their design work; what is frequently termed 'visual research'. My study, rather than seeing people and things, subjects and objects as belonging to separate spheres, perceives them instead as networks of actors, all active in creating the museum experience, though not equipped with equal power to act. Visitors' perceptions and personal interpretations of museum objects are enabled and disabled through display. Our experiences are directed through how objects are framed, encased, grouped, explained, celebrated or bypassed.

1 Tickle discusses a study of four artists working with a museum collection (Tickle 2003).

2 See also *Working Papers in Art and Design* from the University of Hertfordshire (Various 2000–2006).

When the objective of a visit is to record and reinterpret museum artefacts and incorporate them to form new objects and meanings, the museum becomes a significant force in directing design practices: what we make is conditioned by what we have; the objects of the future are dependent on the objects of the past. However, the museum and its objects are not the only meaning-making forces in guiding design students' interpretations. What is perceived and the meanings that are made are also conditioned by cultural competence, 'aesthetic disposition' (Bourdieu 1984) and the 'regimes of truth' (Foucault 1980) existing within our society. On a less abstract level the intended outcome of these museum visits (the gathering of inspiration and ideas for design projects) is conditioned by the students themselves, by the methods they employ (be it drawing, photography or collage), the materials at hand (pencils, crayons, marker pens etc), by the display and by the museum objects themselves (physical properties, aesthetics, cultural meanings). For the purpose of clarity these elements will be separated out and unpicked, but what should hopefully become apparent in my argument is that these are not discrete entities but a network of interdependent factors.

Methodology

This project sought to uncover how learning is constructed within creative visual practice in fashion and textile design education using an ethnographic methodology. Ethnography is simultaneously a methodology and a theoretical orientation, emphasising first-hand exploration of a research setting and a concern with how people make meaning (Brewer 2000; Atkinson, et al. 2001). As a methodology it consists of a set of research techniques or methods, such as participant observation and qualitative interviews, which take place within a defined field (Hammersley and Atkinson 1995). Ethnography is also a product – as such, what I want to find out, how I seek to find it and what I make of it is ethnography.[3]

In this study I have followed a cohort of students over their first two years as undergraduates, focusing on the research component of their course. The methods include semi-structured interviews, gallery observation and accompanied visits. Throughout the fieldwork, photographic evidence has been gathered of the students' work in addition to observational notes, course documents and interview recordings. A group of twelve students, six from textile design and six from fashion design courses were interviewed at regular intervals throughout their first and second years at university. Another eight first year textile design students were interviewed about their visit to the V&A. Where these students are quoted, they are given first name pseudonyms.

3 For a discussion of ethnography as product and process see Pole and Morrison (2003).

The Victoria and Albert Museum

The V&A was established in 1852 as the 'Museum of Manufactures' and, following its move in 1857, was renamed the South Kensington Museum. The institution, which in 1997 was estimated to contain over 4 million items (Lehman and Richardson 1997), was founded on the idea that a museum of beautiful objects could educate the public and, more specifically, the students of design who were recruited to save British manufacturing industries from foreign competition. From the outset, the museum's collection and display policy was to select and present objects that were considered of particular artistic, aesthetic or documentary merit, and to utilise these for educational purposes.

The objects on display today span the last 3,000 years and are divided according to country or area of origin or consumption (the British Galleries, the Nehru and Jameel galleries, China, Japan, Korea), materials (ironwork, glass, ceramics, textiles), discipline (painting, sculpture, photography and fashion) or period (20th Century, Medieval, Renaissance). As Andrew McClelland points out, in large 'encyclopaedic' museums such as the V&A, displays of objects from around the world and from different historical periods are laid out as if to prove the existence of a shared and universal tendency to give visual expression to the human condition, transcending 'local inflection and historic specificity' (McLelland 2008).

The V&A is not a museum of 'design in the lower case' as Judy Attfield termed the 'material culture of everyday life' (Attfield 2000), but a museum of 'the best' examples of design classics and decorative arts. The objects' revered status as 'the best' is granted by the expert opinions of the curators who have deemed them worthy of display. The objects, and the visitors' perception of them, will always be framed by this judgement on which the status of the museum is largely based. Most of the objects on display are so rare or elite that few visitors will have had any direct personal experience of them; hence, for many of the students, making a connection between personal identities and experiences and the museum objects is sometimes difficult. Some of the students in my study state this as an important reason why they do not visit the V&A.

As Bourdieu and Darbel pointed out, aesthetic appreciation and museum visiting are not innate but learned practices associated with cultural capital (Bourdieu and Darbel 1991 [1969]). The V&A as an institution has legitimacy within the wider cultural and social context and a high profile both nationally and internationally. It is also considered the 'convention' and orthodoxy or 'tradition' ('Karen', personal communication, 27 March 2009); 'It's got a lot of baggage with stuffy – delightful collections but stuffy places that people have to go to' (Visual research tutor, personal communication, December 2007).

The V&A is *doxa*[4] and, though offering the potential to contest these conventions, for many students drawing in the museum involves complying with

4 The term *doxa* refers to the established and ingrained conventions within a period (Bourdieu 1977).

and adopting a sort of 'academy approach': careful, detailed drawings of museum objects. The central pedagogical idea behind this practice is to teach students 'to look'; by painstakingly drawing objects students gain a fuller understanding of them, and thereby learn directly from 'exemplary' objects of art and design. The copying by drawing of works of art can be seen as the foundation of modern art education (Ashwin 1975; Macdonald 2004 [1970]).

This approach, however, is time consuming and considered by the majority of both students and tutors in this study as not always useful for the purpose of visual research. Instead more interpretative and abstracted recordings are preferred, focusing on extracting elements that are of particular relevance and interest to the student's project. The visual research tutor quoted above suggested that if students want more detailed recordings they should use their camera: students should decide what they want to record and on the basis of that choose the most effective method of recording and the tools most suitable for the job.

This functional emphasis on research learning is concerned with time as a constraining factor and may seem as restrictive as the 'academy approach'. There is pressure on the student to produce outcomes from the visit that can be utilised in future studio work. Making decisions on what will be most useful is difficult and so students tend to make multiple recordings 'just in case'. Many of the students reported photographing every object they drew as an assurance in case their drawings and sketches would not 'give them enough' research material to work with.

Museum Objects

The museum consists of objects assembled according to historically shifting collecting policies. These objects have entered the museum through acquisitions, donations and loans and make up the museum's collections on which its existence relies. Most of the objects in the V&A's collections were not made for display but intended to serve a multitude of functions, most of which are now superseded by their identity as museum objects. They now only carry detached references to their previous role; for example the nineteenth century riding habit covers not a moving body but a cold, standardised reference to it; the wrought iron banister is forever wrenched from its original home.

Objects in the V&A include the new and old, the precious and mundane, commodities and relics, souvenirs and art. There are objects on display and objects hidden in storage, objects for sale and objects taken for granted. The objects have social, cultural, aesthetic, material, historical and economic qualities. They vary in status and they form relationships with other objects. They also form relationships with other mediators: student, institution, space, display and tools. All of these mediators are carefully interwoven, and the following sections will discuss the ways in which they relate as networks of actors.

What is important to emphasise, however, is that museums make objects explicit. Objects furnish practically every aspect of our everyday lives in ways

which mean they are often taken for granted or are invisible to us. Museum objects are different; their value is made evident and they are presented to us as material beings. For design students who must learn not to take objects for granted, museums are important for gaining material knowledge, whether it is to do with the drape of bias-cut silk, Japanese printing techniques, the history of indigo dye or the relationship between colour and light in stained glass windows.

The Student Experience

A key finding in this research project has been the extent to which the participants' research and design process is bound up with their identities, both in terms of perceptions of their individual creativities, personal histories and more collective identities relating to communities of practice (Lave and Wenger 1998). The students' sketchbooks or research folders become material expressions and sites for testing out ways of being in the world; making connections between the individual and collective, the past and present, the known and unknown. 'Denise', for example, explains how her Chinese background induces a feeling of discomfort in her experience with the dress collections at the V&A:

> D: I think because it's not in front of me so it's ok, because it's just looking at pattern, but I think if I actually held it I'd be like *uhum* yeah it's kind of a Chinese superstitious thing like my mum said that ... if – when people die you are meant to get rid of everything!
> T: That's interesting. So museums are almost like a ...?
> D: – Shrine to the dead! Yeah ... and in a Chinese memorial service you have to walk over fire to get rid of all the spirits that are following you. It's weird and then doing a degree where I have to look at old stuff all the time!
> ... I think if you look at it behind a cabinet it's fine. I think clothes specifically really freak me out, it doesn't really matter about furniture ... yeah, old clothes. Especially when they're on the mannequin and you can see the shapes of them. ('Denise', personal communication, December 3, 2007).

In Chinese culture the clothes of someone who has passed away can be seen as embodying their spirit, hence, she comments, the museum can be 'a shrine to the dead'. She recognises this belief as a superstition but nevertheless feels a strong disquiet in being too close to worn clothing (it is better if it is behind glass or the signs of wear are not too evident). For a knitwear project based on Ikat printing techniques, she preferred to work from images in the exhibition catalogue rather than with the objects on display.[5] Though British-born, Denise identifies the influences of her Chinese cultural background and ethnicity as significant to her experience

5 Exhibition, Central Asian Ikats from the Rau collection, V&A 5 November 2007– 30 March 2008 (V&A 2008).

in the museum. Significant here is the 'negotiation of difference' (Sherman 2008) which museums as culturally located institutions bring into play. This student's experience also highlights the complex relationships formed between visitors and objects. According to the belief system described by the student, clothes are not simply 'objects', divorced from *us*, the subjects. Instead they are invested with the stories of their past lives and owners.

In the following extract 'Sarah' responds to how she would perceive her ideal V&A to be. Her response is linked to the challenges she experienced 'of being in people's way' whilst doing the research.

> ... Yeah, [my ideal V&A would be a] sort of a minimal space ... with the work, a bit more spread out. And also more room, people can't just sit and look at the work and doing the drawing without feeling – because I also felt, sometimes when I was sat and like people walking around me, that I'd be in the way and like: 'Sorry I am trying to be as quick as I can' rather than like feeling comfortable, just sitting around not being in people's way, just getting on with it so ... an easier space to work in' ('Sarah', personal communication 3 December 2007).

The discomfort she feels, emotional rather than physical, is social but interwoven with the physical space. She chooses her materials and methods of recording (a quick pencil sketch or photograph) according to the presence of others and how the item is placed (as a part of a group, high up or low down, in front of or behind other objects, behind glass, against the wall). The interior of a building is also pointed out as influential; she prefers the bare rooms of contemporary art galleries where there is minimal visual interference surrounding the object. Objects are harder to see and 'get at' when there is visual overload; the mass conceals the individual 'thing'.

This form of museum use is a dialogic, creative and social practice. In the V&A, the student, museum object, the sketchbook or camera, the institution itself, the display cabinet, plinth, fellow students, tutor and other visitors, are all participants in the student's research process, though some more overtly than others.

The notion of play and the activity of 'playing around' quickly emerged as key to students' perceptions of their creative practice. To 'play around' seemingly contrasts with the seriousness and assumed rigour of 'doing research'. The participants' descriptions of play centres around a notion of being 'at one' with the work, a trance-like state, where the separation of subjectivity (their sense of self), activity (what they are doing) and product (what they are making) becomes almost indistinguishable.

Further, the students associate the activity of play with rest, freedom from stress and time pressures, intrinsic motivation and emphasis on process and activity rather than specific outcomes. 'Playing around' is often used interchangeably with 'doodling'. The psychoanalyst Donald Winnicott suggested that play is a condition for creativity: '[it is] in playing, and perhaps only in playing, the child or adult is free to be creative' (Winnicott 2005).

The students' own perceptions of the V&A as either 'intimidating' or 'comforting' has implications for the museum as a potential creative space, as somewhere conducive or restricting to play and, by extension, creative practice. Emphasis on effective use of time and on outcome and product rather than process, as indicated earlier, may also be detrimental to creativity and deep learning in the museum. There is a strong correlation between familiarity with the museum (frequency of visits) and the level of creative engagement with the objects. Possible reasons are: a) deep and independent learners are more likely to visit museums and exhibitions, b) the student's cultural competence and socio-economic background may influence the way they use the museum and c) the enormous scale of the museum means familiarity with the collections is a significant advantage.

Museum Display

Glass cases protect and separate the visitor from the museum's objects upon which its institutional value is largely judged. The display maintains order; protecting, presenting, positioning, contextualising and interpreting the objects:

> In [the] galleries, sometimes the cabinets that are against the wall – like they are choosing which side of it you see, and then sometimes I think it would be nice to see what it looks like from the other side or underneath it as well. Because people think the underneath bit is boring but sometimes it's just as interesting, or sometimes just what you can see through the bottom, the glass especially, a different distortion ... ('Sarah', personal communication, 3 December 2009).

Cabinets limit the sensory experience of objects to vision; denying smell, touch and sound. It will therefore always be a relationship at a distance, though sometimes this distance may mean objects become easier to read. Flattened by its display case, the possibilities of the object, which may otherwise seem too infinite, become delineated. We also need to understand the meaning of the glass case: the object should be revered, protected from the grubby hands of the public so it can be preserved for posterity. The display of the object will determine what we see and how we see it; in those terms it is the curator who usually decides what aspects of the object most warrant our gaze. For example, we might not see the side of the vase which is chipped, or the stain on a dress hidden by the object label. The frustrations and practical challenges of display cases are explicitly stated here by 'Anna':

> I like the fact that in the textile room you can get close up to it. It frustrates me a lot when you go around the museum – and I *know* they have to do it for protection, I completely understand, but I just want to like *look* at it without the bang, you know, glass shutting off the thing, so it's quite hard and like reflections

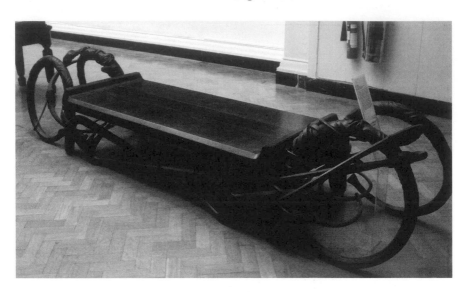

Illustration 9.1 Iron bench (Albert Paley 1994)

when you're taking pictures and those sort of things just make me *ah!* [frustrated expression] ('Anna', personal communication, 29 December 2007).

Students prefer to draw objects outside of their cases. The object shown in Illustration 9.1 is one of the few objects on display that invites the audience (explicitly) to touch it – or more specifically to sit on it. Several students talk about and have recorded this contemporary wrought iron bench with a wooden seat. 'Denise' states: 'I went to ironwork and I found this bench that you can sit on, and I was like wow! I really love that!' ('Denise', personal communication, December 3, 2007).

Why is this object so attractive? The bench occupies a central location in the Ironwork Gallery, a space which is usually relatively quiet. It is placed on the floor and is not protected by glass. Though it is related to the other objects in its material, the iron bench stands out because it is a contemporary piece. The object lends itself to abstraction, and though difficult to photograph as a whole, due to its size and other surrounding objects, it is easy to capture interesting details. Its somewhat quirky design means it quickly becomes something other than a bench. As in the student sketch below (Illustration 9.2) it is recorded less for its 'bench-ness' than for its sense of moving, organic lines intersecting – its 'swirly-ness'. The bench can also be tested out, a label invites the visitor to sit on it. The experience becomes haptic (how does it feel to touch?) and bodily as well as visual. New angles can be found (what does it look like from above or underneath?). Having been 'desacralised' for human interaction by the museum, it may be a comfortable interruption to the intense focus on vision that characterises most museum visits.

Illustration 9.2 Student's detail sketch of iron bench (Anonymous)

Conclusion

We experience objects primarily through sight and touch, though smell and taste also form an important part of our material knowledge. The importance of material knowledge is particularly explicit for design students. Is the cloth hard, soft, wet, dry, cool, crumpled, light, heavy, strong, brittle, smooth, coarse, jagged, glossy? What is it made of? What is its historical background? What is its environmental impact? The museum takes such knowledge seriously and thus makes explicit the lives of objects from their inception, production and consumption to their re-design.

According to the Russian learning theorist Lev Vygotsky the learning self is developed in interaction with other selves and through the use of cultural tools such as language and artefacts (Vygotsky 1978). 'Play' or 'playing around' is considered by the participants to be key to visual research practice and the design process, and so a challenge in using the V&A as a learning space for visual research is the fact that it does not encourage 'play' – or at least it is not perceived to do so. It is organised, structured, supervised, surveyed and controlled and so students find challenging its orthodoxies and constraints difficult; though transgression may potentially be part of the thrill. The students who are most successful in their use of the museum – who reinterpret museum objects to serve their own ideas, are the students with the highest level of 'museum competence'. Frequency of visits and

the degree to which the participants see museums as relevant to their own practice relates, unsurprisingly, to familiarity – particularly being taken to visit museums as a child, and an independent and usually deep approach to learning (see Chapter 3 for a description of deep and surface learning).

This chapter has aimed to draw out and reflect on the issues at play in fashion and textile design students' engagement with the museum as a learning resource, where the inspirational object may become a release mechanism for creative endeavour. As such, objects of the past and present condition the objects of the future. These objects and the particular qualities that make them 'resourceful' are not arbitrary. They are located within a dialectical relationship that includes the physical properties of the object, its locality, its history and status, traversing the person's subjectivity, learning style, even physical well-being (interaction with objects will necessarily be different if sitting comfortably or standing on tip-toe) to a degree where they are tricky to disentangle. Changing one factor impacts on the other mediators.

This non-dualistic emphasis points to the irreducible relationship between cultural tools and the individual and offers a foundation for a model of creative research and the design process. Objects and people are co-produced. Through their research, students explore their sense of self and where they belong in the wider world, as learners, makers, interpreters and designers. These issues should have implications for museum interpretation and pedagogy by drawing attention to the possibilities and obstacles in visitors' creative engagement with the museum and its collections.

Bibliography

Ashwin, C. (Ed.) (1975) *Art Education: Documents and Policies 1768–1975*. London, SRHE.

Atkinson, P., et al. (Eds) (2001) *Handbook of Ethnography*. London, Sage Publications.

Attfield, J. (2000) *Wild Things: The Material Culture of Everyday Life*. Oxford, Berg.

Bourdieu, P. (1977) *Outline of a Theory of Practice*. Cambridge, Cambridge University Press.

Bourdieu, P. (1984) *Distinction: A Social Critique of the Judgement of Taste*. Cambridge, MA, Harvard University Press.

Bourdieu, P. and Darbel, A. (1991 [1969]) *The Love of Art*. Cambridge, Polity.

Brewer, J.D. (2000) *Ethnography*. Buckingham, Open University Press.

Foucault, M. (1980) *Power/knowledge : Selected Interviews and Other Writings, 1972–1977*. London, Harvester Wheatsheaf.

Hammersley, M. and Atkinson, P. (1995) *Ethnography: Principles in Practice*. London, Routledge.

Lave, J. and Wenger, E. (1998) *Communities of Practice: Learning, Meaning and Identity.* Cambridge, Cambridge University Press.

Lehman, A.L. and Richardson, B. (1997) A Grand Design: A History of the Victoria and Albert Museum. London, V&A.

Macdonald, S. (2004 [1970]) *The History and Philosophy of Art Education.* London, The University of London Press.

McLelland, A. (2008) Art Museums and Commonality: A History of High Ideals. In Sherman, D.J. (Ed.) *Museums and Difference.* Bloomington, IN, Indiana University Press, 25–59.

Miller, D. (2007) Artefacts and the Meaning of Things. In Knell, S. (Ed.) *Museums in a Material World.* Abingdon, Routledge, 166–185.

Pole, C. and Morrison, M. (2003) *Ethnography for Education.* Maidenhead, Open University Press.

Rust, C., et al. (2007) AHRC Review of Practice-Led Research in Art, Design and Architecture. Retrieved 29 April 2009, from <http://www.archive.org/details/ReviewOfPractice-ledResearchInArtDesignArchitecture>

Sherman, D.J. (Ed.) (2008) *Museums and Difference.* Bloomington, IN, Indiana University Press.

Tickle, L. (2003) The Gallery as a Site of Research. In Xanthoudaki, M., L. Tickle and V. Sekules (Eds) *Researching Visual Arts Education in Museums and Galleries.* Dordrecht, Kluwer Academic Publishing, 167–182.

V&A (2008) Central Asian Ikats from the Rau Collection. Retrieved 6 January 2009, from <http://www.vam.ac.uk/collections/asia/past_exhns/Ikat/index.html>

Various (2000–2006) *Working Papers in Art and Design.* University of Hertfordshire. Retrieved 29 April 2009, from <http://sitem.herts.ac.uk/artdes_research/papers/wpades/index.html>

Vygotsky, L. (1978) *Mind in Society: The Development of Higher Psychological Processes.* Cambridge, MA, Harvard University Press.

Winnicott, D.W. (2005) *Playing and Reality.* London, Routledge.

Chapter 10
A Conversation across Disciplines

Rebecca Reynolds

This chapter presents a conversation between Chris Rose, principal lecturer in 3D Design at the University of Brighton and visiting professor at Rhode Island School of Design (USA), and Norbert Jopek, Sculpture Curator at the V&A. It takes place in the V&A's Cast Courts, large galleries originally opened in 1873, which contain plaster casts of what were then considered the best works of art from Northern Europe, Italy and Spain. People not able to go on a Grand Tour to see these works in situ, including students of art and design, could view them in the Courts.

The Cast Courts have an enduring fascination for Chris Rose, and he has visited them periodically over the years. Norbert Jopek, as an expert in late Gothic and early Renaissance sculpture, has in-depth curatorial knowledge of many of the objects in the Courts.

Chris and Norbert strolled through the Courts for 40 minutes, stopping at three places to discuss the objects they encountered. In doing so they drew on their different areas of expertise and preoccupations in interpreting objects. This conversation was recorded and edited by Rebecca Reynolds.

Norbert Jopek chose the first stopping place, the figures of Ecclesia and Synagogue, for the innovative sculpture techniques used. This was the first time Chris Rose had looked at them. The second and third objects, the Brunswick lion and the tomb of St Sebaldus, had been picked out by Chris Rose on a previous visit as objects he would be interested in exploring further.

As the curator and design tutor/practitioner talk to each other, areas of overlap and difference between their approaches to understanding objects are revealed. There may be resonances with points made in other chapters about interpretation and understanding of objects in the museum and HE sectors. The conversation presents a composite picture of the objects for the reader and is one example of the process of interpreting and understanding objects through a conversation across disciplines. It is also an example of the continuing challenge and pleasure of interpreting and using a gallery which was set up according to cultural and pedagogical precepts greatly different to those of today.

Ecclesia and Synagogue

NORBERT JOPEK: These two figures [see Illustrations 10.1 and 10.2] come from Strasbourg Cathedral, they are casts of the originals and they can be dated

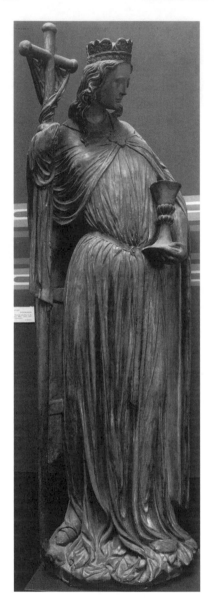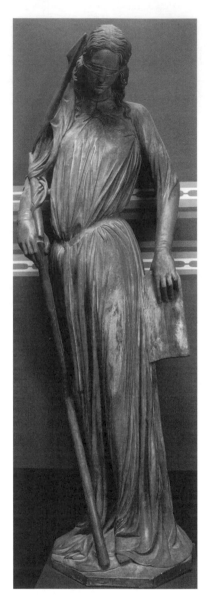

Illustration 10.1 and Illustration 10.2 Personification of the Church (Ecclesia), and Personification of Synagogue

to around 1230 to 1235. On the left we have Ecclesia, the symbol figure of the New Testament, and on the right we see Synagogue with a broken spear and banner, which symbolises the Old Testament. She is blindfolded, since she doesn't recognise Christ. These two figures were made in a workshop in Strasbourg.

I would like to put the emphasis on the naturalism of the robes which really resemble clothes from that time. They are silky and fall down in these wonderful folds. Also the clasps represent contemporary jewellery – even the belts. Ecclesia has a quatrefoil clasp, while Synagogue has a rounded clasp. These resemble jewellery of 1230 to 1250.

CHRIS ROSE: Yes, I love the whole phenomena of inflecting the delicacy of the human form through the use of drapery, which is a discipline. If one's learning to draw a subject you have a personal relationship with, such as a real living person or even a symbolical person, you have to place some kind of barrier between you as the artist and the subject matter in order to be able to render it or depict it – it's a technique to enable you to render it more easily.

And of course moving into the realm of 3D construction and making such figures on different scales enables you to analyse the figure into sections, a bit like topography, and it's that process that allowed the Statue of Liberty to be constructed in sections out of little topographic units, which were analysed from studies of drapery. And looking at the Statue of Liberty from the rear view, you can't even see a human form; you just see a kind of drapery mountain. So as a designer I'm very interested in that technique of interposing something between you and the subject to allow you to study it. And something else we were saying is that there's something very delicate and responsive about the drapery on these figures, as though it's inflecting the air and it suggests something about movement, which I think is quite a powerful feature.

I'm noticing that there's a spear and it's broken, she's still hanging on to it but it's broken and it's somehow caught up with the drapery, so Norbert what's that about?

NJ: The broken spear or broken banner means it's the end of the Old Testament. It's broken, she has the tablets of the Ten Commandments in her right hand, so she is symbolising the Old Testament which has been rendered as a past period and the new period will be dominated by Ecclesia, the church.

CR: Holding a vessel.

NJ: Holding a vessel and a banner in cruciform, which symbolises the cross and Christ's crucifixion and you know, the blood he spilled for mankind.

CR: Yes, and we were talking about the posture of the two figures that are affecting each other. There's some attempt, you were saying, to have some movement suggested between the posture of the two figures together and they're kind of acknowledging each other a little bit, aren't they?

NJ: Yes, there is a silent communication. But apparently the Synagogue, looking down, doesn't seem to listen to Ecclesia, so she denies the communication in one way or the other.

CR: But you can tell the attempt has been made somehow can't you?

NJ: Yes.

CR: I had never thought about that idea about such a delicate notion of an idea or a presence, not being acknowledged by the other person, actually represented in a sculptural form. That's such a delicate and sophisticated concept to achieve.

The Brunswick Lion

NJ: In 1166 the original was made [see Illustration 10.3]. Henry the Lion, the Duke of Saxony, was at the height of his power, and there was already a tradition in Lower Saxony of bronze casting and the lion was made simply as a symbol of his power, that is the reason why it was erected in Braunschweig [Brunswick].

What was so special about it, was the lion is a very monumental cast in bronze and it was probably made first as a wooden model, and then it was cast after that. As you know, the Cast Court was made to provide models for techniques so this cast here is a copy of one of the real monumental bronze castings – I mean we have a lot of small scale bronzes in our collection, but it was simply to give people an idea of how big or how large this object in Braunschweig is.

If you look from the side it's a real lion, modelled on a kind of expertise of the real animal, so it's a particularly powerful body and head. That's the ribs, which are shown in a very powerful position.

We know for sure that Henry the Lion, the Duke of Saxony, went to Jerusalem on a pilgrimage in the 1150s, so certainly some in his entourage may have seen a lion because on the one hand it's very stylised, on the other hand, it has really the power of a lion which is roaring.

CR: My memories of coming into this Cast Court actually go back to this particular lion. I've often brought friends or children here because this lion must be one of my favourite objects in the museum.

What I love about this is the notion that at the time this was made, people in this country would never have actually seen a real lion but they could have heard stories about it from people who went on the crusades.

NJ: And imagine when it was put in the place in Braunschweig, people had never seen a lion before in bronze, it was a completely new idea of how to symbolise power.

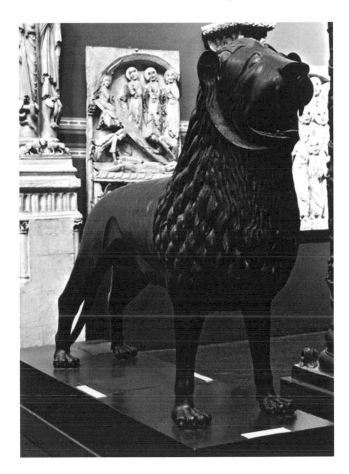

Illustration 10.3 Brunswick Lion

CR: Well it made me think of the whole idea of the symbolical animals, the guardians of the unknown realms and so on and the way animals, you know, griffins and eagles and lions were shown as guardian spirits, so they had a metaphysical form of representation. And this lion appears to combine both the features of a realistic animal, but it's more leaning towards the rendering of a metaphysical animal that's about power and I think that's where those two ideas are combined in this one piece, which makes it so powerful. So it made me think of T.H. White, the author, when he did a re-telling of the Arthurian legend in the 1930s, there was a section in that story where the young King Arthur was turned into different animals by the magician Merlin who was educating him, in order that the young King Arthur could see the world through the eyes of different creatures and realised there was more than one way of looking at things. So this kind of rendering of an animal in that way makes me think of that phenomena because it's this kind of combination,

it sits somewhere between the real world and the metaphysical world. What effect do you think this had, when this was put in the square in Braunschweig?

NJ: Well we don't know, we really don't know but they, people must have been in awe. Because they soon started in the second half of the twelfth century making little lions as candle sticks, based on that. So the lion was such a powerful feature in the immediate psyche of the people, they immediately tried to copy it into various utensils so to speak.

CR: I think there's an interesting little note here, which we could compare to when we were talking previously about the figures with that very sensitive drapery. Here we've got this combination of the stylised mane of the lion plus the ribs giving emphasis to the energy, so you're getting a similar effect regarding a surface that implies or shows other meanings. So what makes this so powerful is that it's not just a kind of a big blob, it's got this muscular structure of the rib cage and this tension in the muscles and so on, even though it is very stylised. Of course the feet, the fantastic claws, have become a feature in so much furniture design – putting clawed feet on tables and chairs and anything that stood on the ground, very much like these.

The other thing that I'm thinking is that just the way this lion is here in this space, its eye level is above ours and you know, you're looking up at it and yet there are a lot of other things in this space that are like long thin objects that are going vertically and they take your eye upwards to the ceiling and then the lion is here looking across the space and I think I might be right in saying that's the only thing in this part of the hall that's doing that as a 3D object, it's actually got a stance and a posture and it's looking somewhere in this space which it is sharing with us, so it has that kind of drama as well.

The Tomb of St Sebaldus

NJ: This is a plaster cast of the shrine of St Sebaldus in Nuremburg [see Illustration 10.4]. It was started very early at the end of the fifteenth century and was only completed by 1519 by the famous foundry of Peter Fischer the Elder, and his son Peter Fischer the Younger was involved in it in later stages. What is interesting is that Peter Fischer started with a Gothic shrine but then suddenly he abandoned the Gothic idea and he populated the surface with putti and little Hercules all formed out of models which he then slightly changed. So if we look around and we look at the puttis playing with dogs, they are all from changed models.

CR: In wax possibly.

NJ: In wax and cloth, so he could easily move them into another position. And so he populated the entire shrine with figures which have nothing to do with St Sebaldus.

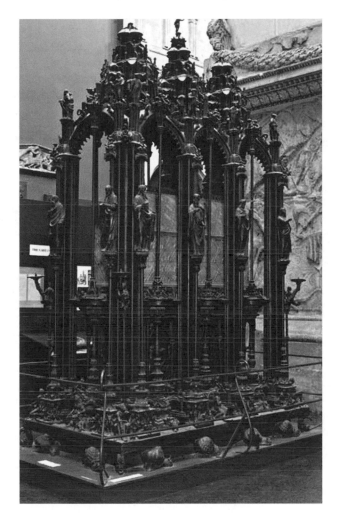

Illustration 10.4 Tomb of St Sebaldus

The Twelve Apostles – well that's the old concept, but why now Hercules? He seems to have enjoyed this fantasy of 'Renaissance' figurative bronzes.

CR: Yes, he started doing this excursion into other sources of reference didn't he? And the references got more and more complex. When I came up to this object from my perspective as somebody who designs pieces of furniture, I couldn't quite get a grip on this at all because it's so complicated. Just looking at it on an abstract level, I thought it was a complete mess. In fact the complexity involved in making that plaster cast is mind boggling because that must have been almost as difficult as doing the original. It's got so much internal detail, this is not about surfaces and

**Illustration 10.5 Detail of Tomb of St Sebaldus, showing figure of
Peter Fischer the Elder**

surface decoration, this is such a complex genuine 3D construction that obviously
went on being more and more elaborate. But as I looked at it more closely, funny
questions arise, like what is that figure doing down there? Why is it all held up
by these kind of giant snails? I can recognise this is about movement isn't it? The
snails move in a very interesting way and it kind of creates this sheer surface, it
elevates the whole thing off the ground and there may have been this sense that the
thing is too heavy and it wanted to float somehow.

NJ: Right, that's the new idea. That's the new idea, putting these snails which are moving very, very slowly under a construction of a church.

CR: Yes.

NJ: Because it is, it resembles a kind of a church shrine. So it is quite an early form of, you know, casts after nature, which were perfected in the second half of the 16th century, when little lizards were modelled out of the nature casts. So nature really was the model for the cast.

CR: Yes, there's quite a theme emerging from our discussions about this connection between observation in nature and these metaphysical or symbolical themes and making connections between the two which I find interesting. The first time I looked at this, because it is so complicated as an object to look at, I found myself just trying to make up stories. I imagined if I was with some young children, we'd make up stories about what these figures were doing and I think I found one that looked like it was sharpening a pencil, and I started to think about the people making this and playing with the figures in much the same way that we do stop frame animation, you start off with a clay figure and you move it into different postures and you take a photograph. This is almost like a collection of that process – having a basic form and then animating it into all these different variations. So I liked the idea of creating stories to try and make sense of what all these figures are doing because they're all in little groups. There's a group here for example that are sort of wrestling, these have got tails haven't they? And they look like they're wrestling with snakes. There's a little frog here looking at this person. I imagine having real fun in the workshop with these.

NJ: Yes.

CR: Taking this as its starting point and developing it. So that brought me right back to thinking about the way we work in the art school, in a workshop, where you get some basic ideas, materials and structures and you experiment with them and play with them in the workshop, as a way of constructing a finished piece. So that sort of connected me back to a contemporary way of working by looking at this and thinking why was it done like this? It made me think of the makers.

NJ: Yes, and the maker is here [see Illustration 10.5]. We have Peter Fischer the Elder with his apron as a founder and he used to have a hammer in his hand so he proudly depicts himself as the maker of all these figures.

CR: He's dressed completely differently to the figures that are depicted isn't he? He's got this kind of workman-like outfit and his little bag of tools.

NJ: Yes, as the founder who makes the dirty work. He's not the genius who invents all this, he shows himself as the one who makes the casts, which is very dirty work.

CR: He's got protective clothing on that's completely different to this kind of decorative clothing that the figures have shown where, you know, they're either naked figures, or semi-clothed, or they have stylised garments on whereas he's definitely got working clothes on with a satchel.

NJ: And you see that was in the early sixteenth century, they tried everything to depict or to model the naked person. The interest in the body now emerges, what we have seen in the thirteenth century with the Nuremberg Cycle there was a similar interest in nature, but here the interest is in the naked figure and in classical antiquity.

CR: Yes. Could you say something about what is there in your view – are there sets of relationships that can be thought about with these figures or is it fairly abstract, is it just about multiple imagery? Because I can't see.

NJ: It's multiple imagery. We know that when Peter Fischer's sons went to Italy and there they got the idea of the new style, the so-called Welsh style and they played with it.

CR: It's a very odd piece of architecture isn't it? If we ignore the figures for a moment and look at the basic structure. I couldn't get my head around how it had been organised as a structure because here we've got columns that are on a kind of pedestal, but then they're on something else and there's all this kind of substructure. It seems to me that it doesn't have a clear architectural language to it, or it almost looks Eastern.

NJ: Well, if we go over here and have a look at the entire piece, you see the structure is fairly clear, we have a little chapel – three naves so to speak.

CR: Yes, OK.

NJ: And we have the little turrets above, so there is a Gothic chapel, but this strong architecture has been turned into this playground of ideas.

CR: Yes. This is almost like an underworld of all these complicated forms, these little kind of bridge-like structures. I mean this is where the Gothic thing is different isn't it? You've got this column in the centre coming down here and becoming elaborated here, which is where it moves away from conventional architecture and composition, and this starts to become so complex and mysterious, these kind of three columns next to each other in each bay. Thinking about the casting masters

that would be put together to make these forms, this is so unbelievably complicated in three dimensional space, what's going on with all these sections, you can see the sections that have been made but whether those are the same with the plaster casts, with the metal, I would be interested in finding out about that.

NJ: Yes, that is, the shrine itself has these angular fields which show the eagle as the symbol of Nuremberg, because it's the Nuremberg Saint who's in here and it is moulded silver so they had a kind of stamp with which they moulded into.

CR: Do you think it was shaped or cast?

NJ: No it was moulded, not cast.

CR: Right.

NJ: You know, you have piece of silver and you have a kind of a stamp.

CR: Yes, like pressing.

NJ: So it's pressed.

CR: Yes, I see. It would be a wonderful thing to get children to draw. I mean what is fascinating just on an abstract level of a 3D object is it has a big form, it has a mid-scale form and it has all this minute detail, so there's people of different interests can engage with this and I can imagine with young children getting them to draw little bits of detail down here, near the bottom and somebody who's interested in interior design or furniture design or architecture could think about the whole structure.

Reflections

After the conversation, Chris Rose offered these reflections on the potential of the Cast Courts for art and design learning:

I've been thinking about just in general why I would bring students of art and design into this gallery, just for general reasons into this space. I think one important thing is that there's a collection of very different ideas and different modes of artistic expression all together in this space, so there are figurative objects, there are narrative structures, there are symbolic or celebratory kind of constructions, there are architectural details, there are quite powerful, symbolic features of the built environment, such as the doorway or the window or the stairs, where do they lead? And the people, people that connect things together, people as columns that support different parts of an architectural construction and symbolic animals, snippets from legends and stories and so on, like Medusa.

So I've become a fan of this idea of rather than lecturing directly to students about a particular subject, rather that this notion of immersion – that you might bring somebody into a space for one reason and they will notice things subconsciously or just in passing. The ambient information that's in this space is very rich and I think that's an important thing to do with people who have expressed an interest in art and design – to bring them into this kind of ambience of many different themes and ideas working together. You know, you can come in here to look at an Italianate piece of work and then find yourself looking at a Nordic structure which has such an utterly different aesthetic.

If you say things like a Nordic aesthetic and an Italian aesthetic to students in a classroom, it's completely meaningless but if you walk into a space like this and people are looking at an Italian piece of sculpture and then you simply walk them over to one of those Norwegian doorways it hits you in such a powerful way that the aesthetic is utterly different, the sensibility is different, the means of expression and the material quality, the references it makes are completely different and there's no substitute for just simply experiencing those differences.

There are other objects which, although they are historical, have a real contemporary feel about them and that's a fascinating thing as well. I think that sort of thing raises interesting questions for students and it tends to work against sort of the wrong assumptions that students might make about you know, what's the point of going to a medieval gallery, 'it's all so old'.

Also the idea of an interaction space, exactly what we're doing now, that these material objects, they are mediating perceptions between us. Simply by standing around them and talking between us about them, the object itself is mediating the development of knowledge. I'm very interested in that phenomenon, of taking somebody out of their normal frame of reference and bringing them into a very rich material and visual world.

Chapter 11

How Can Technology Support Design Students' Learning in Museums?

Rebecca Reynolds

This chapter starts by giving some broad context on the current use of digital technologies in wider society and conceptions of its relationship with pedagogy. I then make some observations about uses of technology in museums and in HE, and draw out some implications for considering the particular needs of design students.

This is a huge and ever evolving area, and so as a starting point for a discussion of how technology can support design students' learning in museums, I will look at two comments. The first is from art historian Tim Benton, quoted in Anderson:

> I am worried about replacing artefacts with information about objects. In many museums there has been a replacement of the objects with a meta-experience, often a teaching experience. There is a dimension of objects which resists interpretation. I've found some of the most exciting and enduring things when 'lost' in the V&A. It is very important that the technology should bring people back to the objects. What I'd like to do whenever I'm going around the V&A is to plug into a point in the wall and be able to interrogate the artefact, have my questions answered, and accumulate my own observations in a two-way process. (Anderson 1997: 29)

Benton's comment raises many points relevant to a discussion of technology as a support for design students' learning in museums. Firstly, he has concerns about the possibility of technology negatively affecting learning in the museum, both in the service of teaching approaches which he sees as unsuitable to museums ('there has been a replacement of the objects with a meta-experience') and because of its potential to distract from objects ('It is very important that the technology should bring people back to the objects'). Secondly, and notwithstanding this, he sees technology as the means to learn what he wants in the museum ('be able to interrogate the artefact, have my questions answered ...'). Despite the risk of technology competing with objects, he sees it as crucial that information, carried on technology, is available in the same space as the objects. Thirdly, he is clear that technology should not only be a means of transmitting information but help him to develop his understanding of the objects ('accumulate my own observations in a two-way process'). Furthermore, it is a vision of personalised learning ('my

own observations'). Fourthly, the authoritative scholarship of the museum can be disseminated through technology ('have my questions answered').

We may also note that he sees technology as a servant of his learning process, a means to reach learning objectives ('accumulate my own observations') which have been developed without it. He does not appear to see the way he learns as partly formed by the technology he is using.

The second comment is from design tutor Richard Doust:

> Technology is not about replacing 'traditional' uses of museums; it's an additional
> tool. Today's design students are 'digital natives', and they're going to find it
> unusual if technology doesn't support their learning, including in the museum.
> All tutors, including design tutors, need to be aware of how students' learning
> patterns have changed, for example their familiarity with mobile devices and
> technology–enabled social networking. If these are included it will make their
> learning much more relevant to them. (Personal communication, 11 February
> 2009)

Here, Doust is concerned with patterns of technology use outside the museum, rather than with the ways in which technology supports learning inside the museum. Technology has changed the way students learn, and museums need to keep up. He strikes a less cautious note than Benton, and is more confident that technology will not encroach on 'traditional' uses of museums.

Taken together, these comments raise points which are central to the consideration of how technology might – and might not – support the needs of design students in the museum: the potential of technology to both augment museum learning and distract from it; the ability of technology to respond to individual learners' needs and take into account their cognitive processes; young learners' familiarity with new technology and the need for educators to be aware of these. I will refer back to these during this discussion.

As a working definition of how technology can be used in education, I take the definition of e-learning offered by the Higher Education Funding Council (HEFCE):

'The use of technologies in learning opportunities, encompassing flexible learning as well as distance learning, and the use of information and communication technology as a communications and delivery tool, between individuals and groups, to support students and improve management of learning' (HEFCE 2005: 5).

The 'learning opportunities' discussed in this chapter are those associated with museums.

Popularity of New Technology

We are often offered general statements about the way in which technology has permeated peoples' lives, particularly those of the young. It may be difficult to

separate fact from myth, particularly as the rapid and ongoing development of new technologies creates new and continually changing usage patterns which may be hard to track and can be under or overestimated. In fact, Steve Woolgar, Director of the *Virtual Society?* programme, uses the term 'cyberbole' to describe exaggerated claims for the power of technology (Woolgar 2002).

Many research studies aim to establish the actual impact of new technologies on the lives of young people. For example, a study by Williams and Rowlands investigates evidence for assumptions about the effect of technology on the research patterns of young people from teenagers to young undergraduates. It takes a number of myths about the 'Google generation' such as the assertion that they cannot tolerate delay, and that they prefer information in 'easily digestible short chunks' (Williams and Rowlands 2007: 19), and examines evidence for each one. For example, the authors agree that widespread use of new media means that people of all ages (not just young people) are more impatient of delay, and that evidence suggests that 'many students do not explore information in any deep or reflective manner' (Williams and Rowlands 2007: 19).

Another study researched use of digital technologies by 7 to 18-year-olds and stated that '... the use of digital technology has been completely normalised by this generation, and is now fully integrated into their everyday lives' (Green and Hannon 2007: 11). It identified types of technology users such as 'digital pioneers', who try out new technological applications before others and 'information gatherers', for whom cutting and pasting is 'a way of life' (Green and Hannon 2007: 12). It added that most young people are 'involved in creative production' such as editing photos and creating and maintaining websites. This would provide some evidence for Doust's comment that today's design students are very familiar with new technologies.

Pedagogy and Technology

It is a matter of debate whether technologies actually change the way people learn, or simply change the way in which learning resources, based on existing pedagogical models, are delivered and accessed.

As an example of a conception which leans towards the former, we could take a criticism by Andrews and Haythornthwaite of the HEFCE definition above for conceptualising technology as a 'delivery mechanism' for existing forms of learning, and not acknowledging the 'co-evolutionary nature of technology and its use' (Andrews and Haythornthwaite 2007: 2). The authors comment that it is a 'trap to assume that learning exists independently of the technologies used to enhance it' (Andrews and Haythornthwaite 2007: 2). They identify flexibility, asynchronicity and collaboration between many parties as key elements of e-learning. As a contrast with this view, Mayes and de Freitas comment: 'there are really no models of e-learning per se – only e-enhancements of models of learning. That is to say, using technology to achieve better learning outcomes, or a more

Museums and Design Education

effective assessment of those outcomes, or a more cost-efficient way of bringing the learning environment to the learners' (Mayes and de Freitas 2004: 4).

The task for the e-learning theorist, they say, is to ascertain the added value of the 'e' and identify pedagogical principles underlying it. They make the intriguing suggestion that internet-enabled learning opportunities can be seen as offering a new model of education, not a new model of learning – in other words, it may influence the way learning is encouraged and delivered, but does not require a new account of learning (Mayes and de Freitas 2007).

Theorists are keen to identify what is particular about different types of technology, their unique challenges to our current understanding of education and learning, and their contributions to educational practice. For example, in theorising mobile learning, Sharples argues for a 'mutually productive convergence' between technology and educational theory (Sharples, et al. 2007: 221). He suggests a 're-conception of education, as conversation in context' for a 'mobile age' in which learning uses digital networks outside the classroom. This reconception replaces 'education as the transmission or construction of knowledge', with 'a cybernetic process of learning by continual negotiation and exploration' (Sharples, et al. 2007: 244). He describes this as both a complement to formal education, and as a challenge to classroom-based instruction.

To give another example, Bruns concentrates on the phenomenon of user-generated content, where users form networks which produce knowledge. These networks do not take account of any difference between expert producer of knowledge and not-so-expert learner. This process is enabled by 'new, participatory technologies of information access, knowledge exchange and content production … [which are part of] user-led content and knowledge production …There has been an explosion in the amount … of available content on a wide variety of topics, from a growing number of sources' (Bruns 2007: unpaginated). Such collaboratively compiled knowledge, on sites such as Wikipedia, is a threat to expert practitioners.

In Bruns's view, tertiary education therefore needs to be reconceptualised so that tutors act as guides through 'always already available information' rather than as gatekeepers for scarce knowledge resources. He posits the notion of a 'produser' as someone who both produces and uses educational content, and envisages experimentation with the establishment of 'entirely produsage-based educational institutions' (Bruns 2007: unpaginated).

Digital technology may also open up the opportunity for more interaction on the part of the learner and can 'provide a creative role which stresses the power the student can have as an author rather than as an operator who simply retrieves information or selects between predetermined routes' (Beardon and Worden 1995: 63). This is a long way from Benton's conception of technology as providing the answers to questions.

In a climate in which technology is thus seen by some as changing the nature of education, other writers warn of the dangers of using new technology without considering its pedagogical implications. For example, Brabazon warns that

'literacies are being lost' through the unquestioning incorporation of technological platforms into HE (Brabazon 2008: 17). She criticises the view that information availability is intrinsically democratic and empowering, and comments that greater access to information via the internet 'does not promote the development of high quality writing, wide reading and innovative interpretations' (Brabazon 2008: 17). In a similar vein, Laurillard warns that technological innovations are not always appropriate for pedagogical goals, and in our desire to use new technology in education we may lose sight of what these goals are. Education should 'hold the reins of the investigation' (Laurillard 2007: 153) into what new technologies can offer education, and new technologies should be evaluated against pedagogical requirements.

The relationship between technology and pedagogy is thus seen in a variety of ways, from a support for existing approaches to learning, which is Benton's view in the extract above, to an all-pervasive influence which can mould learning habits and approaches to education, and therefore requires a redefinition of these processes. Doust's comment above leans more towards this latter view, in stating that students' learning habits have changed and tutors need to keep up.

There are both dangers and benefits to these changes in learning habits – they bring new opportunities for redefining education, but may be damaging to learning if adopted uncritically.

Technology Inside the Museum

New technology in the museum brings into contrast two extremely different learning media. The museum houses actual objects, often old, usually physically immobile, not easily modifiable, and often displayed according to vastly different ways of understanding the world to those of today. New technologies can be the opposite of each of these, and are one way of interpreting the museum environment in a new way while interfering as little as possible with it.

Laurillard suggests that mobile learning enables 'digitally-facilitated site-specific' learning (Laurillard 2007: 156). It has particular application to museums since, of course, one learns on the move in a museum, and there is a need for learning resources which connect with the specific environment.

'Sit forward' and 'sit back' are phrases which have been used for some time to describe different types of multimedia. Sit forward media are interactive; the user skips around, chooses segments to listen to or read, and puts parts together as they want. Sit back media are narrative, such as television, where the user switches on a sequence and listens or reads from the beginning. Museums could perhaps be described as sit forward (or 'stand forward') places where the learner moves around and decides what to look at, and would therefore be environments for sit forward multimedia, since the visitor is likely to move from place to place and access chunks of information or interpretation which apply to different works.

The interplay between the virtual and actual is of prime importance in considering new technologies in relation to museums. The Anderson report, *A Common Wealth*, the first major report on museum education, has reassuring words for those who, like Benton, have reservations about the impact of virtuality on peoples' ability to appreciate the actual: 'it is probable that technology will not undermine but stimulate the public's desire to have a gallery experience; the 'virtuality' offered by new media may balance and complement, rather than erode, the 'actuality' that is found in real human relationships and contact with real objects in the museum' (Anderson 1997: 27).

Woolgar reinforces this position; he posits as a 'rule' of virtuality 'the more virtual, the more real' – for example, just as watching televised football has contributed to higher, not lower, attendance at matches, an increase in the online presence of museums has coincided with an increase in the number of visitors to actual museums (Woolgar 2002). A survey of over 1,700 people in the US provides evidence to support this; it found that internet users were more likely to visit museums than non-users, and indicated that the internet is not replacing visits to actual museums (Griffiths and King 2008).

One model of a complementary relationship between the virtual and real aspects of a museum is as a 'virtuous circle' in which visits to the museum website encourage visits to the actual museum, which again encourages visits to the website and so on (Barry 2006).

Indeed, the museum can now be thought of as a 'distributed system' (Beardon and Worden 1995: 63) or 'distributed network' consisting of both actual and virtual parts. For example, Illustration 11.1 shows a generic model of a museum developed by Nancy Proctor, Head of New Media at the Smithsonian Museum and Art Gallery. This has the actual museum in one quadrant, with the other three consisting of various types of technologies. This is a strikingly non-hierarchical diagram; it is not the case here that the virtual museum is seen as less important than the actual. There are many more potential links between the various elements, but their sheer variety, even uncontrollability, make it difficult to demonstrate in a diagram. For example, labels can be linked with text messaging; iTunes can be linked with downloadable tours. The variety and number of virtual incarnations of the museum lead to rich and varied ways of exploiting both its real and virtual resources.

The integral importance of virtual resources to museums is heightened by the need of many museums to brand and market themselves on a global scale. Here virtual resources, with their global reach, may be used by people who never visit the building and collections. For example, there were over 24 million visits to the V&A website in 2007–2008, compared to just over 2.5 million actual visits.

The phrase 'the virtual museum' has also lost any oxymoronic meaning it may once have had, and museums' virtual incarnations are no longer seen as a supplement or second best to their physical ones. Virtual museums and archives include the Web Gallery of Art (Kren and Marx 1996), which offers guided tours, period music and postcards. Another example is the Virtual Pathology Museum

The Distributed Museum

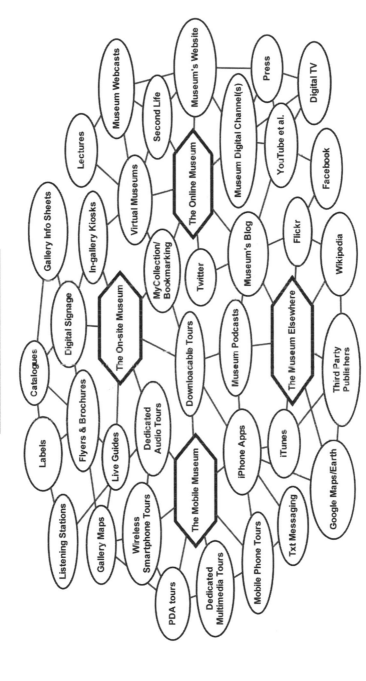

Illustration 11.1 The museum as a distributed network

(QMUL 2009), which contains images of specimens for use in medicine and dentistry from Queen Mary, University of London's museum. Indeed some virtual museums, such as some of those described in Chapters 13 and 14, offer experiences not possible in real museums, such as the chance to design objects not subject to the laws of physics.

Digital technologies are also associated with increased user participation in curatorial and educational processes such as the development of interpretive content. One conception of the effect of these processes is the 'community-based post-museum' (Russo and Watkins 2004: unpaginated) which is based on an exchange of views from inside and outside the museum and contributions from a range of people. It sees curatorial practice as 'open-ended co-creative processes which draw audiences into the creation of content' (Russo and Watkins 2004: unpaginated). It is becoming more and more usual for such user-generated content to be included on museum websites, for example in the Museum of London's 'Belonging: Voices of London's Refugees' (MoL 2006).

Input from outside the museum may well be welcomed by museum practitioners as an addition to the range of interpretation and information they offer, and as a way of engaging with a wider range of participants (Durbin 2004). Content can also be developed outside the control of the museum. For example, unofficial podcasts were developed for the Museum of Modern Art (MoMA) in New York containing spoof interviews and unofficial interpretations of artworks. These were applauded in *Museums Journal* for being a step towards a 'mediated museum', in which truth is not the sole preserve of the museum as an institution (Feber 2007: 19). However, it is not clear how or whether such content is valued by the public. For example, one review of the unofficial MoMA podcasts on the website hosting them applauded the idea, but criticised them for containing 'lazy banter', expressing a desire for 'art historians or educated art lovers' to make them (LearnOutLoud 2009).

Museums may also offer the opportunity to create one's own products digitally using museum collections. This is not common on museum websites, and even less common on gallery-based technology. They are more common as events, in which visitors can take part in activities such as designing a CD cover (an event at the V&A in 2004) or composing music (as took place at the Science Museum in 2000).

Another key trend is to enable visitors to use their own digital device in innovative ways. People may have their own favourite technological devices and applications and marrying these with the museums' collections and knowledge can be a practical and cost effective way for museums to meet educational challenges. This is one way for museums to keep pace with the way people use technology outside the museum, as Doust recommends.

Increasing digitisation means that parts of the collection which cannot be displayed in galleries can be viewed in digitised form on the museum's website and on visitors' own devices in the galleries. However, Anderson warns that museums need to develop 'imaginative, high quality learning resources which have genuine

educational value' as well as simply providing access to images and information (Anderson 1997: 29).

Technologies and Different Audiences

The increasing recognition of the importance of education in museums over the last 20 years or so has led to a focus on the visitor and consequent differentiation and targeting of different audiences. Technology can help museums to cater for different audiences, using well-founded and innovative educational strategies, and can allow greater access to the collections. For example, mobile learning devices can offer resources for different audiences at greater depth than is possible as part of the displays, as shown by Benton's earlier comment. It is usually easier to modify web-based resources than actual exhibitions, and online learning resource development has developed faster than exhibition design development (Schaller and Allison-Bunnell 2003).

Technology in Higher Education

Driven by government priorities, HE institutions are making efforts to expand the range and increase the number of students who enrol, partly by varying the ways in which courses can be taken. Different and more flexible patterns of study such as distance learning and part-time learning are becoming more popular, and technology is taking a growing role here, for example in innovative technological applications developed by the Open University and other institutions. Uses of technology in HE include podcasts of lectures, virtual discussion forums, online modules, technological applications adapted to different disciplines, and so on.

Expansion in student numbers has led to worsening staff-student ratios, which may also indicate a crucial role for technology in encouraging independent research skills. However, it is important that digital resources are not justified purely as an attempt to solve concerns about current conditions in education, and that they contribute learning approaches which are appropriate to HE in their own right and expand conceptions of HE pedagogy.

It is not clear to what degree this is happening. For example, Laurillard criticises most use of technology in HE as being generally based on an outdated information transmission model of education: 'Sadly, few educational applications of technology go beyond the provision of access to ideas, which does not mark them out from books' (Laurillard 2007: 162). In her view, most uses of new technologies in HE do not explore innovative and well-founded pedagogical approaches – they do not analyse and use to its fullest what the 'e' could add to e-learning. This is a serious omission if universities are to hold their own against competition by 'the knowledge industries' outside universities which provide skills and knowledge needed in today's knowledge society (Laurillard 2002a). However, developing

such approaches to e-learning depends on developing new pedagogical models for HE: 'The academic community has not redefined what counts as 'higher learning' and therefore cannot draft the specification for how the new technology should do anything other than what learning technology has always done: transmit the academic's knowledge to the student'(Laurillard 2002a).

In fact, many models of e-learning have been developed with the aim of giving a pedagogically sound basis to the ways in which technology is used in HE. For example, Mayes and Fowler map stages of learning onto categories of e-learning. They describe the learning cycle in three stages:

- 'Initial contact with other people's concepts'
- 'the process of building and combining concepts through their use ... in meaningful tasks'
- 'the testing and tuning of conceptualisations through use in applied contexts', which in education involves conversations with tutors and peers (Mayes and de Freitas 2004: 34).

Different types of materials and tools are linked to each stage; for example, material for the third stage may come from discussions via networked learning. Many other models with relevance to HE are outlined in this report.

Another example is Laurillard's conversational framework. This takes a range of processes which should be part of learning at HE level with tutors and peers, such as apprehending, investigating, discussing and experimenting. She places them in a framework against which the development and use of new technologies can be plotted, and argues that learning technologies can support the full range of student learning together, but not individually (Laurillard 2002b). She also offers a version adapted to learning in informal settings where the tutor is not present, which could include exhibition spaces (Laurillard 2007). This version emerges as a model which covers fewer processes than are possible in a formal learning context, but more processes than much current gallery-based technology. An example of the evaluation of museum-based HE learning materials according to this framework is given in Chapter 5.

Such theories return us to the need to evaluate new technologies in terms of the learning of the user rather than in terms of innovative modes of delivery. This is also shown in Benton's comment, where he states his learning needs and imagines a mode of delivery to meet them.

Museum-based Technology and Design Students

Here I will consider the particular needs of design students in relation to some of the issues discussed so far. It is clear that design students will share the many benefits technology has brought to museums, from greater access to collections

to multimedia representations of how objects are made. However, there may be particular drawbacks in certain uses of technology for design students.

Resources on Gallery-based Technology

There are some ways in which the growing popularity of interpretation on gallery-based technology may have particular implications for design students, in that this is an example of the real and actual being used together. Practice-based design students need to interact with real materials – to touch them where possible, and perceive texture, weight, size and so on. The most commonly found learning style amongst design students is that of 'hands-on' accommodators, also known as experiential learners (Caban and Wilson 2002). Both tutors and students will reject technology if they see it as dictating their learning in the museum and not responding to their individual needs (Fisher 2007). This echoes Benton's expectation that technology stays subordinate to objects and answers the questions he wants to ask. If technology is used as a tool, these comments imply, it should not be directive and should not obtrude between surroundings and the user.

Tutors sometimes complain that students spend too much time researching online and not enough time interacting with objects (Fisher 2007) and that if research into 3D objects is done solely or mostly on a 2D screen, then the skills needed to work with real objects may not get enough of a chance to develop. In a group of eight design tutors, the only one who was sympathetic to screen imagery in the museum taught on-screen design and therefore viewed it as a medium in its own right (Fisher 2007). However, there is some evidence that if people cannot see examples of technology in art and design galleries they tend to think it inappropriate, but when they see it their view changes (MHM 2003).

It could be argued that gallery-based technology further distances students from considering and understanding such tactile attributes of objects. After all, most objects in museums are already behind one 'screen' in the form of a display case, and it may be a disadvantage to introduce another object mediator in the form of a screen on a handheld multimedia device. On the other hand, a PDA screen may take one 'behind' the display case, for example by showing details of an object close-up, or angles of an object not on view, such as the back.

In addition, design tutors often mention that students need to slow down in museums and take time to closely observe objects, gather details and learn things which may not be immediately useful but which may be important later. If computer technology in general is used for focused searching with quick results, and gallery-based technology encourages similar responses, then this may not be conducive to such 'slow motion' looking skills. It may also be feared that technology will remove the contemplative, musing space and fill it with information. Benton, for example, fears that the experience of the object will be replaced by a 'meta-experience, often a teaching experience.'

In addition, design students are encouraged to develop innovative and personal approaches to designing (Avann and Wood 1980; Buchanan 1995). Students may

therefore fear their own personal interpretation of galleries and objects will be pre-empted by too much interpretation in the galleries.

Many design education professionals may thus feel uneasy at the assertion that technology should play an integral part in in-gallery exploration.

Conclusion

What does the foregoing tell us about the possible uses of technology in museums for the HE sector and for design students? Firstly, there is a recognition in both HE and museums of the need for learning resources using technology which is designed to take into account the user's learning processes and preferences and go beyond offering access to 'information and images' (Anderson 1997: 28) or 'access to ideas' (Laurillard 2007: 162). Many current uses of technology connected with museums would fail this test. For example, to my knowledge there are currently few examples of museum handheld audio or multimedia guides which ask the user questions, or encourage them to interact with other users, ask them to reflect on what they have experienced during a visit, or offer ways of researching further. This is perhaps unsurprising, given the fact that such materials are aimed at a wide variety of users whose learning needs may differ greatly from each other. However, if the diversity of new technologies offers the opportunity to serve different museum audiences, this allows more leeway to put into practice educational approaches suited to different groups, including HE students.

We can draw out certain trends which museums can take advantage of in using digital technologies in education. If a majority of people use digital technologies as a creative medium (Green and Hannon 2007) then museums will need to continue offering more opportunities for visitors to create their own productions, perhaps using their own devices, drawing on museum collections and buildings to do so.

On a practical note, the most effective use of technologies may not be the most expensive. Nor are the most effective uses of technologies the most innovative. The desire to theorise what is unique and new about forms of learning connected with particular types of technology does not mean that the technology has to be used in that particular way. In fact, it makes sense in terms of resources and wide reach to develop 'multi-platform' designs which can be used on different forms of technology – for example, on a desktop PC and a PDA.

At the moment, I would suggest we have gone past Benton's vision in one sense; technological applications allow us to navigate museums on the web, build exhibits in virtual space, listen to debates or museum symposia in our own time, and so on. In another sense, we are still far from a position where a visitor's own questions about any object in a museum can be answered next to the object. In fact, Milosavljevic et al. report on a project to construct 'personalised virtual labels on-the-fly'. They say that supplying 'varying levels of descriptions' for 'all the conceivable questions a user might have' is impossible for more than a few

objects in a museum and more than a few 'user types' (Milosavljevic, et al. 1998: unpaginated).

Developing technology in museums for HE design students requires us to ask how HE students use museums, how effective ways of using them could be encouraged, and the role of learning support and information about objects in these processes. Perhaps it is possible for museums and universities to support each other in developing innovative and sound technology and technological applications which support HE students in their studies. Much remains to investigate. For example, should detailed contextual material about objects be kept outside the museum, leaving most museum time for interaction with actual objects? Or is there a case for bringing, say, detailed archival material 'front of house'? Is technology an optimal way of doing this, and if so what types? Might tutors welcome targeted support, accessed through new technologies, or would they regard this as an encroachment on their own expertise and aims for their students? On the other hand, could museum-based technology offer learning strategies and resources in the museum which might be missing from students' education otherwise?

If museums as physical spaces are multi-purpose, then technology can perform different functions according to the visitor's purpose. Design students use museums for different purposes at different stages of their courses, sometimes browsing and at other times doing focused project-based research. Sometimes technology could play an integral part in a visit, sometimes it is not appropriate. We need to return to the question of what the 'e' in 'e-learning' can offer which is unavailable elsewhere. I would suggest that this question is particularly pertinent in the museum environment, an environment which demands attention and where technology can easily become a diversion.

Bibliography

Anderson, D. (1997) *A Common Wealth: Museums and Learning in the United Kingdom*. London, Department of National Heritage.

Andrews, R. and Haythornthwaite, C. (2007) *The Sage Handbook of E-Learning Research*. London, Sage Publications.

Avann, M. and Wood, K. (1980) *User Education in Art and Design: Theory into Practice*. Newcastle Upon Tyne, Arts Libraries Association.

Barry, A. (2006) *Creating a Virtuous Circle between a Museum's On-line and Physical Spaces*. Museums and the Web 2006, Toronto. Archives and Museum Informatics. Retrieved 23 October 2006, from <http://www.archimuse.com/mw2006/papers/barry/barry.html>

Beardon, C. and Worden, S. (1995) The Virtual Curator: Multimedia Technologies and the Roles of Museums. In Barrett, E. and Redmond, M. (Eds) *Contextual Media: Multimedia and Interpretation*. Cambridge, MA, The MIT Press.

Brabazon, T. (2008) Transforming Learning: Building an Information Scaffold. *Networks*, 4, 16–21.

Bruns, A. (2007) *Beyond Difference: Reconfiguring Education for the User-led Age*. Proceedings ICE 3: ideas, cyberspace, education, Loch Lomond, Scotland. Retrieved 11 May 2009, from <http://eprints.qut.edu.au>

Buchanan, M. (1995) Making Art and Critical Literacy: A Reciprocal Relationship. In Prentice, R. (Ed.) *Teaching Art and Design: Addressing Issues and Identifying Directions*. London, Cassell, 29–49.

Caban, G. and Wilson, J. (2002) Understanding Learning Styles: Implications for Design Learning in External Settings. In Davies, A. (Ed.) *Enhancing Curricula*. London, RIBA.

Durbin, G. (2004) *Learning from Amazon and eBay: User-generated Material for Museum Web Sites*. Museums and the Web, Toronto. Archives and Museum Informatics. Retrieved 11 May 2009, from <http://www.archimuse.com/mw2004/papers/durbin/durbin.html>

Feber, S. (2007) A Podtour of the Museum of Modern Art in New York has been Remixed by Guerilla Podcasters. Don't Panic. This is a Very Good Thing. *Museums Journal* 107/12, 19.

Fisher, S. (2007*) How do HE Tutors and Students Use Museum Collections in Design?* Qualitative Research for the Centre of Excellence in Teaching and Learning through Design. Unpublished report.

Green, H. and Hannon, C. (2007) *Their Space: Education for a Digital Generation*. London, Demos.

Griffiths, J.-M. and King, D. (2008) *Interconnections: The IMLS National Study on the Use of Libraries, Museums and the Internet*. Washington, DC, Institute of Museum and Library Services.

HEFCE (2005) *HEFCE Strategy for E-Learning*. HEFCE.

Kren, E. and Marx, D. (1996) The Web Gallery of Art. Retrieved 11 May 2009, from <http://www.wga.hu/index1.html>

Laurillard, D. (2002a) Rethinking Teaching for the Knowledge Society. *Educause Review* 37/1, 16–25.

Laurillard, D. (2002b) *Rethinking University Teaching: A Framework for the Effective Use of Learning Technologies*. Abingdon, Routledge Falmer.

Laurillard, D. (2007) Pedagogical Forms for Mobile Learning: Framing Research Questions. In Pachler, N. (Ed.) *Mobile Learning: Towards a Research Agenda*. London, WLE Centre, Institute of Education, 153–175.

LearnOutLoud (2009) Learn out Loud. Retrieved 20 January 2009, from <http://www.learnoutloud.com/Podcast-Directory/Arts-and-Entertainment/Painting_-Architecture_-and-Sculpture>

Mayes, T. and de Freitas, S. (2004) *StageTwo: Review of E-Learning Theories, Frameworks and Models*. JISC.

Mayes, T. and de Freitas, S. (2007) Learning and E-Learning. In Beetham, H., and Sharpe, R. (Eds) *Rethinking Pedagogy for a Digital Age*. London, Routledge, 13–25.

MHM (2003) *Engaging or Distracting? Visitor Responses to Interactives in the V&A British Galleries*. Manchester, Morris Hargreaves McIntyre.

Milosavljevic, M., et al. (1998) *Virtual Museums on the Information Superhighway: Prospects and Potholes*. Annual conference of the International Committee for Documentation of the International Council of Museums (CIDOC '98), Melbourne. Retrieved 11 May 2009, from <http://citeseer.ist.psu.edu/old/92973.html>

MoL (2006) Belonging: Voices of London's Refugees. Retrieved 15 May 2009, from <http://www.museumoflondon.org.uk/English/EventsExhibitions/Community/Belonging/>

QMUL (2009) VPathMuseum. Retrieved 11 May 2009, from <http://vpathmuseum.smd.qmul.ac.uk/>

Russo, A. and Watkins, J. (2004) *Creative New Media Design: Achieving Representative Curatorial Practice Using a Cultural Interactive Experience Design Method*. Interaction: systems, practice and theory, Sydney. Retrieved 11 May 2009, from <http://eprints.qut.edu.au/archive/00010101>

Schaller, D. and Allison-Bunnell, S. (2003) *Practicing What we Teach: How Learning Theory can Guide the Development of Online Educational Activities*. Museums and the Web 2003, Toronto. Archives and Museum Informatics. Retrieved 11 May 2009, from <http://www.archimuse.com/mw2003/papers/schaller/schaller.html>

Sharples, M., et al. (2007) A Theory of Learning for the Mobile Age. In Andrews, R. and C. Haythornthwaite (Eds) *The Sage Handbook of E-Learning Research*. London, Sage Publications, 221–247.

Williams, P. and Rowlands, I. (2007) *Information Behaviour of the Research of the Future*. British library/JISC.

Woolgar, S. (2002) *Virtual Society? Technology, Cyberbole, Reality*. Oxford, Oxford University Press.

Chapter 12

'See What I'm Saying': A Case Study in Visual Research, Digital Media and Language

Patrick Letschka and Jill Seddon

The 'See What I'm Saying' research project, supported by the Centre of Excellence in Teaching and Learning through Design (CETLD) at the University of Brighton, examined the introduction of digital media into the academic practice of visual research. The aim of the project was to enable students to observe, reflect on and articulate the processes of object creation and the placing of objects into museum collections.

It ran once in the autumn term of 2006 and once in the autumn term of 2007. Each time the project involved ten pairs of second year undergraduates, one student in each pair studying 3D Design/Wood, Metals, Ceramics and Plastics (WMCP) and the other studying History of Design and Decorative Arts and Visual Culture (HoD/VC). The material on which this chapter is based is taken from three sets of student responses to feedback questionnaires, recordings of seminars with invited speakers and students' reflective writing.

The two groups of students had already developed a distinct approach to the made object in their own discipline. Those on the WMCP course focus on bespoke manufacture rather than industrial design, through workshop-based processes and material exploration. The HoD/VC group develops expertise in historical, theoretical and visual analysis mainly through text-based research and written and verbal presentations. As educators from two different disciplines (one, a maker and the other, a design historian), we were keen to develop a close collaboration between students studying two very different subjects.

Both groups brought with them a good level of expertise in using portable recording technology. Introducing digital filming and editing software to explore concepts was seen as a middle ground where everyone would have an equal level of knowledge about digital applications. The aim of the project was to enable students to develop, through a managed learning and teaching environment, a fresh way of examining objects, both inside and outside the museum, visually and through language. Emphasis was also placed on articulating the design and making process by integrating language with visual research through film. At the same time, we were monitoring the effect of different learning environments, to see whether a shifting of the learning space between the lecture room, the

museum space and the online University of Brighton *Community* website would provide extra support for students and enrich their experience of the project (see Illustration 12.1).

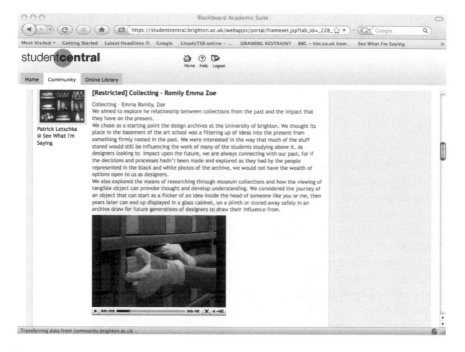

Illustration 12.1 'See What I'm Saying' webpage on University of Brighton *Community* website

We posed a series of questions in our research: what could the different approaches of the two groups of students offer each other in terms of learning and teaching?; would it be possible to intervene in the way each group saw its position so that a written discourse could reflect its visual counterpart and vice-versa?; what were the opportunities for exploring technology-based interactive learning?

Working on the Project

The initial task focused on students producing a series of 30-second (in later stages one minute) films that identified and questioned certain aspects of objects stored in museum collections. This could mean objects within museum, private, domestic or commercial collections. We also included the contemporary making of objects destined for collections. In the first year of the project we made two visits to the V&A for the students to work on the themes 'Covert' and 'Behind the Scenes'.

In the second year, students worked on the latter theme of 'Behind the Scenes' at two local museums – Preston Manor, an Edwardian house in Brighton and Newhaven Fort museum, a Napoleonic fort currently housing displays relating to local experiences of the Second World War.

The first part of the project was delivered in a familiar face-to-face session where students worked in pairs and participated through presentation, discussion and analysis.

Filming and editing
Developing technical skills
Working in pairs, sharing expertise

30 second film title: *Senses*

Introduction to 'Housing Collections' through lecture, seminar and a site visit.

30 second film title: *Collections*
30 second film title: *Accidental Collections*

Transferring working methods directly onto the Web. Technical Lecture. Posting edited work and commenting online

30 second film title: *Covert*

Introduction to collections in storage from the maker's point of view. Lecture and site visit

30 second film title: *Making*

Reflection and resolution. Responding to the themes through creative interpretation.

30 second film title: *Behind the Scenes*

Project concludes with an on-line archive/exhibition.

Illustration 12.2 'See What I'm Saying' project plan

The project required considerable technical support, staff training and facilities. Students' films were projected onto a large screen in a university lecture theatre. This helped students to understand the difference between online and cinema viewing. The space was adaptable enough to run seminar sessions and lectures. Students had access to a well-equipped computer suite, which offered network security and an online private space of the *Community* site.

In our initial proposal we had presumed that students would have a general awareness of internet social networking sites and that some students would be familiar with uploading films onto sites like YouTube and Facebook. At the first briefing session students were asked to complete questionnaires about their knowledge of internet social networking sites. These identified that students who were already using social networks felt positive about the *Community* site. We decided however that a formal introduction was necessary so that everyone would feel confident about using it.

Illustration 12.3 Making, 2006

The direct experience of selecting appropriate material, editing it into a film and then presenting it to a group, produced some very interesting results.

The groups in both years became confident and committed to the project but had limited time to share and reflect on their learning experiences during the

timetabled weekly two-hour session. As the project progressed, students became more aware of the superior quality of images produced by recording equipment and moved away from their mobile phones, seeking out the best equipment on offer at the university. The project went online halfway through the programme with the group meeting up at museum locations and for the final session. Moving the project onto the *Community* website was intended to allow students the space to post their films with a written statement and enable continuity of work across different locations.

Engaging with Objects

In the first year of the project we invited silversmith David Clarke and in the second year Professor Hans Stofer of the Royal College of Art (RCA) to talk about their experiences of having work in museum collections. We wanted students to think about and reflect upon the multilayered relationship makers have with their objects. Both speakers had very different perspectives. Clarke was very open about his ambition, whilst a student at the RCA, to win the annual commission from the V&A for a piece of silver for the permanent collection. When he succeeded and his piece was acquired by the museum, he experienced a significant loss of control about how it would be displayed and cared for. Describing himself as 'a maker who orchestrates', Clarke was clearly dismayed at the way in which a second piece purchased for the V&A collection was displayed, and even more so, that a third piece had remained in storage, apparently pending the rearrangement of the twentieth-century displays.

Clarke did however, describe a more positive side to his relationship with the museum; he referred to getting to know the curatorial staff, who he characterised as 'very specialist and passionate about what they do' and gaining privileged access to the stores.

In contrast, Hans Stofer, whose session with the students took the form of an interview, stated that he had never been to see any of his work in collections. He described his experience of selling an early wire piece through Contemporary Applied Arts,[1] as creating a feeling of insecurity: 'I felt it's not quite ready to go out there, but of course when it's out there you can't get it back'. Stofer referred to a loss of control when an object leaves his ownership, but unlike Clarke did not care how it was displayed or whether his intentions were misinterpreted. His main interest lay in what he would do next: 'for me an object is a manifestation of a process, it's a stage, then move on to the next ...' He referred to curators and collectors 'trying to communicate a particular kind of philosophy' in which his objects played a role.

1 Contemporary Applied Arts (CAA) is a registered charity that has been set up to promote and champion British craft. It is an exhibition and retail venue for learning about, appreciating and promoting contemporary craft (CAA 2009).

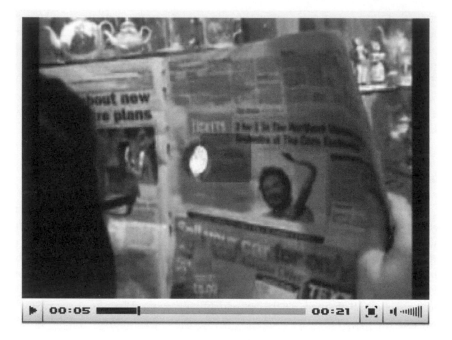

Illustration 12.4 'Covert', V&A, 2007

It was impossible to identify the explicit influences of these sessions with makers on the students' work. They did, however, encourage a high level of reflection on the role and purpose of museums, and what they mean to their audiences including makers.

When asked how the filming process influenced the ways in which they looked at objects, some students stated that they took more notice of the context of the object's surroundings or started taking into account the life of an object. The most direct reference to the discussions about makers and collections by Stofer and Clarke came from two students who wrote:

> We considered the journey of an object that can start as a flicker of an idea inside the head of someone like you or me, then years later can end up displayed in a glass cabinet, on a plinth or stored away safely in an archive for future generations of designers to draw their influence from.

In the films that resulted from the students' first visit to the V&A, it was noticeable that students had made a deliberate choice to focus on non-precious objects, such as a plastic wind-up toy in the V&A shop and out-of-the-way, mundane spaces of the museum. In response to a film on the graffiti artist Banksy's website (that showed him secretly inserting his own pieces into national collections), one student wrote

– '… it … makes you … question the position in which we place certain works of 'art' above others'.

The 'Covert' theme encouraged a sense of disguise and stealth, even transgression, in unobserved interference with temporary barriers and a snatched ride in a wheelchair.

Linda Sandino, a Senior Research Fellow for the Voices in the Visual Arts (VIVA) project at Camberwell College of Arts, spoke to students about her work exploring the construction and meaning of life stories as a way of helping students to evaluate the use of audio interview techniques and sound recording.

The insights she offered appeared to have stimulated a heightened awareness about the effectiveness of sound when, after the first few silent films, students began to introduce it into their work. Having been requested not to use music on their soundtracks, some students used sound very effectively to convey atmosphere, for example in echoing the marble-lined halls of the V&A, or the noise of air raid sirens wailing at Newhaven Fort. Other filmmakers conveyed a sense of an intimate relationship with objects, revealed at the V&A by a conversation with the team working on the renovation of the Cast Courts and at Preston Manor by a curator talking in the ceramics store. One student offered the following insight: 'A lot can be said about an object by listening to the sounds surrounding it, if it is in a museum that is crowded or a quiet private collection the surrounding sounds would be completely different'.

Acquiring New Knowledge

We approached the data from the student feedback questionnaires with no preconceived ideas about what students might have gained from participating in the project. We looked for common themes emerging from their comments and we grouped them into four categories: collaboration, technical processes, e-learning and transferable knowledge.

Collaboration

Student pairs worked together to generate ideas, produce and present films and written and verbal texts. Some students had to resolve issues of time management and taking into account one another's viewpoints. Most participants were aware of the advantages and disadvantages of working in pairs – '… I found it both challenging and rewarding working with another person from a different course … It was good to get an alternative perspective from someone who is coming at the subject from a different direction'.

In general there was an appreciation that exposure to the views and practices of another equally expert student allowed a fresh viewpoint to open up a mutually interesting subject.

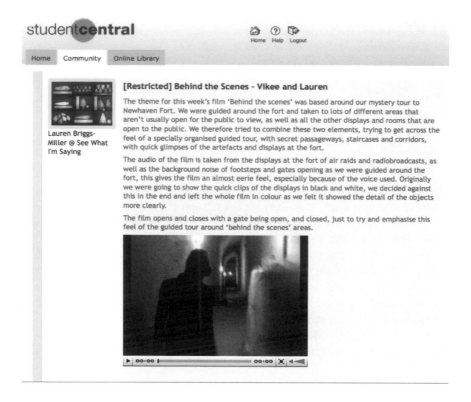

Illustration 12.5 'Behind the Scenes', Newhaven Fort, 2007

Technical Processes

At the beginning most students were learning how to make a film whilst actually doing it; as one pair put it: '... this unfamiliarity was a positive thing: we knew no limitations to the editing and filming process'.

All students rapidly acquired the necessary expertise; indeed towards the end some were expressing frustration with the relative simplicity of the iMovie editing software and wanted to progress to a more sophisticated one. Given the short length of the films, the first concern to emerge was the necessity to edit down not only the footage but also the number of ideas and concepts that could be conveyed. As confidence in the use of the technology grew, so did levels of creativity in the ways in which it could be used: '... we were able to identify a speed at which this type of film could move without feeling cluttered and including a simple pattern of transitions that could further illustrate our connections and bring the film together as a whole'.

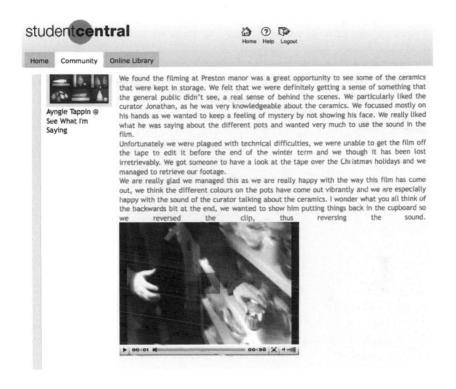

Illustration 12.6 'Behind the Scenes', Preston Manor, 2007

E-Learning

Posting their films on the *Community* website was a new experience for most students. Many commented that the site was a semi-public arena that allowed them to make their work almost instantly accessible to others whilst also evoking a desire to make it as professional as possible. Awareness of an audience had a significant effect on the making process: '... [it] made me consider how the film would work in relation to other films on the site ... so it encouraged me to try and make films that would stand out and be a bit different to the rest'.

The transition from viewing the films as a group on a large screen to viewing them individually as small images on a computer screen influenced students' decisions regarding how much visual detail to include. The students began to omit smaller detailed objects and apply higher colour contrast to the films made for the website. In some of the films shown on the large screen, tiny buttons and fingerprints were shown as part of a scene but this sort of detail was lost in the editing process for the smaller format, in favour of more general spatial shots.

This sense of presenting material to an audience also extended to the text that students had to write to accompany the films on the website. Students felt that they constructed these pieces more carefully than they might otherwise have done; making considerable efforts to explain their ideas to others (see Illustration 12.5 'Behind the Scenes', Newhaven Fort, 2007 and Illustration 12.6 'Behind the Scenes', Preston Manor, 2007). The potential for exchanging these ideas through an online dialogue was recognised but not fully realised; most students hesitated in actually writing anything online in response to questions or observations. They quite often logged on to monitor their peer group activities but there was a marked reluctance on the part of some students to post comments, resulting in a sense of frustration, as expressed by one pair: '[in] one particular case we took notice of positive comments about a film to influence how we made a subsequent [one]. However, the lack of comments made about films meant that this couldn't happen that much'.

Transferable Knowledge

Students enhanced and shared their research and presentation skills, jointly collecting, analysing and interpreting information. They were also encouraged to reflect on their experience of the project in their final analysis. They gave a great deal of thought to the ways in which the use of film could add new dimensions to the interpretation of objects. Some were particularly interested in how they could manipulate the pace and passing of time, both the running time of the film and the metaphorical time of an object's lifespan. Others enjoyed the process of layering that film allowed, which they felt gave a psychological depth to the ideas that they wanted to convey. There was widespread enthusiasm for the use of the medium and appreciation of its potential, summed up by one comment: '[it] is amazing to see that 30-second films can express such deep and poignant ideas and philosophies and also spark debate'.

Conclusion

Feedback throughout the project was consistently positive, with students demonstrating high levels of creativity in responding to the challenges we had set. We observed a mutual respect from students about the different approaches and skills other students had brought to the group. Nevertheless, using film as a 'middle ground' demonstrated a willingness from students to go beyond their defined areas of expertise and to participate in genuine collaboration. Tasks were not divided along course lines; theory-based students welcomed a more visual approach in expressing their ideas and practice-based students were keen to articulate theirs using written and verbal skills. Many of the comments made by students showed a sophisticated level of understanding about the limitations and potential of written, verbal and film-based discourse and the ways in which these might interact with

each other. The use of film as a visual research tool enabled them to explore and interpret the meanings of objects in ways that went beyond and even subverted the intentions of curators and museums as cultural institutions.

Our exploration of technology-based interactive learning produced some interesting results. The tools for production, recording, editing, and posting onto the *Community* website, once mastered, quickly became of secondary concern to the students. Students felt able to share comments and messages about films that had been posted, although not all actively participated in this. All students completed their assignments on time.

Our observation of the effects of the different learning environments on the student experience was crystallised at the final session with each group. The students made it quite clear that the meeting and sharing at the start of the project and the physical forming of the group played a vital part in feeling confident enough to post work onto the internet. This may be because students came to the project voluntarily from different disciplines, although their learning experience could be said to fit Jo Ann Oravec's definition of 'blended learning' as '... a 'middle space' of options as to how to integrate face-to-face and online models' (Oravec 2003: 225). She goes on to explain that an individual student voice can stimulate online debate, which in itself becomes a crucial part of the learning experience. Once students' confidence had been established, both cohorts felt happy about making their work public although this was not the primary aim of the project. One student mentioned showing the whole *Community* site to relatives and explaining the project to them through watching films and reading comments online. To develop this aspect of sharing ideas and experiences in a more systematic way it is now intended that the final outcome of the project should be a publicly-accessible archive of films made by students about collections of objects as an ongoing resource for participants to add to and comment upon, extending involvement to a much wider audience. In this way we hope to communicate some sense of our thoroughly enjoyable and thought-provoking collective experience.

Bibliography

CAA (2009) Contemporary Applied Arts. Retrieved 1 May 2009, from <http://www.caa.org.uk/information/about-caa.html>
Oravec, J. (2003) Blending by Blogging: Weblogs in Blended Learning Initiatives. *Journal of Educational Media* 28/2, 225–233.

Chapter 13

The Virtual Museum

Mark Carnall and Beth Cook

Twice as many people play *World of Warcraft* as live in Scotland (BE 2005; BE 2008). The average virtual citizen of *Second Life* uses more energy per year than the average real person living in Brazil (Carr 2005). More people are estimated to have visited the virtual Oreburgh Museum in the *Pokémon Diamond and Pearl* games in 2007 than visited London's V&A, Natural History Museum and Science Museum combined (above ten million Pokémon visitors to seven million real world visitors to the national museums) (Miller 2007; Nintendo 2007b; Nintendo 2007c; ALVA 2008).

This chapter will look at some of the educational benefits and opportunities that have been afforded using examples of virtual worlds from the following categories:

- Massively multiplayer online role-playing games (MMORPGs).
- Sandbox multi-user worlds.
- Multi-user dimensions/Dungeon/Domain MuDs.
- Videogame worlds.
- Alternative reality worlds.

This chapter will first set the scene for the use of virtual worlds and then define the virtual worlds previously listed. It will then look at the possible applications of existing and specially-designed virtual worlds in higher education (HE) and museums. It will also consider issues around combining the virtual and the real, and what impact this could have for students in HE.

Virtual Worlds

Common perceptions of virtual world users have worked to undermine the potential applicability of virtual worlds for education. Virtual worlds are stereotypically considered the domain of adolescent western males, but in the UK an estimated 59 per cent of 6–65 year-olds play videogames and the average age of UK gamers is 28 years old (Pratchett 2005). Virtual worlds are also often demonised in the media and cited as inspiring real world violence, addiction, and even poor academic performance (BBCNews 2004; Johnson 2006; BBCNews 2007; Benedetti 2007). However, the Department of Culture, Media and Sport (DCMS) found evidence

linking virtual worlds to violence to be contradictory (Harris 2001; Boyle and Hibberd 2005).

Virtual worlds have been the subject of much academic study and like other forms of media warrant study in their own right. Architects, archaeologists and biologists already use virtual worlds of sorts to design new buildings, reconstruct ancient settlements and to model climates.

In order to remain pertinent and accessible to their visitors it is necessary for museums to keep up with current technological standards and exploit the educational opportunities newly provided by technology. It is also important when museums do incorporate technology that it meets the current intellectual and aesthetic standards of that media available elsewhere (Thomas 1998). Virtual worlds and digital landscapes have been readily adopted by other media and their incorporation into wider culture further demonstrates the need for universities and museums to incorporate virtual worlds into pedagogy. This could help keep teaching pertinent to the wider world in which students live, and make use of a communication tool which allows great freedom of expression and representation combining motion, sound, colour and text. This has particular relevance for students engaged with subjects such as design, to which this chapter will refer.

Museums have also highlighted virtual worlds both in terms of design and their role in popular culture. In 2004, the Design Museum hosted a small exhibition celebrating the design of games such as *Tomb Raider, Crash Bandicoot* and *Pac-Man* (Namco 1980; EidosInteractive 1996; Sony 1996). In 2006/07 the Science Museum also curated a high profile exhibition, *Game On*, celebrating the history of videogames with over 100 playable titles on show.

Museums themselves feature in virtual worlds and are often more compelling than virtual spaces currently offered by museums. Videogames such as *Tomb Raider: The Angel of Darkness*, *Animal Crossing*, *The Da Vinci Code* game, *Gears of War, Grand Theft Auto IV and* all of the *Pokémon* games to list a few, have all included believable museums in their virtual worlds (EidosInteractive 2003; Nintendo 2004; 2KGames 2006; Microsoft 2006; Rockstar 2008). The museums range from destructible playgrounds to faithful reconstructions of existing museums and nearly all of them make up fun spaces to interact with. Rodriguez and Wieneke expand on this in their chapter on *Second Life* (see Chapter 14).

In the developed world at least, virtual worlds have already ingrained themselves in the public mindset. However, there is much greater scope for virtual worlds to be used in pedagogy to provide novel learning experiences beyond learning about the virtual worlds themselves. The next section explores what could be meant by the umbrella term 'virtual worlds'.

What is a Virtual World?

The exact definition of a virtual world is open for interpretation. The following is a brief list of how one could define a virtual world:

1) Massively Multiplayer Online Role-Playing Games (MMORPGs)

These large worlds are populated by a mix of real player avatars (virtual characters) and non-playable characters (NPCs). Players can travel from ocean depths to mountain heights, sharing experiences with virtual friends and foes, controlled by other players. There are adventures and quests to go on but a large part of the experience is exploring and interacting with other players. Some examples include *World of Warcraft* and *Guild Wars* (BE 2005; NCSoft 2005).

2) Sandbox Multi-user Worlds

Similar to the above but with even more freedom to explore, interact, and to create. These kinds of virtual worlds do not have an end point, and players can create their own games with endings and goals within the sandbox world. Sandbox worlds like *Second Life* allow players to create their own virtual objects, from virtual shoes to virtual space stations, and sell them for large amounts of in-world currency (LindenLab 2009a). The transfer of real-world cash to in-game currencies and vice versa means *Second Life* has been calculated to have a GDP in the hundreds of millions of dollars (Kirkpatrick 2007).

3) Multi User Dimensions/Dungeon/Domain MuDs

The first multi-user virtual worlds lacked graphics and were driven through text alone. Players navigated the space and interacted with other inhabitants by typing instructions from a list of text actions. This form of virtual world remains popular today, perhaps because it offers an abstract existence undefined by what you can see on the screen.[1] There is much greater scope for engagement, creation, debate and discussion within MuDs and sandbox worlds than in MMORPGs.

4) Videogame Worlds

The above definitions depend on the multi-user aspect of the virtual world to validate their existence. However, technically any virtual experience, no matter how abstract it may be, has a 'space' and constraints that define what players can or cannot do within that space. In this case even the simple play space of *Tetris*, or *Pac-Man* would count as a virtual world (Namco 1980; Nintendo 1989). Many of these kinds of virtual worlds are task-driven and focused on completing the game. Videogames such as *Solitaire*, *Minesweeper* and *Super Mario Brothers* are by far the most popular kind of virtual worlds (Nintendo 1985). These virtual

1 For an unrivalled account of one of these virtual worlds, LambdaMOO, see Dibbell, J. (1999) *My Tiny Life: Crime and Passion in a Virtual World*. New York, Henry Holt and Company.

worlds allow for a much more narrowly-defined form of achievement with limited freedom for exploring themes and spaces.

5) Alternative Reality Worlds

This category refers to daily activities such as emailing or creating a spreadsheet. We could also include activities on Facebook, Wikipedia, YouTube, and web forums since they are a kind of interactive virtual 'space'. Digitised museum collections could also be considered in this definition. These virtual worlds are perhaps the most readily used in education because they are familiar, easily accessible and trendy.

Expanding the Campus

One of the most immediate and obvious benefits of using virtual worlds in teaching is that the geographical location of teachers, students and collaborators becomes less important. In museums especially, much work has been undertaken in recent years for the benefit of the enigmatic 'online audience'.

In theory, by using virtual worlds and virtual spaces, objects and information become available to everyone. In reality many online databases and catalogues have been launched only to be used by internal audiences or subject specialists. Barriers to use have included the kind of language used by museum specialists when categorising objects. For example, a 2005–2008 project at the V&A, *Capacity Building and Cultural Ownership,* helped to re-identify 3,000 objects in the collections with relevance to the African Diaspora (V&A 2007). Previously these were often catalogued in a number of different ways that made it difficult to identify them as such.

The virtual campus expands beyond the lecture theatres and exhibition halls of the physical campus but is still limited to areas with an internet connection and/or access to a power cable (although mobile devices are increasingly able to access content online). This is an important consideration to bear in mind when developing and using virtual worlds in teaching. By constructing virtual worlds we are far from opening up learning opportunities to everyone.

In using a virtual world we exclude anyone without access to the required technology – the majority of our potential audience. If downloads are required, this excludes audiences using computers where downloadable content is not permitted, such as most universities and schools. In addition, even the most wonderful of virtual worlds may be neglected if the interface is not user friendly or if content is difficult to find. Lastly, but perhaps most importantly, we should not be using virtual worlds merely for the sake of using the technology or at the expense of those who are not technologically literate. A platform like *Second Life* has enjoyed a large amount of positive media coverage in recent years but logging in for the first time can be a clunky and chaotic experience.

Another huge advantage of using virtual worlds in education is that avatars are not subject to real physical laws. Virtual worlds allow us to be abstract, for example to be an all-seeing god (*Black and White*), a force of gravity (*Mercury Meltdown*) or a gust of wind (*Lost Winds*) (EA 2001; Atari 2006; Frontier 2008). We can surely better understand theories, concepts and real-world processes by shifting our perspectives. A good example of this is the *Foldit* project (UW 2009). This is a game where the goal is to solve complex 3D puzzles which are actually unfolded protein structures. By 'solving a puzzle' people are helping science to fold proteins together in order to understand how they work. In order to solve some of these problems computers required extensive programming and were not always successful. Humans have good visual puzzle-solving skills and by turning the biological puzzle into a videogame there are now thousands of people helping *Foldit* to model proteins, which may help scientists understand diseases such as HIV, Alzheimer's and cancer.

Similarly, many subjects studied at university involve abstract concepts that are hard to demonstrate or explain. Virtual worlds provide the potential for different approaches to explaining and exploring such concepts. For example, an internet favourite includes Mario, of *Super Mario Brothers* fame, explaining wave theory simply using the game's physics (Magius 2005). The provision of different activities around a subject could help cater to the needs of people with different learning styles (see Chapter 2 for further explanation). In addition, if students are already using virtual worlds in their own lives then both museums and universities should consider the possibilities of using virtual worlds as part of their education strategies.

Perhaps the biggest advantage of virtual worlds above other media is that they are interactive. Virtual worlds allow players to interact with a world and other players in real time either on the screen or in front of it. For the individual this is important as they can explore and experiment with their surroundings, which is an important part of learning in itself – a kind of experiential learning. Evidence shows that using virtual worlds encourages users to communicate with other players, sharing experiences and findings with peers and also with family members (Mileham 2008: 191–239). For educators this is also beneficial as they can easily view and record the behaviours of visitors in a virtual space.

Adapting Existing Virtual Worlds

There are currently an unquantifiable number of commercially and freely available virtual worlds – from free-to-play internet games to the most recent blockbuster title like *Metal Gear Solid 4* (Konami 1998). Potentially they could all be used in an educational context. What better way to get museum visitors enthused about marine biology than a group session playing *Endless Ocean* on the Nintendo Wii (Nintendo 2007a)? Another superb virtual world, *Spore*, is practically designed to teach evolution (EA 2008). Players 'evolve' their own species from existence

as a single cell organism all the way up to terra-forming, galaxy conquering civilisations (Laun 2008).

Depending on the learning outcome, subject matter and audience there is much scope for incorporating existing virtual worlds into a learning environment as a number of projects already do. Linden Lab, creators of the platform *Second Life,* provide extensive support for educators who wish to use the platform for education. Harvard, New York, San Diego State, Stanford and Texas State Universities all have virtual campuses on the Second Life Grid (LindenLab 2009b).

The advantage of using existing virtual worlds is that the high cost of creating virtual worlds is bypassed. All that is needed is the correct software, hardware, an appropriate space and preferably a knowledgeable facilitator. This setup is not unfamiliar in museums and universities, which are used to setting up audio-visual equipment for lectures, exhibitions and installations. As people become more confident using technology in their daily lives, they may be more comfortable about using it in different environments – such as the museum or other educational settings. This increasing use of technology can be seen in current design courses – many design students are taught to use computer-aided design programmes (CAD), such as Vectorworks and Cinema4d which are used extensively in architecture both for students and in a professional context (Maxon 2009; Nemetschek 2009).

While museums will not be able to supply experiences involving the wide range of programmes that their visitors might be familiar with, it is at least important for them to consider the kind of virtual experience visitors are used to when planning their own approach, and the increasing ubiquity of such experiences in everyday life.

However, successfully incorporating existing virtual worlds into teaching can create some problems. In the first instance educators have to be aware of the range and diversity of available virtual worlds in order to be able to incorporate them in education. If you know where to look, the popular *Pokémon* series of games can be used to show quite complex biological topics such as taxonomy, genetics and selective breeding. The key to using this kind of virtual world in education is to facilitate links between people who understand the topics, and people who understand the virtual world in which these topics can be explored.

A number of videogames feature beautifully constructed virtual museums that would be prime for engaging with virtual visitors. For example *PC Format* magazine ran a competition in conjunction with Bradford's Cartwright Hall, for videogame players to design a new level of *Unreal Tournament*, a popular first person shooter for the PC (GT 1999). *PC Format* included architectural plans and photographs on disc and the player that created the most accurate gallery won a top-of-the-range PC. The competition was massively successful and the winning Cartwright Hall level was downloaded by 10,000 players and supplied to a further 70,000 players on a free disk with *PC Format* (Heal 2004). This commercial competition has clear lessons for museums and universities looking to engage in new and different ways with their students. It supplied materials, a brief, and a deadline for completing a piece of work – the creation of a virtual

environment – and by setting this competition within the context of a popular contemporary environment received an overwhelming response. The level of prize would be untenable within a museum/HE environment, but the worth of the potential exposure for the winning work should not be underestimated. Museum and university educators may be able to work with game developers in order to adapt the virtual worlds they have created for an environment more conducive to learning.

Creating New Worlds

As we have seen, adapting existing virtual worlds for use in education does have some scope but in order to fulfil educational potential, practitioners may need to work with game developers to adapt the virtual worlds to refine the focus on education, whilst still retaining the element of fun. An alternative would be to create whole new virtual worlds. This way the content and rules of the world can be more easily controlled and museum practitioners will have a comprehensive knowledge of the world because they helped to build it.

Creating new virtual worlds allows educators to create learning environments specific to the topic and learning outcomes that they want to achieve. However, creating and maintaining a whole new virtual world requires vast amounts of expertise and time. In commercial perpetual worlds there are staff working around the clock, keeping virtual economies stable and reacting to player complaints. Museums cannot sustain these kinds of virtual worlds without outsourcing the entire project at great cost. In addition, in order to compete with commercial virtual worlds they have to be highly polished in terms of graphics, haptic devices, control mechanisms, avatar freedom and audio.

One issue with accomplishing this is that the technology goes out of date very quickly. Museums with limited funding and a very wide scope of activities have to compete with the multi-million-pound, highly competitive videogame industry – not an easy task.

This being stated, the Natural History Museum London did create two virtual worlds for the 2007 Ice Station Antarctica exhibition, which aimed to explain what being a scientist in Antarctica was like. The goal of one game was to highlight different species of sea animal with an underwater torch whilst keeping an eye on air supply. In the other game players had to collect meteor fragments from the ice on skidoos. Both games were fun to play but raised questions about the techniques chosen to interpret the exhibition message. The diving game successfully allowed players to experience conditions they will probably not get to experience in real life, and shed some light on the diversity of the frozen sea fauna and flora. However, the skidoo game was less successful. The learning outcome of the game (presumably for people to understand that scientists go to Antarctica to collect meteorites) was not clear. The emphasis of this game was clearly on entertainment at the expense of education. The gallery as a whole included no more than a dozen real museum

objects, and this is an example of an occasion when virtual worlds were used to replace real objects and traditional interpretation techniques altogether.

One area of further research is to investigate whether combining virtual world teaching with real world teaching is more effective than using either separately. For example, one CETLD project called *Spotlight,* run by the Royal College of Art (RCA), piloted a series of virtual interdisciplinary tutorials using *Moodle,* an open source Virtual Learning Environment (VLE) – an alternative reality world as described previously. This chapter has talked about the importance of considering why new technologies might be used for projects, and this example thought carefully about this: 'The decision to use virtual technologies has been prompted both by an interest in its potential and in a practical concern about departmental timetabling' (Mitchell 2008b). The concluding evaluation of the project considered it to be a qualified success, displaying some of the benefits and some of the drawbacks that have been mentioned regarding engagement with digital worlds:

> The tutorials did provide an opportunity for students to showcase their work and to share ideas and experiences across discipline boundaries ... and elements of the course are likely to be repeated in a revised format in the forthcoming academic year ... [However] on a voluntary basis the students resented the degree of perceived compliance necessary, and ultimately disengaged in the later tutorials. (Mitchell 2008a)

This reflects patterns of digital usage which often have enthusiastic initial take up followed by rapid lessening of interest.

Future Perfect?

Some of the above examples show how virtual worlds can either be adapted or created from scratch to facilitate learning or simply get people interested in a subject or a space. However, museums and universities still have some barriers to traverse before they can use virtual worlds to maximum benefit.

There are also a number of other considerations that need to be taken into account before using virtual worlds, which may be partly why museums have been so slow to adopt virtual worlds in education. Museums, as public bodies, have to prove that projects are effective and useful with continuous evaluation. As such, they cannot afford to experiment with revolutionary techniques and methods but have to use tried and tested technologies (at the same time competing with cutting-edge commercially available software) (Macdonald and Alsford 1997). Issues of ownership and copyright are also potentially serious concerns for museums that choose to create resources inside existing virtual worlds. Many museums are unwilling to develop resources that they do not own or that could be taken offline without notice. In addition, those who have developed 3D virtual environments for use by museums have complained that 'interest wanes from an enthusiastic

beginning: the 3D world looks both enticing and promising, but the attention curve drops sharply as the users find the space either too difficult to navigate or not satisfyingly engaging' (Di Blas, et al. 2003).

With the capabilities of technology seemingly endless, the problem of novelty value is particularly problematic. Some commentators seem anxious to predict the next best thing even when the current technology appears to be in bloom or has yet to fulfil its maximum potential (Duffy 2007). Visitor evaluation comparing an exhibition that exists in real life and *Second Life* seems to indicate that virtual users also demand a wider range of mixed media content than galleries and websites are currently providing. They want objects, images and labels but they also demand up-to-date video and web references (Gordon 2007). For education institutions, keeping such resources up to date can be difficult when many projects are funded for a fixed period of time.

Combining the Virtual and the Real

This field of study is relatively unexplored yet raises many questions. Would people understand more about objects if they could see them in real life (albeit in a glass case) and play with them in a reconstructed virtual landscape? Can people learn about objects by throwing them around in a virtual world with physical laws similar to the world we live in? Could there be an educational value in destroying objects while in the safety of a virtual world? Could we learn more about the characters in a painting from a label in an art gallery or if we went inside the virtual world of the painting? Does a labelled piece of Roman pottery tell us more than a virtual world in which players have to make, trade or use the pot?

All of these questions are worthy of further study and are particularly pertinent for museums. The explosion of the web in the 1990s raised concerns that people would stop visiting museums if they could access them online. This is evident today as most museums maintain websites that offer little more than contact detail and event listing pages. Research over the past few years, however, has shown that 'online museums actually drive physical museum attendance instead of discouraging physical visits; in the majority of studies planning a museum visit is consistently cited as the primary reason people visit museum websites' (Marty 2007). Due to museum anxiety about putting content on the web, information about objects, institutions and people is now more readily available via sites such as Wikipedia. In recent years the museum response to the web revolution has been to digitise collections and make the databases available online; however, as mentioned previously there often appears to have been little thought how this information will be used and by whom. Offering limited object information online may be ultimately frustrating for casual museum visitors and researchers, including students.

A virtual museum would allow visitors to interact with the objects in a reconstructed museum context. Combining both real and virtual museums would

allow for more complete understanding of objects. By viewing and handling the object we can assess its texture, weight, size, colour and smell. By interacting with it virtually we can put it into a context, see how it moves (or sounds in the case of instruments) and how it works. The technology will progress and become more affordable and virtual worlds will become more readily accepted in their own right and be seen as valid educational tools. This potentially has the power to transform how we interact with objects and how we interact with each other.

Many new technologies seem to have been incorporated into museums for the sake of innovation with little foresight to the end users of the outputs (Semper 1998). The end use of applications is often much narrower and less altruistic than the original scope of project proposals.

The kind of virtual world used controls the pedagogical scope. Academics and museum practitioners should think carefully about their learning objectives and audience before employing virtual worlds over more traditional teaching methods, or choosing one kind of virtual world over another.

Bibliography

2KGames (2006) *The Da Vinci Code*. DVD-ROM.

ALVA (2008) Visits made in 2007 to visitor attractions in membership with ALVA. Association of Leading Visitor Attractions. Retrieved 15 November 2008, from <http://www.alva.org.uk/visitor_statistics/>

Atari (2006) *Mercury Meltdown*. Atari. DVD-ROM.

BBCNews (2004) Society Must Act to Cut Obesity. Retrieved 29 April 2009, from <http://news.bbc.co.uk/2/hi/health/3739988.stm>

BBCNews (2007) Virtual Worlds Threaten 'Values'. Retrieved 29 April 2009, from <http://news.bbc.co.uk/2/hi/technology/7061641.stm>

BE (2005) *World of Warcraft*. Blizzard Entertainment. CD-ROM.

BE (2008) *World of Warcraft*® Reaches New Milestone: 10 Million Subscribers. Retrieved 29 April 2009, from <http://eu.blizzard.com/en/press/080122.html>

Benedetti, W. (2007) Were Videogames to Blame for Massacre? Retrieved 29 April 2009, from <http://www.msnbc.msn.com/id/18220228/>

Boyle, R. and Hibberd, M. (2005) *Review of Research on the Impact of Violent Computer Games on Young People*. Stirling Media Research Institute. Retrieved 29 April 2009, from <http://www.culture.gov.uk/images/publications/research_vcg.pdf>

Carr, N. (2005) Avatars Consume as Much Electricity as Brazilians. Retrieved 29 April 2009, from <http://roughtype.com/archives/2006/12/avatars_consume.php>

Di Blas, N., et al. (2003) The SEE Experience: Edutainment in 3D Virtual Worlds. In Bearman, D. and J. Trant (Eds) *Museums and the Web 2003*. Toronto, Archives and Museum Informatics, 81–92.

Dibbel, J. (1999) *My Tiny Life: Crime and Passion in a Virtual World*. New York, Henry Holt and Company.

Duffy, S. (2007) Second Life: Is the Party Over? *Not Another Marketing Weblog* Retrieved 29 April 2009, from <http://namw.wordpress.com/2007/09/30/secondlife-is-the-party-over/>

EA (2001) *Black and White*. EA Games. CD-ROM.

EA (2008) *Spore*. EA Games. DVD-ROM.

EidosInteractive (1996) *Tomb Raider*. CD-ROM.

EidosInteractive (2003) *Tomb Raider: The Angel of Darkness*. DVD-ROM.

Frontier (2008) *Lost Winds*. Frontier Developments. WiiWare.

Gordon, R.A. (2007) Accessibility and Virtual Presence: The Implementation of Museum Exhibitions in Virtual Environments. MA Dissertation. University College London.

GT (1999) *Unreal Tournament*. GT Interactive. CD-ROM.

Harris, J. (2001) The Effects of Computer Games on Young Children – A Review of the Research. Retrieved 29 April 2009, from <http://www.homeoffice.gov.uk/rds/pdfs/occ72-compgames.pdf>

Heal, S. (2004) Shooting Gallery. *Museums Journal*. 104, 22–23.

Johnson, B. (2006) The Writing is on the Wall – Computer Games Rot the Brain. Retrieved 29 December 2006, from <http://www.telegraph.co.uk/comment/3635699/The-writing-is-on-the-wall-andndash-computer-games-rot-the-brain.html>

Kirkpatrick, D. (2007) It's Not a Game. Retrieved 29 April 2009, from <http://money.cnn.com/magazines/fortune/fortune_archive/2007/02/05/8399120/>

Konami (1998) *Metal Gear Solid 4*. Konami. Blu-ray Disc.

Laun, C. (2008) Virtual Learning: 25 Best Sims and Games For the Classroom. Retrieved 29 April 2009, from <http://www.collegeathome.com/blog/2008/06/03/virtual-learning-25-best-sims-and-games-for-the-classroom/>

LindenLab (2009a) *Second Life*. Retrieved 29 April 2009, from <http://www.secondlife.com>

LindenLab (2009b) Virtual Environments Enable New Models of Learning. Retrieved 29 April 2009, from <http://secondlifegrid.net/slfe/education-use-virtual-world>

Macdonald, G. and Alsford, S. (1997) Conclusion: Towards the Meta-Museum. In Jones-Garmil, K. (Ed.) *The Wired Museum*. Washington, American Association of Museums, 267–278.

Magius (2005) Super Mario Physics. Retrieved 29 April 2009, from <http://www.newgrounds.com/portal/view/248844>

Marty, P. (2007) Museum Websites and Museum Visitors: Before and After the Museum Visit. *Museum Management and Curatorship* 22/4, 337–360.

Maxon (2009) *Cinema 4D*. Maxon. DVD-ROM.

Microsoft (2006) *Gears of War*. Microsoft Game Studios. DVD-ROM.

Mileham, R. (2008) *Powering Up: Are Computer Games Changing our Lives?* Chichester, John Wiley & Sons.

Miller, R. (2007) Pokémon Diamond and Pearl Sell 10 Million. Retrieved 29 April 2009, from <http://www.joystiq.com/2007/07/30/Pokemon-diamond-and-pearl-sell-10-million>

Mitchell, C. (2008a) Spotlight: Evaluation Report – Conclusions. *CETLD*. Retrieved 29 April 2009, from <http://cetld.brighton.ac.uk/projects/completed-projects/spotlight/evaluation-report/conclusions>

Mitchell, C. (2008b) Spotlight: Outline. *CETLD*. Retrieved 29 April 2009, from <http://cetld.brighton.ac.uk/projects/completed-projects/spotlight/introduction>

Namco (1980) *Pac-Man*. Arcade.

NCSoft (2005) *Guild Wars*. DVD-ROM.

Nemetschek (2009) *Vectorworks Architect*. Nemetschek. DVD-ROM.

Nintendo (1985) *Super Mario Brothers*. 320kb cartridge.

Nintendo (1989) *Tetris*. Gameboy Cart.

Nintendo (2004) *Animal Crossing*. Gamecube Optical Disc.

Nintendo (2007a) *Endless Ocean*. Nintendo. Wii optical disc.

Nintendo (2007b) *Pokémon Diamond*. Nintendo DS Game Card.

Nintendo (2007c) *Pokémon Pearl*. Nintendo DS Game Card.

Pratchett, R. (2005) Gamers in the UK. Digital Play, Digital Lifestyles. Retrieved 29 April 2009, from <http://open.bbc.co.uk/newmediaresearch/files/BBC_UK_Games_Research_2005.pdf>

Rockstar (2008) *Grand Theft Auto IV*. Rockstar Games. DVD-ROM.

Semper, R. (1998) Designing Hybrid Environments: Integrating Media into Exhibition Space. In Thomas, S. and A. Mintz (Eds) *The Virtual and the Real: Media in the Museum*. Washington, American Association of Museums, 119–127.

Sony (1996) *Crash Bandicoot*. Sony Computer Entertainment Europe. CD-ROM.

Thomas, S. (1998) Mediated Realities: A Media Perspective. In Thomas, S. and A. Mintz (Eds) *The Virtual and the Real: Media in the Museum*. Washington, American Association of Museums, 1–18.

UW (2009) *Foldit*. University of Washington. Retrieved 29 April 2009, from <http://fold.it/portal/info/science>

V&A (2007) V&A Report on Cultural Diversity 2007. Retrieved 29 April 2009, from <http://www.vam.ac.uk/files/file_upload/42695_file.pdf>

Chapter 14

Learning in Second Life

Karina Rodriguez-Echavarria and Lars Wieneke

Second Life[1] is a virtual world in which people, represented by virtual personae called avatars, can communicate with each other and cooperatively design the environment. Virtual worlds like *Second Life* allow higher education (HE) students and tutors not only to visit virtual museums, but also to communicate, co-experience and cooperatively create new objects and collections. *Second Life* therefore continues the transformation, started by previous internet-based technologies, to the way individuals have traditionally learnt. Hence, an impact of this technology on enhancing current teaching and learning practices can be expected. In a recent report, three quarters of UK HE institutions were estimated to be actively using *Second Life* at institutional or individual level (Kirriemuir 2008). In addition, museums and heritage institutions have demonstrated an increasing interest in experimenting with this type of environment. These data are supported by the diverse activity of these institutions in *Second Life*, which includes exploratory work, marketing, supplementary/complementary learning and teaching, as well as research (Kirriemuir 2008).

This chapter begins by introducing *Second Life*, and then presents different examples of museum and HE uses of *Second Life*. We argue that the possibilities for communication, action and shared creation in *Second Life* offer a far wider spectrum of possibilities and potential for design education than has yet been adopted.

Learning from Virtual Worlds

As a popular role model for the growing genre of massive multi-user virtual worlds,[2] *Second Life* has gained extensive media coverage recently. The press has particularly highlighted the connection of *Second Life* with the eternal myth of multiple identities, but also came to criticise the amount of freedom that some dare to take in this (digital) utopia. However, *Second Life* also gained significant attention in the context of research into distant learning environments as well as museum communication. After press coverage and public attention dropped, these

1 *Second Life* is a trademark of Linden Research, Inc. *Museums and Design Education: Looking to Learn, Learning to See* is not affiliated with or sponsored by Linden Research.
2 See Chapter 13 for definition of sandbox multi-user worlds.

projects continued, and started to offer insights into the trials and tribulations raised through the peculiar interpretation of interactivity by virtual worlds. They started to make observations about how this concept of interactivity shaped and changed both understanding and expectations of once well-defined concepts like user, owner, visit and participation.

At its very core, *Second Life* forms a multi-user virtual environment (*muve*), or sandbox multi-user world: a software application that allows users to communicate in real time with each other. The first and probably most apparent feature in this regard is *Second Life*'s use of three-dimensional graphics. In terms of content design, both the design of the avatar as well as the design of the environment resemble the practice of a collage, where snatches gathered from different sources are customized and combined to form an integrated whole. There are relatively few rules for the design of content in *Second Life*. This leads on the one hand to a surprising amount of creativity and innovation but on the other hand to questionable practices and designs in terms of taste and manners.

Using their avatars, users walk, fly or teleport themselves through the *Second Life* world. They meet other avatars and can communicate with them through text or voice chat. Users have great freedom to design their own avatars. Although anthropomorphic representations dominate in general, other animated and inanimate shapes are used as well. Users can also alter the surroundings of the virtual world through an integrated authoring environment, which enables them to build objects like houses, cars or interiors. In order to make these objects both viewable and useable by others, objects need to be placed on virtual land. Users can rent and buy this land, a feature that is used by some to build up their own private dream house. Despite the fact that many laws of physics can be enabled or disabled with a single click, these virtual constructions often use and idealise the fundamental elements of real world constructions with roofs, windows, walls or stairways. However, these familiar elements are not always useful as avatars do not have to travel in a real world fashion and can make navigation in *Second Life* arduous.

In relation to the size and impact of the internet it is worth noticing that despite the ubiquity of media coverage of *Second Life* both environments are hardly comparable in size. Compared to the internet as a whole, *Second Life* is a relatively small-scale environment with 15,542,982 total residents (Nino 2007; SL 2008b; Various 2008).[3] Its population density of 32.7 inhabitants per km^2 (SL 2008h; SL 2008k) is higher than the population density of the United States of America at 31 inhabitants/km^2 (CIA 2009).

With its focus on user creativity, *Second Life* embeds a strong rights management system. Whatever a user creates belongs to him and *Second Life* enables not only the exchange of objects but also the economic basics for the creation of a market

3 In addition it must be remembered that this figure refers to the total number of accounts created, not the total number that remain used and active: statistics show that only 10 per cent of users with an account are still logging in after their first 90 days (Nino 2007).

space: a) a virtual currency, entitled the Linden dollar, which can be exchanged against the US dollar based upon a free-floating exchange rate and b) a micro-payment system that enables users to buy and sell objects.

Second Life enables different practices and levels of usage – from a 3D chat environment up to the design of an interactive environment which responds to user inputs and connects to external services – but users need to be technologically competent in order to make full use of its capabilities. *Second Life* operates through an external software application, and users need to download the environment before they can interact with the service. Furthermore, 3D navigation is still unknown to a majority of users and may provide a significant challenge. These characteristics can limit the mainstream appeal of *Second Life*. In addition, the existence of *Second Life*, and the objects it contains, depends solely on the fortunes of the company Linden Labs, which owns the platform it is hosted on.

With *Second Life*'s focus upon the user and their ability to create, modify but also destroy whatever exists in this world, it becomes a test bed for museums and HE institutions to find out about how to enable and manage learners' creativity. Due to the nature of virtual worlds and their current early state of development, universal step-by-step instructions that can be transferred to any upcoming environment are unlikely to be found. All activities in *Second Life* are in various ways entangled with the constraints of the environment. However, patterns of interaction can be identified that are more likely to be transferable to future environments.

Second Life for Learning and Teaching in HE and Museums

In this section, different approaches to learning and teaching in HE through *Second Life* will be discussed, along with several case studies which highlight the use of interaction patterns in both HE and museum uses of *Second Life*.

At present, there is no common agreement between or within the communities on best practice in the integration of learning theories in the use of virtual worlds. Nevertheless, different learning and teaching approaches, ranging from those developed within the educational sector to those more informally used within the museum sector, share commonalities that are useful to understand the relevance of technologies such as *Second Life*. These include the constructivist approach, as well as theories used within the museum sector, such as object-based learning (Hein 1998; Paris 2002) (see Chapters 3 and 7 for further discussion of these issues). These approaches supply evidence that learning in HE and museums:

- is a personal experience which relates to the learner's background and personal context;
- is not restricted to the classroom or museum walls;
- starts before and continues beyond the class or museum visit; and
- is an active and social process. (Falk and Dierking 2000)

Previous internet-based technologies, mainly based in paradigms of text and image-based interaction, have supported the first three of these characteristics. However, virtual worlds, such as *Second Life*, address the fourth characteristic in ways not previously possible on the internet. This is because in contrast to other environments, communication, social activities and productive action take place in the same environment and not in separate applications. There are plenty of replicas of the 'virtual campus' and the 'virtual museum', with benefits including the virtual communication and co-experience of the environment among learners. As this potential is being assimilated by HE and museum professionals, their interest in supporting learning and teaching is moving beyond using the *Second Life* environment to recreate the campus or museum building along with its current learning practices. However, the scientific community is experimenting with *Second Life* to enable creative thinking and collaborative exploration. Currently, the most common patterns in *Second Life* which can be found for learning and teaching include:

- virtual exhibitions and displays recreating the real world;
- distance and collaborative learning based on communication;
- understanding of abstract concepts through experience;
- design, creation and productive participation.

Experiments in *Second Life* which follow these patterns are enabling those involved in all subjects; and particularly those where creativity plays a central role, such as design and related subjects, to push the boundaries of the environment and to develop new practices.

Activities of HE and Museums in *Second Life*

The following sections will highlight particular examples of museum and HE activity in *Second Life*, as well as their implementation of concepts for learning in the context of both HE and museum education. This section aims to compare HE and museum uses of *Second Life* in order to discuss their approaches and to point out similarities and differences. Due to the dynamic nature of the environment, the following examples are snapshots, which might alter in the course of time.

Reconstructing the Real

Currently examples of HE institutions and museums recreating virtual replicas of their site in *Second Life* include the Sussex University online campus (SL 2008o), which recreates the campus buildings including teaching, social and open spaces. In the context of museums, examples of reconstructions can be found at The Dresden Gallery (SL 2008a), a reconstruction of the *Gemäldegalerie Alte Meister*

in the *Sempergalerie* at the *Zwinger* in Dresden, Germany or in the reconstruction of the Sistine Chapel (SL 2008l).

The reconstruction of these sites not only refers to the buildings but also their interiors. In the case of the *Gemäldegalerie Alte Meister*, digitised versions of the paintings can be found as well while the Sistine Chapel in *Second Life* features interior decorations and wall paintings.

Reconstructions of the real in *Second Life* not only transfer buildings, sites and interiors but also patterns of usage to the virtual environment. The Sistine Chapel and the *Gemäldegalerie Alte Meister* both apply a code of conduct that explicitly bans certain behaviours and replicates the real-world code of conduct that applies to these spaces. The same can be seen in an HE context. While real-world design of lecterns and auditoriums follows constraints such as audibility or control of student behaviour, similar constraints do not have to exist in a virtual world. However, their integration in *Second Life* shows that the practices of use that developed in relation to these designed environments have continued relevance as a point of departure for the exploration of the uses of virtual worlds. Users are currently uncertain of which codes of conduct are applicable to *Second Life*: how do students know when it is polite to ask questions to tutors, or queue to speak to the tutor on a one-to-one basis? Hence, the reconstruction of practices performs a function that may be replaced in the long run.

In an HE context, a familiar environment for teaching and learning activities can be constructed in *Second Life*. For museums, reconstructions of the real world environment in a virtual space also have specific aims. This includes enabling users who might not be able to gain physical access to their buildings to visit the place.

Communication and Discussion in the Virtual World

As chatting is an inherent feature of any *muve*, users in *Second Life* make use of this function in different contexts. HE institutions are deploying a variety of facilities within *Second Life* to serve as platforms for augmented communication activities. Examples of islands include Open Life Island by the Open University (SL 2008j) and Solent Life Island for fashion, media styling and digital music students by the Southampton Solent University (SL 2008m). The latter includes an area for staging fashion shows, a gallery for exhibitions as well as meeting places. All these spaces are designed to enable learners to debate, review and exhibit their design ideas.

Museum environments in *Second Life* also include many places for communication and presentation. For example, the International Spaceflight Museum (SL 2008e), a virtual museum with no real-world counterpart, offers interesting examples for both public presentation and informal communication (SL 2008g; SL 2008f).

Users can chat informally or conduct formal meetings relatively easily. Examples of spaces include a combination of open and closed meeting rooms,

Illustration 14.1 Solent Life Reception (SL 2008n)

Illustration 14.2 Open Life Island (SL 2008j)

Illustration 14.3 Tsunami demonstration, National Oceanographic and Atmospheric Administration (SL 2008r)

lounges, auditoriums and offices. These are designed to host a diverse range of activities that enable students and tutors to meet, collaborate and exchange ideas across geographical and hierarchical boundaries. Hierarchy, implied by age and qualifications, is less obvious in the virtual environment and informal observations show that learners and tutors initially interact as peers within the environment (Kirriemuir 2008).

Experiences in a Virtual World

HE institutions and museums are experimenting with developments within *Second Life* to enable learners to experience and understand abstract ideas or concepts. Examples include the use of *Second Life* to explain weather events, such as tsunami, hurricanes and the effect of melting glaciers on the ocean level (National Oceanographic and Atmospheric Administration (SL 2008i)). In addition, the exhibition Virtual Hallucinations (SL 2008s) and the *Second Life* version of the Exploratorium (the initial prototype (SL 2008c) and the main environment (SL 2008d)) illustrate concepts by creating experiences in *Second Life*.

Virtual Hallucinations tries to communicate aspects of schizophrenia through *Second Life*. It provides a walk-through clinic environment where everyday objects start to change their shape and voices speak to the avatar while they walk

from room to room. Similar to this approach, the Exploratorium[4] (a hands-on science museum) intends to show its visitors processes and effects that cannot be experienced in everyday life because they would be too dangerous or because of time and space constraints (Rothfarb and Doherty 2007).

Although the developers of both applications had a significant background in computing[5] they were primarily experts in the subject matter being communicated and developed the environment without collaborating with external technology and design experts.

A further pattern – although less explored – lies in enabling learners to create and participate in events which would be difficult to recreate in the real world. Examples within *Second Life* include projects designing, developing and evaluating performance and drama events (SL 2008q). These projects involved combinations of live and virtual performances.

Enabling Participation

Due to the proliferation of computer technology in everyday life, not only have the demands of users towards content grown – as reflected in the increasing production value of computer games and special effects in movies – but also the abilities of users to make use of computer and media technology in a productive way has changed. In this respect, *Second Life* offers a large degree of freedom for the creation and production of new content. This characteristic of the environment enables both tutors and learners to take a more productive role in the creation of knowledge. The most popular learning pattern is to allow learners to create objects or exhibits within *Second Life*.

In an interesting development, the *Second Life* counterpart of The Tech Museum of Innovation in San Jose, the Tech (SL 2008p), invites users to design new exhibits. These are then recreated in the real world museum. This gives the museum an insight into the demands of a particular, productive subgroup of its audience as well as a constant flow of new exhibits for their exhibition in *Second Life*. Users have the opportunity to actively affect the real-world programme of an institution as well as having a forum for their designs.

Enabling productivity offers another potential benefit as illustrated by these examples. The process of content creation is rewarding, gives users something to do instead of presenting prepared information and has the potential to sustain their engagement.

4 The Exploratorium in Second Life continues therefore the tradition of the original Exploratorium in San Francisco. Similar to the virtual environment, Oppenheimer intended the Exploratorium to be a space where the unperceivable can be perceived (Henning 2006).

5 The creator of Virtual Hallucinations has both a medical and a computer science degree according to Baldwin (Baldwin 2004), while the creators of the Exploratorium are curators in a science museum.

Museums in this way are challenged to define their goals, to build on existing interfaces with the relative minority of active creative users and to design ongoing activities that engage with the majority of users. In HE environments in contrast, the concept of learning through processes is already established. Nevertheless, the content that is produced in such processes is often neglected as a new generation of students recreates the same content in order to achieve the pre-defined learning goals.

Conclusion

Virtual worlds offer great potential for museums and HE. In particular, changing attitudes within the user base, which amplify productive engagement, provide new opportunities for learning through the exploration of virtual worlds. Overall, *Second Life* can be regarded as a platform that makes high demands upon users who want to participate in the environment. As such, the mainstream appeal of *Second Life* is limited. Furthermore, *Second Life* might not last long term but museums and HE can leave benefit from engagement with it through:

- new insights into user demands and activities;
- the development of structures that enable and support communication between users and institutions, and
- the productive engagement of users.

The cooperation between HE institutions and museums in *Second Life* leaves further room for improvement as direct cooperation is relatively infrequent. An exception to this can be found in the SciLands project, a cooperative project between several science and technology museums, universities and research institutes that form a mini-continent in *Second Life* (SciLands 2009).

So far, relatively few formal evaluations of the effect of *Second Life* upon teaching and learning have been conducted. Further research is needed in order to support claims that students prefer *Second Life* to other technologies in a learning context. This chapter suggests, however, that this research is worth undertaking in order for HE institutions and museums to benefit from the full potential of communication, action and shared creation that *Second Life* offers.

Bibliography

Baldwin, N. (2004) A Lever To Move The Mind. Retrieved 28 April 2009, from <http://secondlife.blogs.com/nwn/2004/09/in_the_minds_eye.html>

CIA (2009) The World Factbook: United States. Retrieved 28 April 2009, from <https://www.cia.gov/library/publications/the-world-factbook/geos/us.html#People>

Falk, J. and Dierking, L. (2000) *Learning from Museums: Visitor Experiences and the Making of Meaning.* Walnut Creek, CA, Altamira Press.

Hein, G.E. (1998) *Learning in the Museum.* London/New York, Routledge.

Henning, M. (2006) *Museums, Media and Cultural Theory.* Maidenhead, Open University Press.

Kirriemuir, J. (2008) A Spring 2008 'Snapshot' of UK Higher and Further Education Developments in Second Life. Retrieved 28 April 2009, from <http://www.eduserv.org.uk/~/media/foundation/sl/uksnapshot052008/final%20pdf.ashx>

Nino, T. (2007) Peering Inside: Second Life's User Retention. Retrieved 28 April 2009, from <http://www.massively.com/2007/12/23/peering-inside-second-lifes-user-retention/>

Paris, S.G. (2002) *Perspectives on Object-centered Learning in Museums.* Mahwah, NJ, Lawrence Erlbaum Associates Inc.

Rothfarb, R.J. and Doherty, P. (2007) Creating Museum Content and Community in Second Life. Retrieved 28 April 2009, from <http://archimuse.com/mw2007/papers/rothfarb/rothfarb.html>

SciLands (2009) SciLands Virtual Continent. Retrieved 28 April 2009, from <http://www.scilands.org/>

SL (2008a) The Dresden Gallery. Linden Labs. Retrieved 20 October 2008, from <http://slurl.com/secondlife/Dresden%20Gallery/210/134/43>

SL (2008b) Economic Statistics 19 October 2008. Linden Labs. Retrieved 22 October 2008, from <http://secondlife.com/statistics/economy-d ata.php>

SL (2008c) Exploratorium: Initial prototype. Linden Labs. Retrieved 20 October 2008, from <http://slurl.com/secondlife/Midnight%20City/173/60/26>

SL (2008d) Exploratorium: Main environment. Linden Labs. Retrieved 20 October 2008, from <http://slurl.com/secondlife/Exploratorium/110/86/26>

SL (2008e) International Spaceflight Museum. Linden Labs. Retrieved 20 October 2008, from <http://slurl.com/secondlife/Spaceport%20Alpha/119/152/25>

SL (2008f) International Spaceflight Museum: Informal Communication. Linden Labs. Retrieved 20 October 2008, from <http://slurl.com/secondlife/Spacepor t%20Alpha/15/238/22>

SL (2008g) International Spaceflight Museum: Public Presentation. Linden Labs. Retrieved 20 October 2008, from <http://slurl.com/secondlife/Spaceport%20 Alpha/118/152/24>

SL (2008h) The Marketplace. Linden Labs. Retrieved 22 October 2008, from <http://www.secondlife.com/whatis/economy-graphs.php>

SL (2008i) National Oceanagraphic and Atmospheric Administration. Linden Labs. Retrieved 20 October 2008, from <http://slurl.com/secondlife/Meteora/177/161/27>

SL (2008j) Open Life Island. Linden Labs. Retrieved 20 October 2008, from <http://slurl.com/secondlife/Open%20Life%20Island/98/48/25>

SL (2008k) Second Life Virtual Economy. Linden Labs. Retrieved 22 October 2008, from <http://www.static.secondlife.com/economy/stats_200808.xls>

SL (2008l) The Sistine Chapel. Linden Labs. Retrieved 20 October 2008, from <http://slurl.com/secondlife/Vassar/189/90/25>

SL (2008m) Solent Life Island. Linden Labs. Retrieved 20 October 2008, from <http://slurl.com/secondlife/Solent%20Life%20Island/94/97/25>

SL (2008n) Solent Life Reception. Linden Labs. Retrieved 20 October 2008, from <http://slurl.com/secondlife/Solent%20Life/94/97/25>

SL (2008o) Sussex University Online Campus. Linden Labs. Retrieved 20 October 2008, from <http://slurl.com/secondlife/Sussex%20Campus/92/114/26/>

SL (2008p) The Tech Museum of Innovation. Linden Labs. Retrieved 20 October 2008, from <http://slurl.com/secondlife/The%20Tech/191/158/37>

SL (2008q) Theatron. Linden Labs. Retrieved 20 October 2008, from <http://slurl.com/secondlife/Theatron%203/176/124/23>

SL (2008r) Tsunami Demonstration, National Oceanographic and Atmospheric Administration. Linden Labs. Retrieved 20 October 2008, from <http://slurl.com/secondlife/Meteora/177/161/27>

SL (2008s) Virtual Hallucinations. Linden Labs. Retrieved 20 October 2008, from <http://slurl.com/secondlife/Sedig/34/43/22>

Various (2008) Internet Usage Statistics. Retrieved 22 October 2008, from <http://www.internetworldstats.com/stats.htm>

Afterword

Anne Boddington, Beth Cook, Rebecca Reynolds and Catherine Speight

The idea for this book emerged in late 2007, when the CETLD had been active for nearly two years. It was already apparent that, despite work being undertaken in both museums and the higher education (HE) sectors around the subjects of student support and collaborative working, much of this was taking place in the context of isolated projects. These were very much dependent upon individual staff enthusiasm and opportunistic arrangements.

Our work since May 2006 has focused on a number of projects, issues, and emerging ideas about how museums might better understand contemporary HE and subsequently complement and support students studying design and related subjects. This book draws together some of these projects, and places them in the wider context of other research and teaching experiments we have encountered. Initially we conceived this publication would be primarily aimed at those working in museums or HE and would draw out strategic and practical lessons from the experiments and investigations of ourselves and others. Reflecting on these three years we hope that the research described provides an evidence base for continuing strategic support to develop and sustain long-term and constructive relationships between museums and universities. As our research has progressed we have also come to realise that this book serves another purpose, in opening up the potential for more radical dialogue between the two sectors that extends beyond individual projects or subjects, and addresses issues that are of more general concern to those working with HE students.

As our research progressed, we became aware that we were in many ways caught within our own institutional silos, each with its own language, educational and research imperatives and scholarly practices. Each sector had its own goals and targets, strategic plans and missions to fulfil. The challenge of such a partnership as this is that many of the same words have come to mean different things, and subtle shifts in meanings often lead to misunderstandings or misinterpretation. One example of different uses of language in each sector is the use of 'visual research' in the HE sector, and 'object-based learning' in museums.

Clarifying the terminology used in the different institutions has proved challenging but vital – not in order that each institution uses the same words to mean the same things, but to make each aware of the others' knowledge and expertise in the many processes involved in museum and HE learning.

One example of different areas of expertise emerged in an early resource development project conducted by CETLD at the V&A. It became clear to us

during the project that the V&A and the University of Brighton had different priorities and expectations. In simplified terms the V&A was more concerned with the creation of a product that could be offered to audiences. Their priorities for the project focused on the practicalities of using and implementing the materials developed, exploitation of a wide range of museum resources, high production values and ensuring that the materials fitted in with the museum's brand. The University of Brighton on the other hand was concerned more with the project as a source of original research, focusing on the process of developing the materials rather than the end product. This included emphasising pedagogic issues connected with design students' learning, research outcomes and outputs, and the need to 'problematise' the process by questioning assumptions and finding fruitful research questions. These two sets of aims are both valuable and in no way mutually exclusive – considering both together provided the potential for a greater contribution to education provision than concentrating on one or the other. However, this experience did clarify the need for all project aims to be explicitly articulated and tested at the beginning of any collaborative endeavour.

The preceding chapters and the projects they describe are the result of considerable dialogue between partners and colleagues to find a shared language through which both sectors can collaborate. To close this book it may therefore be interesting to offer a few thoughts about where we have reached and suggest some ideas, issues, opportunities and aspirations for moving this work forward in the future.

Through understanding the contexts in which museums and HE sectors operate, the exchange and transfer of educational methods can be more precisely examined. In considering the title for this volume, two were originally suggested. The first was *Extending the Campus* and the second *Learning to Look*. As the book developed, however, neither seemed entirely appropriate. The first was difficult because it presents the museum as an extension of a university environment, rather than as a constituent part of a more expansive learning landscape. The second was equally problematic. Unlike students in the humanities or social sciences, design students are already skilled at 'looking' and need to learn visual interrogation in order to understand objects. This is often tutored and encouraged through a process of analytical drawing that may capture structure, construction, surface and of course form. It is part of a process that is a form of deconstructive enquiry that helps students to develop an understanding of the object. Our research has shown that museums can play a vital role in this process, but that the purpose and methods for any such development need to be carefully structured and articulated.

The contemplation and concentration required to draw is in many ways the visual equivalent of workshop- or studio-based practice. This is where maquettes and objects are made and remade, materials are tested through trial, error and the occasional magical accident happens. It is, however, educationally revealing that students in a museum setting describe taking photographs as an insurance mechanism, to make sure they have 'captured' the object. Is this an indication that students are not always clear what the educational purpose of drawing and

visual interrogation might be? In reflecting on these experiences our final subtitle, *Looking to learn; Learning to see,* was chosen because it focuses on learning and understanding through employing different but associated sequences of activity. 'Looking' and 'drawing' are analogous to, but different from a workshop/studio practice of 'making' and 'playing'. Both sequences of activity are complementary but differently located within the academy and the museum.

This book has outlined some of the issues museums and universities face when trying to work collaboratively. Recent thinking by the UK government on the delivery of cultural policy and strategy has acknowledged the important role that museums occupy in supporting and enhancing cultural provision both regionally and nationally. There has been significant government investment aimed at stimulating links between the worlds of formal education and the museum sector, representing a period of rapid and radical change. This funding has been largely limited to schools-based formal education with the needs of HE students often subsumed into those of a general adult audience. The success of museums working with schools strongly indicates that the right sort of infrastructure may already exist for museums working with universities, but that further research and commitment is required from both sectors in order to make the most of this potential, and make sure that the widespread integration of museums into formal education does not stop at secondary level.

The overlaps and differences between HE and museum pedagogy, and what the two can learn from each other, are also discussed and are an important aspect of this collaboration. Our research has identified that if we hold too rigidly to preconceived forms of pedagogy that are appropriate to each setting, we limit the scope for the type of learning that can and might happen in each context. Instead we need to recognize the wealth of pedagogic research undertaken in each sector and share it, rather than reinventing the pedagogic wheel when a lot of work has already been done. One key challenge that remains is to develop tools and resources based on this research that are adaptable or usable in a number of contexts.

In design students' experiences we see very strongly some of the areas where museums and HE differ in their approach to and understanding of educational issues. The conversation in Chapter 11 reveals clearly two different kinds of scholarship – both equally valid, but taking very different approaches to the interpretation or interrogation of the object. A number of chapters touch on the potential wonder of a museum visit, and the uniqueness of the experience. Research helps students to explore their sense of self, and where they belong in the wider world – as learners, makers, interpreters and designers. The museum is an important setting for understanding the construction of cultural meaning as well as thinking about the process of designing for an end user.

Use of technology is one of the most difficult areas that HE and museums face today. The book emphasises that new technologies are expanding constantly and rapidly. It becomes clear that large institutions are almost always in the situation of playing catch-up with regard to these advances. Museums and HE institutions

are also often frustrated by the challenges of competing with much smaller and more flexible commercial companies who are able to respond more quickly to changing software and technology, and are also able to invest greater resources in their development. We have come to the conclusion that it is likely to be more effective to concentrate on smaller projects that make use of the technologies that people already possess and use. However, our research in these fields also emphasises the need for the introduction of new technologies to focus on what and how they might effectively deliver the appropriate learning, rather than on the level of technological advancement. When this happens, there can be a real value and innovation in considering ways of enhancing learning and teaching through new technologies in both museums and HE.

The Future?

What is increasingly clear is that for museum and university collaborations to be sustainable and to survive without relying on individual relationships and short-term project funding, there is a need for both sectors to rethink and realign their infrastructures and the way they organise student learning in both contexts. Rather than trying to construct one institution as an extension of the other, museums and universities need to recognise and use their positions in complementary ways. They will thus make visible for students a larger learning environment, or learning space. In so doing, both institutions will enable a return to a more continuous, albeit transformed landscape for learning, as was outlined at the beginning of the book – where museums and art schools formed part of a more consolidated vision of discovery, knowledge and learning.

Central to this dialogue has been the need for both kinds of institutions to become more permeable and to recognize and celebrate their strengths and differences. Both museums and universities are learned institutions, but museums are distinct from universities. Although both have educational roles to play, museums might be best described as part of, or leaders in the formation of, a global scholarly and cultural infrastructure, within which universities might be said to be the clear leaders of formal education.

Our initial CETLD proposition identified and articulated the need for collaboration and for 'joined-up thinking' that would build upon and strengthen the various alliances between museums and HE and ensure that these were complementary in the support they provide. Working together and building on the research outlined in this volume it is clear that we could:

- create interrogative tools to enhance knowledge and skills;
- design mechanisms that provide mutual support and that stimulate research and scholarship;
- share learning resources for others to access which draw on the knowledge and expertise of both communities.

The creative and cultural industries are now viewed as vital for stimulating strategic growth and innovation in collaboration with Higher and Further Education. Museums must be part of this, and it is essential that museums and universities adapt their infrastructures to enable long-term, fruitful partnerships. As Morna Hinton describes in the preface, despite closely linked origins during the nineteenth century, museums and HE developed in parallel throughout the twentieth century. Might now be an opportune time to revisit that earlier model of museum-university relationship, bringing the expertise developed in the two sectors back together?

Index